LETTERHEAD & LOGO DESIGN 3

Creating The Corporate Image

ROCKPORT
PUBLISHERS

ROCKPORT PUBLISHERS, INC.
Rockport, Massachusetts

First published in the United States of America by:
Rockport Publishers, Inc.
146 Granite Street
Rockport, Massachusetts 01966
Telephone: (508) 546-9590
Fax: (508) 546-7141
Telex: 5106019284 ROCKORT PUB

First published in Germany by Rockport Publishers, Inc. for:
Nippan
Nippon Shuppan Hanbai Deutschland GmbH
Krefelder Str. 85
D-40549 Dusseldorf
Telephone: (0211) 504 8089
Fax: (0211) 504 9326

Distributed to the book trade and art trade in the U.S. and Canada by:
North Light, an imprint of
F & W Publications
1507 Dana Avenue
Cincinnati, Ohio 45207
Telephone: (513) 531-2222

Other Distribution by:
Rockport Publishers, Inc.
Rockport, Massachusetts 01966

ISBN 1-56496-228-8

10 9 8 7 6 5 4 3 2 1

Art Director: *Laura Herrmann*
Designer: *Laura Herrmann*
Layout/Production: *Thom Lewis*
Production Manager: *Barbara States*
Production Assistant: *Pat O'Maley*

Printed in China

CONTENTS

INTRODUCTION 4

GRAPHIC DESIGN/ADVERTISING 5

CREATIVE SERVICES 38

ARCHITECTURE 60

PHOTOGRAPHY 77

PROFESSIONAL SERVICES 90

HEALTHCARE/EDUCATION & NONPROFIT 119

FOOD/BEVERAGE 142

REAL ESTATE/PROPERTIES 167

INDUSTRY/MANUFACTURING 187

MISCELLANEOUS 211

INDEX/DIRECTORY 250

INTRODUCTION

Each new business begins with a letterhead and a logo . . . literally. Before anything else is accomplished, a letterhead and a logo is created. Sometimes before a business plan is created . . . a letterhead and logo is created. Often before office space is leased . . . a letterhead and logo appears! In fact, I've created entire identity systems even before the company telephone number is known . . . no kidding. Nothing is closer to the birth of an enterprise and nothing can be more important than a properly conceived, designed and executed logo and letterhead.

In addition to icons, words and numbers, business papers convey a surprisingly accurate and remarkable complete amount of additional information. In fact, that little 2 x 3½ business card is probably the most influential seven square inches in the world of print communication.

Actually, the entire nature of an organization and/or an individual is evident on the surface of the simple business card. One can detect or deduce intelligence, self assurance, innovation and leadership. In addition, characteristics such as mimicry, inauthenticity, slovenliness and miserliness are also apparent, even to the casual observer.

If you are presented with a slipshod business card, you won't be surprised when you step into a dirty lobby upon arrival for your first visit. Conversely, business papers, created by bona fide talent, can generate a powerful visual statement which can set the cultural tone for an entire organization.

Curiously, not one of the nation's leading business schools devoted even a single course to the subject of visual identities . . . in spite of the obvious success of companies who have purposefully, accidentally or otherwise tapped into the power of design.

Consider, on a personal level, the visual imagery that has been placed in your mind by enterprises such as Benetton, Apple and Nike. If you think advertising has created those feelings of yours, think again. Other advertisers have created the ads and spent the money, yet they have failed to get the job done on you.

Design is the real power behind this phenomenon of imagery. Advertising is only the conduit. Ads are the wiring, design is the electricity. You get shocked by the electricity, not by the wires.

As you thumb through the pages of this book you will see the work of some of the world's most amazing people . . . Graphic Designers. You will discover pleasant visual puns and clever metaphors as well as stunning interpretations of the traditional elements of typography, paper and color.

While all of the designs featured in this book are interesting or beautiful, some of them are brilliant. Graphic Design is ubiquitous. It's everywhere in our culture and, at it's best, it contributes to the beauty and richness of our lives.

Michael Stanard

GRAPHIC DESIGN/ ADVERTISING

HOFFMANN & ANGELIC

GRAPHIC DESIGN · HANDLETTERING · ILLUSTRATION

317
1675 Martin Drive
White Rock
B.C. Canada
V4A 6E2
PH. 604/535-8551 • FX. 604/535-8551

E M A
design

1 2 2 8
fifteenth
street
suite 301
denver
colorado
80202

facsimile
303.825.2800
telephone
303.825.0222

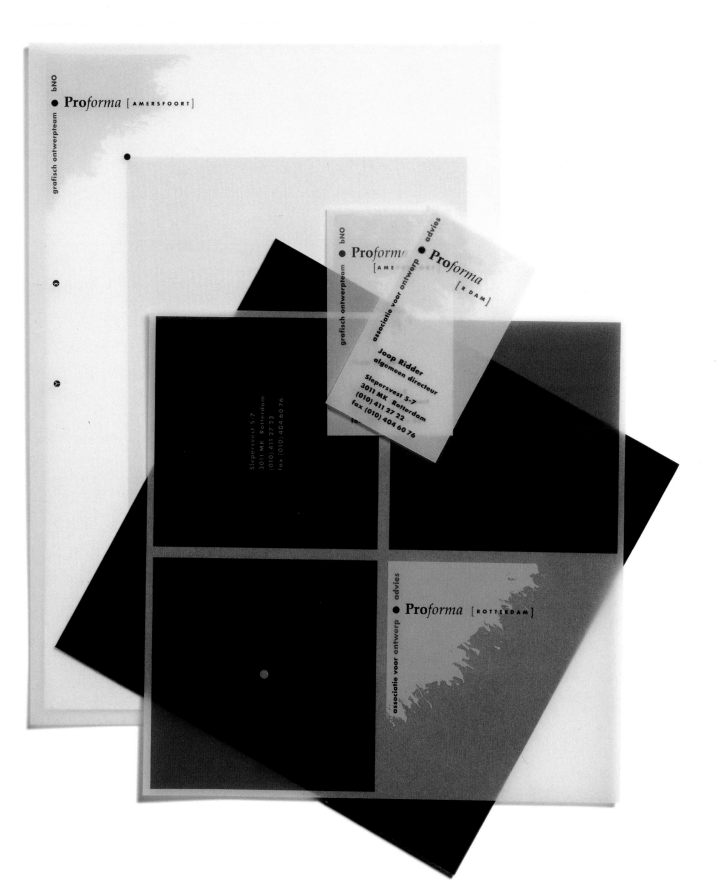

DESIGN FIRM	Proforma Rotterdam
ART DIRECTOR	Aadvan Dommelen
DESIGNER	Gert Jan Rooijakkers
CLIENT	Proforma
PAPER/PRINTING	Calque

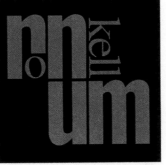

Ron Kellum Inc. 151 First Avenue PH-1 NY, NY 10003

Telephone: 212-979-2661 Fax/Modem: 212-260-3525

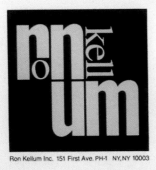

Ron Kellum Inc. 151 First Ave. PH-1 NY, NY 10003

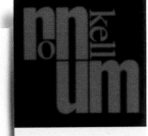

Ron Kellum

Ron Kellum Inc.
151 First Ave. PH-1 NewYork, NY 10003
Tel: 212-979-2661 Fax: 212-260-3525

DESIGN FIRM	Ron Kellum Inc.
ART DIRECTOR	Ron Kellum
DESIGNER	Ron Kellum
ILLUSTRATOR	Ron Kellum Inc.
PAPER/PRINTING	Strathmore Writing

DESIGN FIRM	38 North
ART DIRECTOR	Nida Zada
CLIENT	38 North
PAPER/PRINTING	4 colors

DESIGN FIRM	Musikar Design
ART DIRECTOR	Sharon R. Musikar
DESIGNER	Sharon R. Musikar
PHOTOGRAPHER	Sharon R. Musikar
CLIENT	Musikar Design
PAPER/PRINTING	Classic Crest, 2 colors

DESIGN FIRM	Bartels & Company, Inc.
ART DIRECTOR	David Bartels
DESIGNER	Brian Barclay
ILLUSTRATOR	Brian Barclay
CLIENT	Bartels & Company, Inc.

DESIGN FIRM	Cisneros Design
ART DIRECTOR	Fred Cisneros
DESIGNER	Fred Cisneros
CLIENT	Cisneros Design
PAPER/PRINTING	Classic Crest

415 East
Olive Avenue
•
Fresno
California
93728
•
209-497-8060
•
FAX
209-497-8061

Charles Shields

415 East Olive Avenue
Fresno, California 93728
209-497-8060
FAX. 209-497-8061

DESIGN FIRM	Shields Design
ART DIRECTOR	Charles Shields
DESIGNER	Charles Shields
CLIENT	Shields Design
PAPER/PRINTING	Simpson Quest

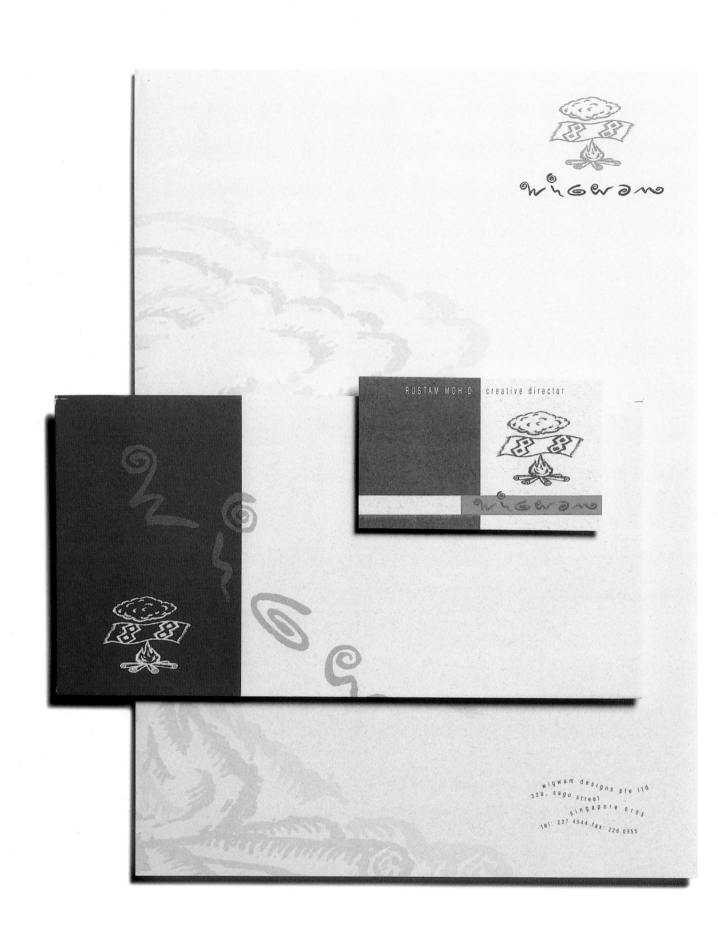

DESIGN FIRM Wigwam Designs Pte. Ltd.
ART DIRECTOR Rustam Moh'd
DESIGNER Rustam Moh'd
ILLUSTRATOR Muk Koon Hoong
CLIENT Wigwam Designs

DESIGN FIRM	Ortega Design
ART DIRECTOR	Susann Ortega
DESIGNER	Susann Ortega, Joann Ortega
ILLUSTRATOR	Susann Ortega
CLIENT	Ortega Design
PAPER/PRINTING	Simpson Evergreen, foil stamp, embossed

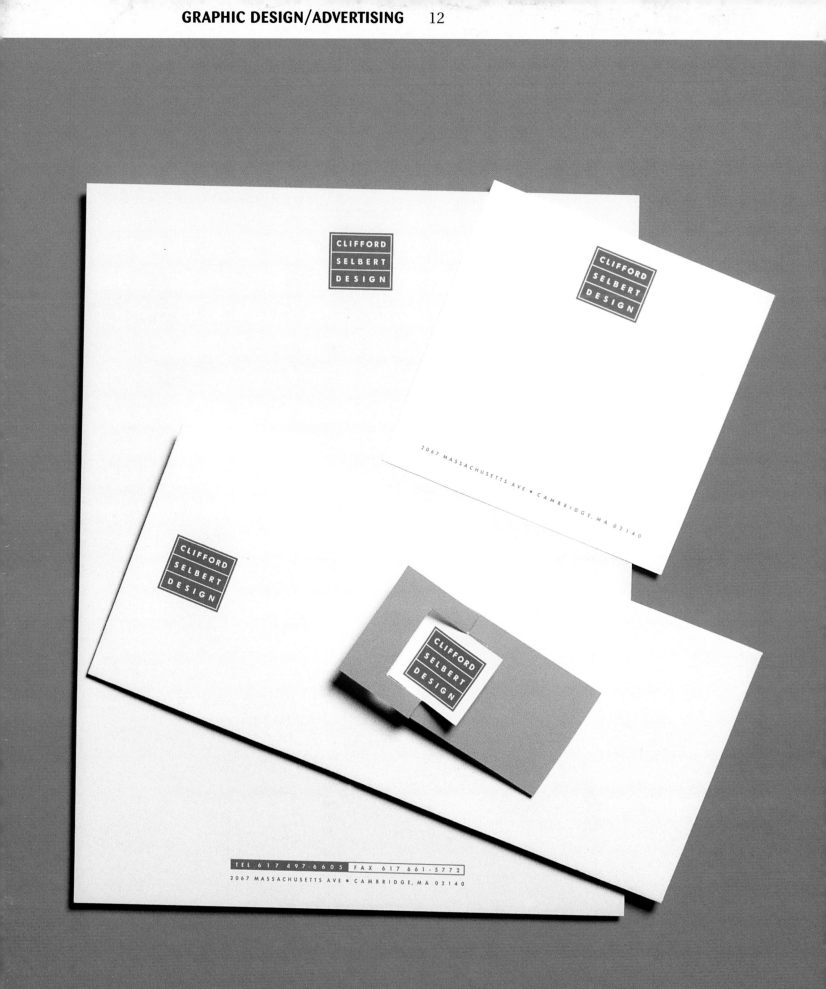

DESIGN FIRM Clifford Selbert Design
ART DIRECTOR Clifford Selbert, Melanie Lowe
DESIGNER Melanie Lowe
CLIENT Clifford Selbert Design
PAPER/PRINTING Strathmore

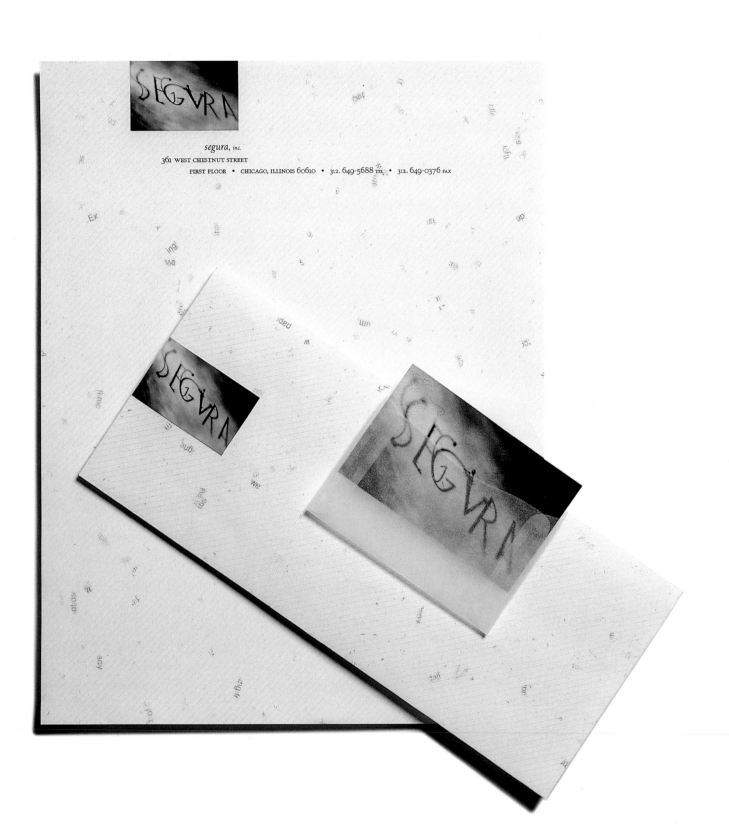

DESIGN FIRM	Segura Inc.
ART DIRECTOR	Carlos Segura
DESIGNER	Carlos Segura
ILLUSTRATOR	Greg Heck
CLIENT	Segura Inc.
PAPER/PRINTING	Wagner

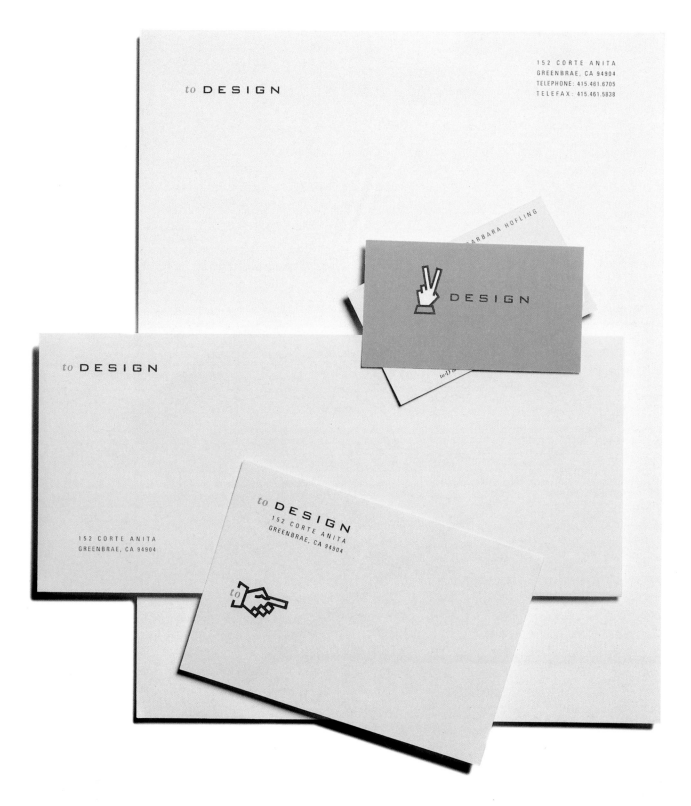

DESIGN FIRM THARP DID IT
DESIGNER Rick Tharp, Jean Mogannam
CLIENT to DESIGN/Barbara Hofling
PAPER/PRINTING Neenah Paper

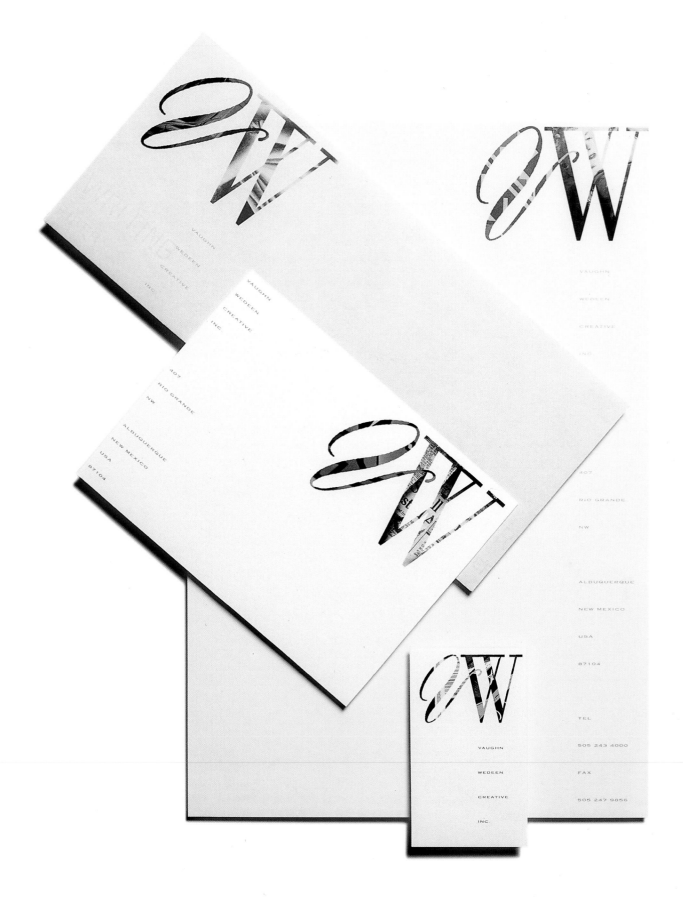

DESIGN FIRM	Vaughn Wedeen Creative
ART DIRECTOR	Rick Vaughn, Steve Wedeen
DESIGNER	Rick Vaughn, Steve Wedeen
ILLUSTRATOR	Various
CLIENT	Vaughn Wedeen Creative
PAPER/PRINTING	Strathmore Ultimate White

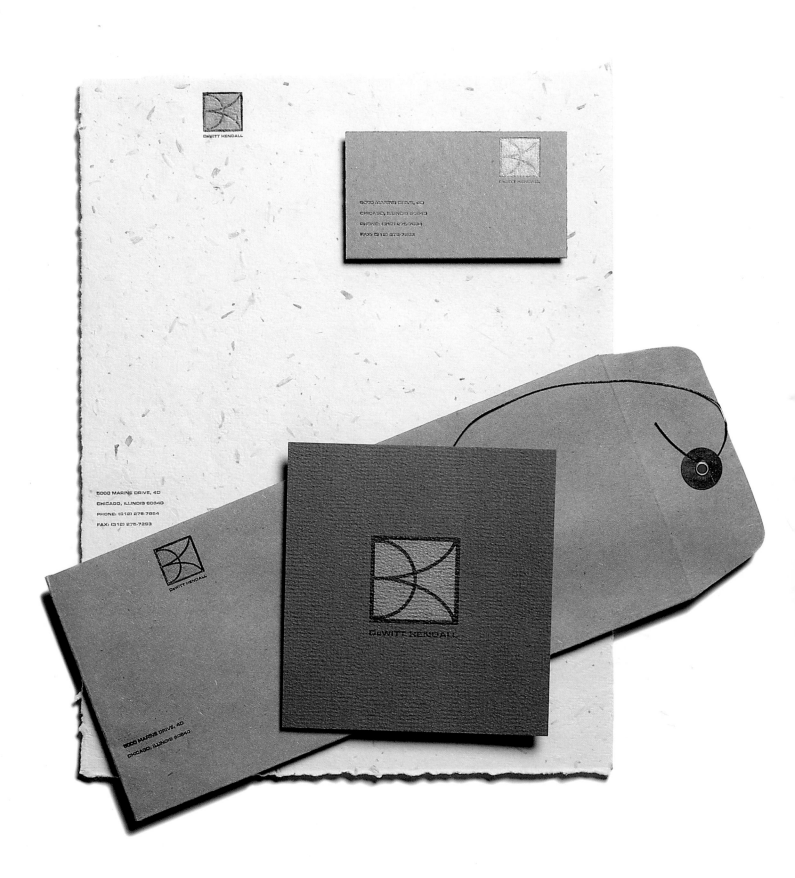

DESIGN FIRM	Dewitt Kendall – Chicago
ART DIRECTOR	Dewitt Kendall
DESIGNER	Dewitt Kendall
ILLUSTRATOR	Dewitt Kendall
CLIENT	Dewitt Kendall Chicago
PAPER/PRINTING	Kraft 3-ply industrial chipboard, handmade rice husk paper (stationery) Simpson Gainsborough, 2 hits of copper (business card)

GRANDPRE & WHALEY LTD.

475 Cleveland Ave. N., Suite 222

Saint Paul, Minnesota 55104

Facsimile 612 / 645-2430

Telephone 612 / 645-3463

GRANDPRÉ & WHALEY LTD.

475 Cleveland Ave. N., Suite 222

Saint Paul, Minnesota 55104

Facsimile 612 / 645-2430

Telephone 612 / 645-3463

KEVIN WHALEY
Art Director / Designer

"...with a View"

GRANDPRE & WHALEY LTD.

475 Cleveland Ave. N., Suite 222

Saint Paul, Minnesota 55104

GRANDPRÉ & WHALEY LTD.
475 Cleveland Ave. N., Suite 222
Saint Paul, Minnesota 55104
Facsimile 612 / 645-2430
Telephone 612 / 645-3463

"Communication with a View"

DESIGN FIRM	GrandPré and Whaley, Ltd.
ART DIRECTOR	Kevin Whaley, Mary GrandPré
DESIGNER	Kevin Whaley
CLIENT	GrandPré & Whaley, Ltd.
PAPER/PRINTING	Strathmore

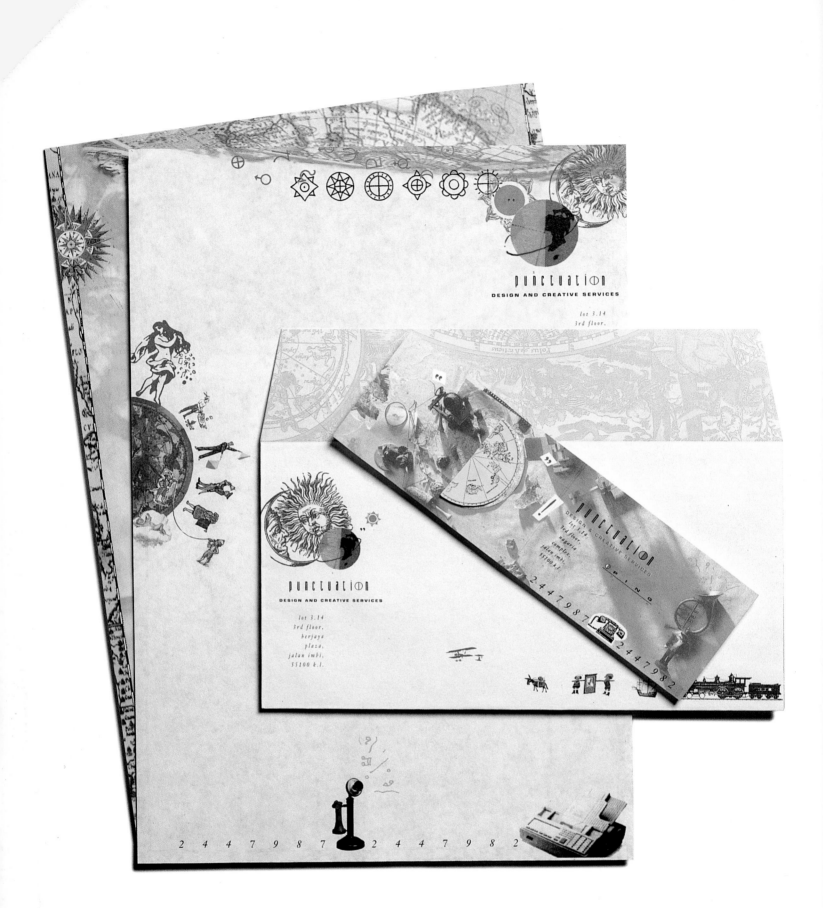

DESIGN FIRM	Punctuation
ART DIRECTOR	Ping
DESIGNER	Ping
CLIENT	Punctuation
PAPER/PRINTING	New Raglin, Stratakolour

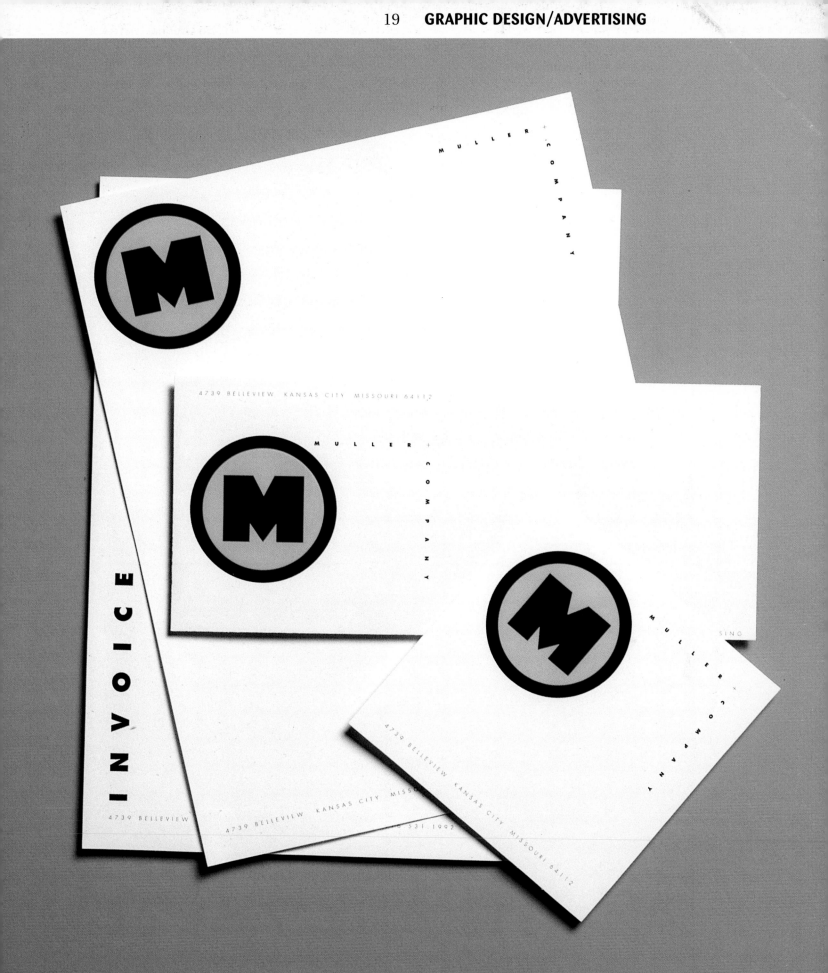

DESIGN FIRM Muller + Company
ART DIRECTOR John Muller
DESIGNER John Muller
CLIENT Muller + Company
PAPER/PRINTING Proterra Chalk Vellum

DESIGN FIRM Cactus Design
ART DIRECTOR Susan Hankoff-Estrella
DESIGNER Susan Hankoff-Estrella
ILLUSTRATOR Theo Camut
CLIENT Cactus Design
PAPER/PRINTING Strathmore Renewal, Chamois

DESIGN FIRM Jeff Shelly
ILLUSTRATOR Jeff Shelly
CLIENT Jeff Shelly

DESIGN FIRM M. Renner Design
ART DIRECTOR Michael Renner
DESIGNER Michael Renner
ILLUSTRATOR Michael Renner
CLIENT Studio Pignatelli

DESIGN FIRM Blue Sky Design
ART DIRECTOR Bob Little, Joanne Little,
 Maria Dominguez
CLIENT Blue Sky Design
PAPER/PRINTING Crane's Crest Fluorescent White

DESIGN FIRM Envision
ART DIRECTOR Julia Comer, Walter McCord
DESIGNER Julia Comer, Walter McCord
ILLUSTRATOR Julia Comer, Walter McCord
CLIENT Envision
PAPER/PRINTING Strathmore Alexandra Brilliant, 3 colors

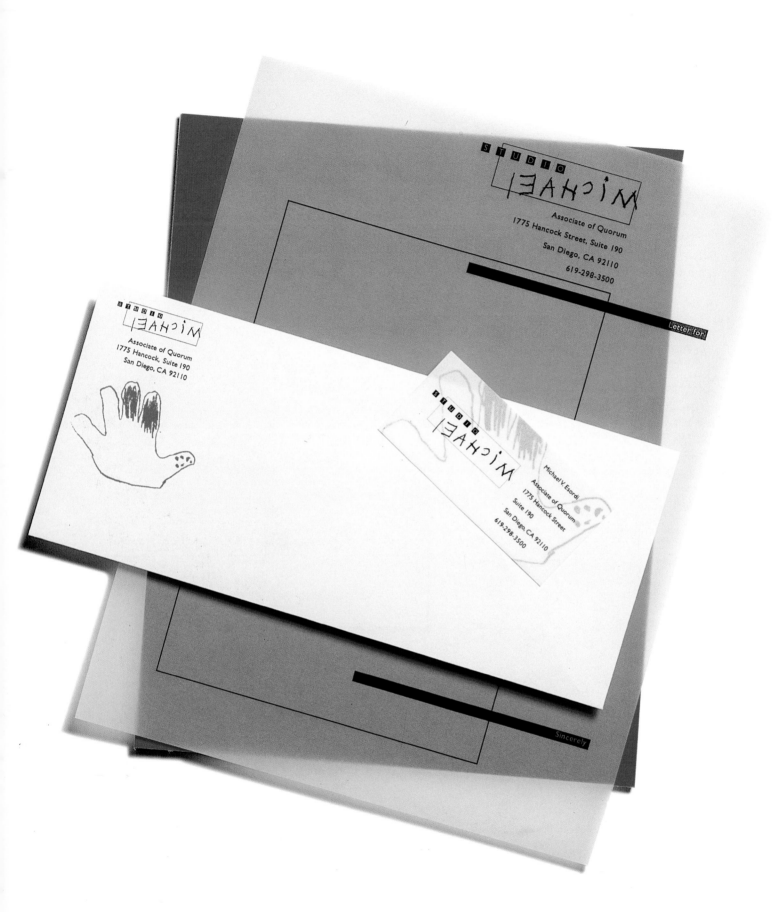

DESIGN FIRM	Studio Michael
ART DIRECTOR	Michael Esordi
DESIGNER	Michael Esordi
ILLUSTRATOR	Michael Esordi
CLIENT	Studio Michael
PAPER/PRINTING	Classic Crest, UV Vellum

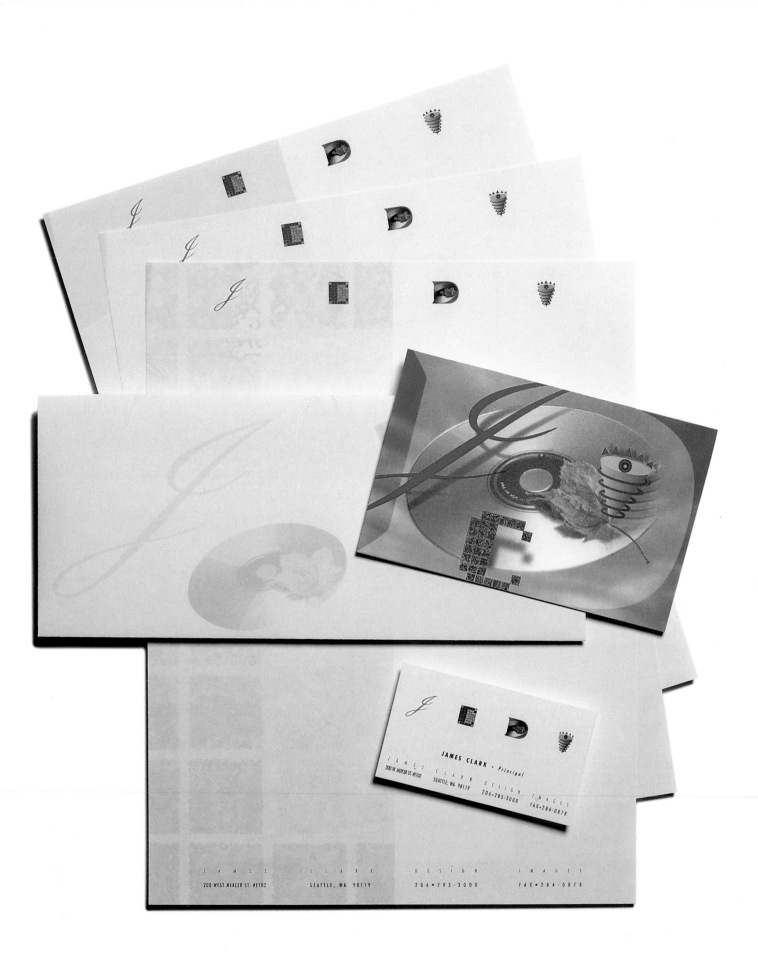

DESIGN FIRM	James Clark Design Images
ART DIRECTOR	James Clark
DESIGNER	James Clark
ILLUSTRATOR	Dyanna Kosak
CLIENT	James Clark Design Images
PAPER/PRINTING	Printing Control

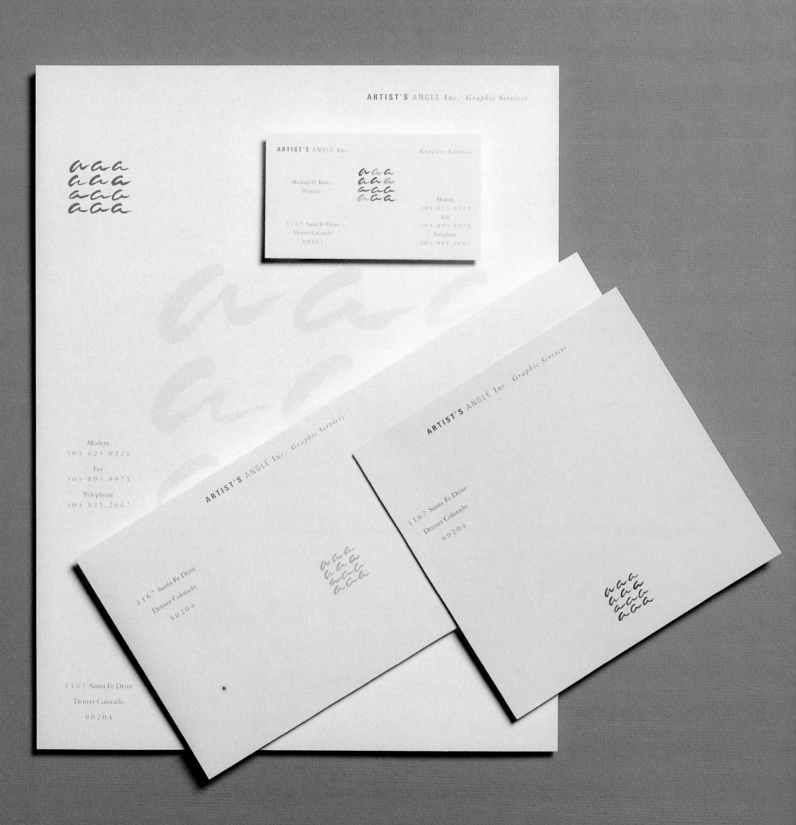

DESIGN FIRM Ema Design
ART DIRECTOR Thomas C. Ema
DESIGNER Debra Johnson Humphrey
CLIENT Artist's Angle
PAPER/PRINTING Classic Crest

DESIGN FIRM	Randy McCafferty
DESIGNER	Randy McCafferty
ILLUSTRATOR	Randy McCafferty
CLIENT	Randy McCafferty
PAPER/PRINTING	Speckletone

DESIGN FIRM	Elizabeth Resnick Design
ART DIRECTOR	Elizabeth Resnick
DESIGNER	Elizabeth Resnick
CLIENT	Elizabeth Resnick Graphic Design
PAPER/PRINTING	Strathmore Writing, embossed flourescent, offset dark green

DESIGN FIRM	Heart Graphic Design
ART DIRECTOR	Clark Most
DESIGNER	Clark Most
CLIENT	Heart Graphic Design
PAPER/PRINTING	Benefit Natural Flax

DESIGN FIRM	Puccinelli Design
ART DIRECTOR	Keith Puccinelli
DESIGNER	Keith Puccinelli, Heidi Palladino
ILLUSTRATOR	Keith Puccinelli
CLIENT	Puccinelli Design
PAPER/PRINTING	Gilbert Neo

DESIGN FIRM Creative EDGE

DESIGNER Rick Salzman, Barbara Pitfido

CLIENT Creative EDGE

PAPER/PRINTING Gilbert Esse

MICHELE BEAUCHAMP

619.689.0089

BEAUCHAMP DESIGN
9848 MERCY ROAD NUMBER EIGHT
SAN DIEGO CALIFORNIA 92129
619.689.0089

DESIGN FIRM Beauchamp Design
ART DIRECTOR Michele Beauchamp
DESIGNER Michele Beauchamp
CLIENT Beauchamp Design
PAPER/PRINTING Starwhite Vicksburg

DESIGN FIRM Laura Herrmann Design
ART DIRECTOR Laura Herrmann
DESIGNER Laura Herrmann
CLIENT Laura Herrmann Design
PAPER/PRINTING Classic Linen, Writing and Duplex

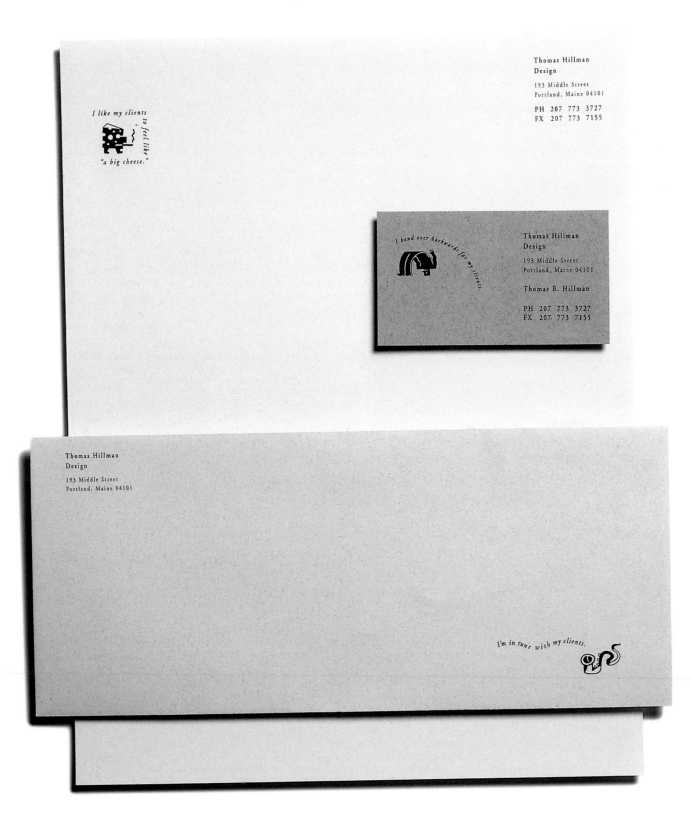

DESIGN FIRM	Thomas Hillman Design
ART DIRECTOR	Thomas Hillman
DESIGNER	Thomas Hillman
ILLUSTRATOR	Bob Aufuzdish, Eric Donelan
CLIENT	Thomas Hillman Design
PAPER/PRINTING	Neenah Environment

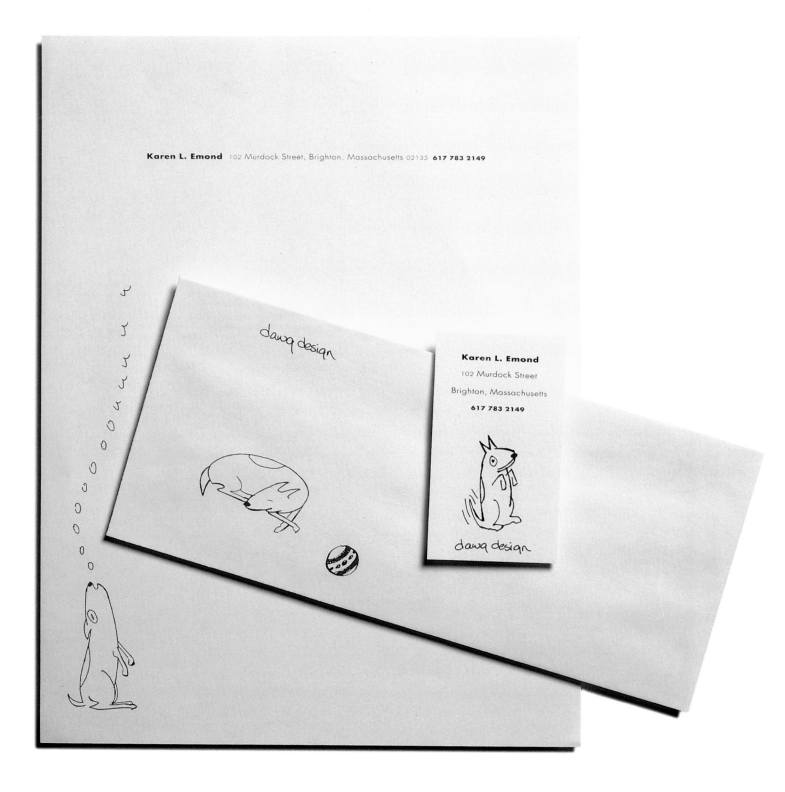

DESIGN FIRM Hawley & Armian Marketing/Design
DESIGNER Karen Emond
CLIENT Dawg Design
PAPER/PRINTING Strathmore Writing

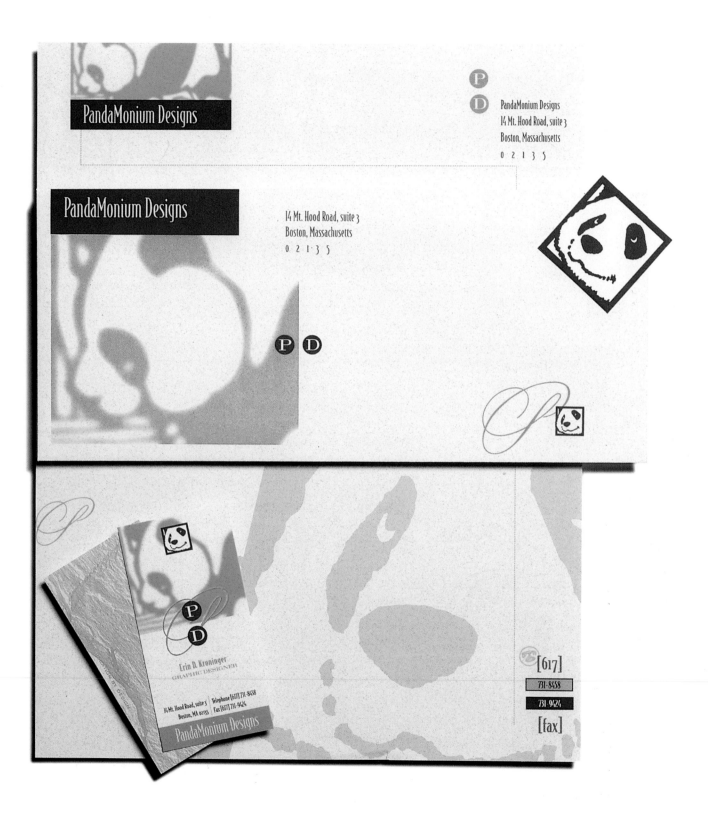

DESIGN FIRM Pandamonium Designs
DESIGNER Raymond Yu
CLIENT Pandamonium Designs
PAPER/PRINTING Howard Crush Leaf

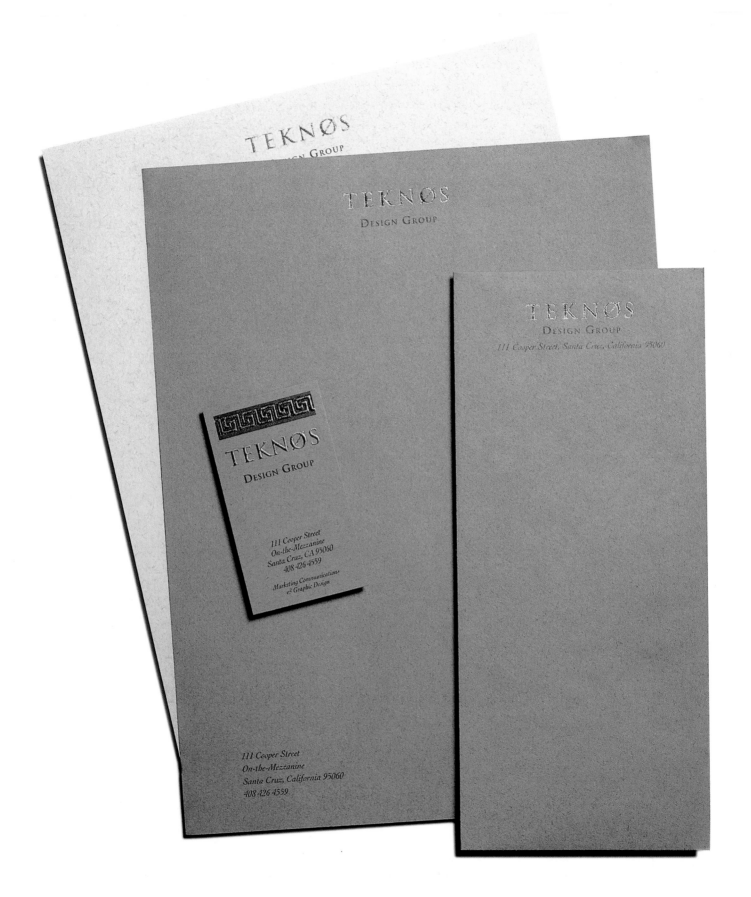

DESIGN FIRM Teknøs Design Group
DESIGNER Annaliese Fee
CLIENT Teknøs Design Group
PAPER/PRINTING Simpson Evergreen, Spruce

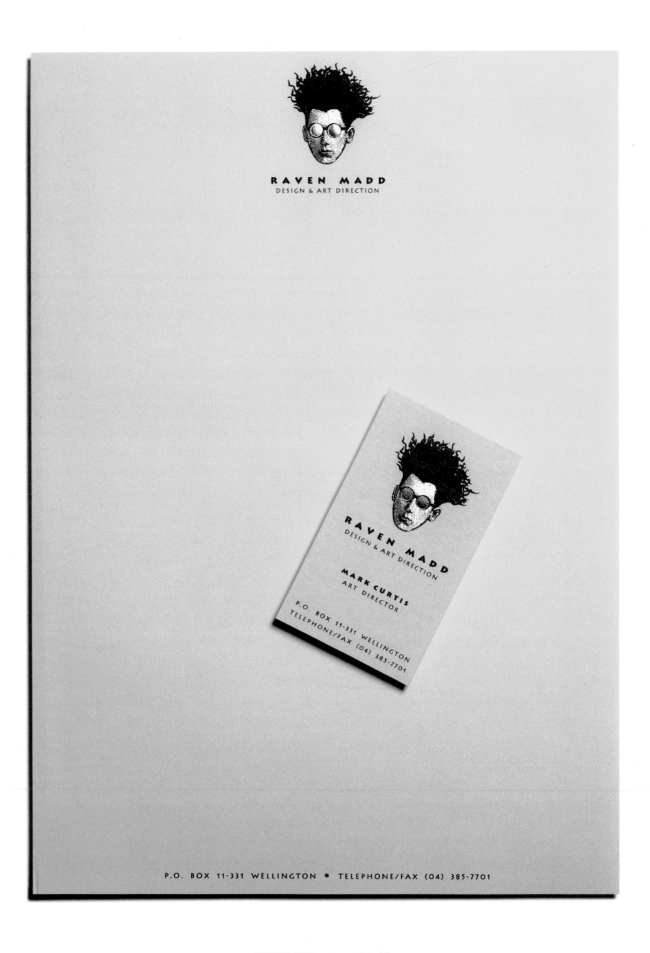

DESIGN FIRM	Raven Madd
ART DIRECTOR	Mark Curtis
DESIGNER	Mark Curtis
ILLUSTRATOR	Mark Curtis
CLIENT	Raven Madd
PAPER/PRINTING	N2 Print Ltd.

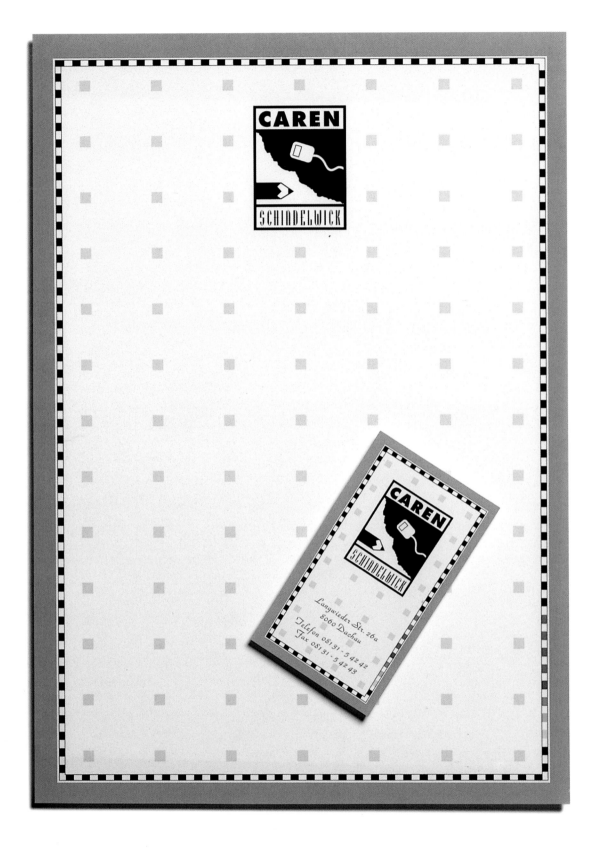

DESIGN FIRM Kom Design Munich
ART DIRECTOR Caren Schindelwick
CLIENT Caren Schindelwick
PAPER/PRINTING 4-color printing

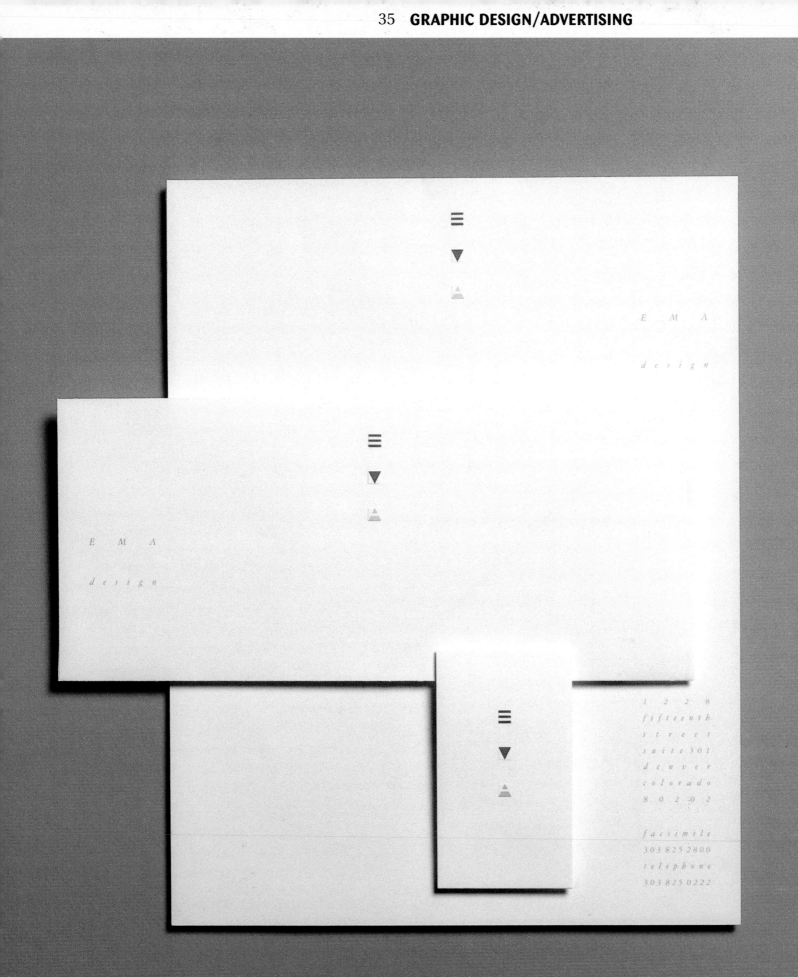

DESIGN FIRM	Ema Design
ART DIRECTOR	Thomas C. Ema
CLIENT	Ema Design
PAPER/PRINTING	Kimberly Writing

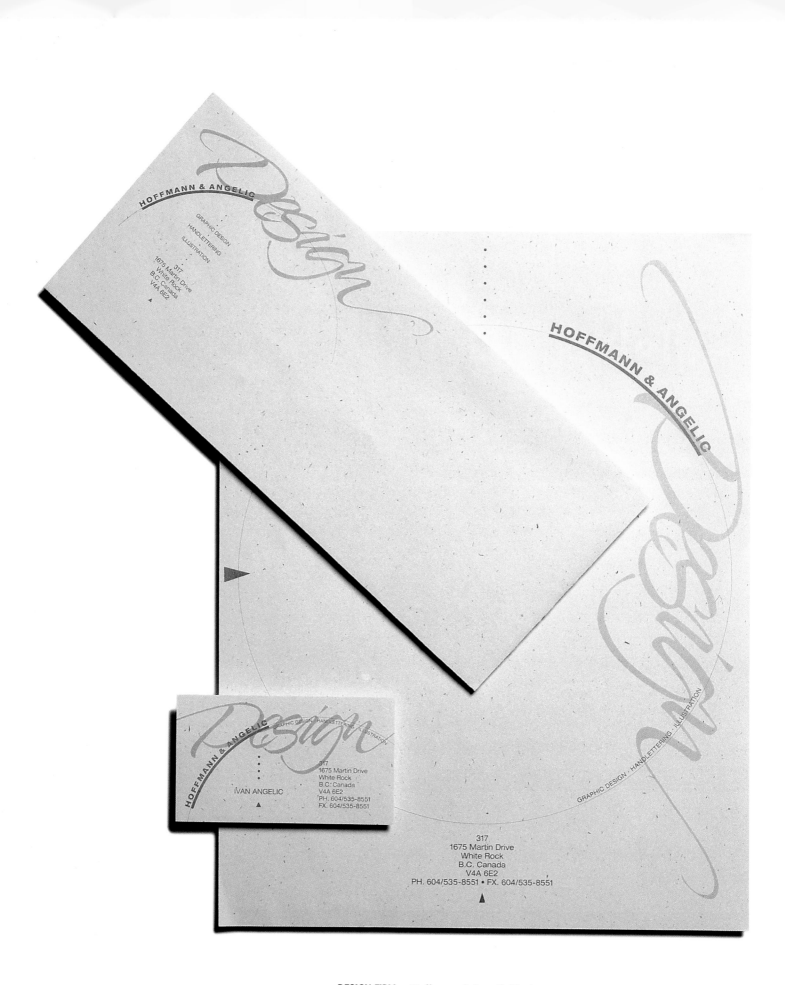

DESIGN FIRM	Hoffmann & Angelic Design
ART DIRECTOR	Ivan Angelic
DESIGNER	Andrea Hoffman
CALIGRAPHER	Ivan Angelic
CLIENT	Hoffmann & Angelic Design
PAPER/PRINTING	Genesis/Milkweed

DESIGN FIRM Sommese Design
ART DIRECTOR Kristin Sommese
DESIGNER Kristin Sommese
CLIENT Sommese Design

DESIGN FIRM Muller + Company
DESIGNER David Shultz
CLIENT Chris Muller

DESIGN FIRM Creative Services by
Pizza Hut
ART DIRECTOR Lisa Voss, Lori Cox
DESIGNER Lisa Voss
CLIENT Creative Services by
Pizza Hut

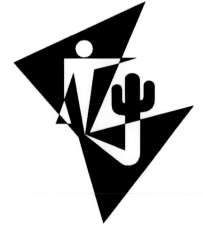

DESIGN FIRM Hornall Anderson
Design Works
ART DIRECTOR Jack Anderson
DESIGNER Jack Anderson,
David Bates, Lian Ng
ILLUSTRATOR Yutaka Sasaki
CLIENT Hornall Anderson
Design Works

DESIGN FIRM Segura Inc.
ART DIRECTOR Carlos Segura
DESIGNER Carlos Segura
ILLUSTRATOR Carlos Segura
CLIENT Sol Communications

DESIGN FIRM Tieken Design &
Creative Services
ART DIRECTOR Fred E. Tieken
DESIGNER Fred E. Tieken
CLIENT American Advertising
Federation

IMAGES **FRIEDMAN** GALLERY

hill williams DESIGN

6314
NORTH
LAKEWOOD
CHICAGO
ILLINOIS
60660

(SOURELIS + ASSOCIATES)

☎ 312 465 7977

CREATIVE SERVICES

S
+
A

PRINTOLOGY

REO TYPE

Pine Square

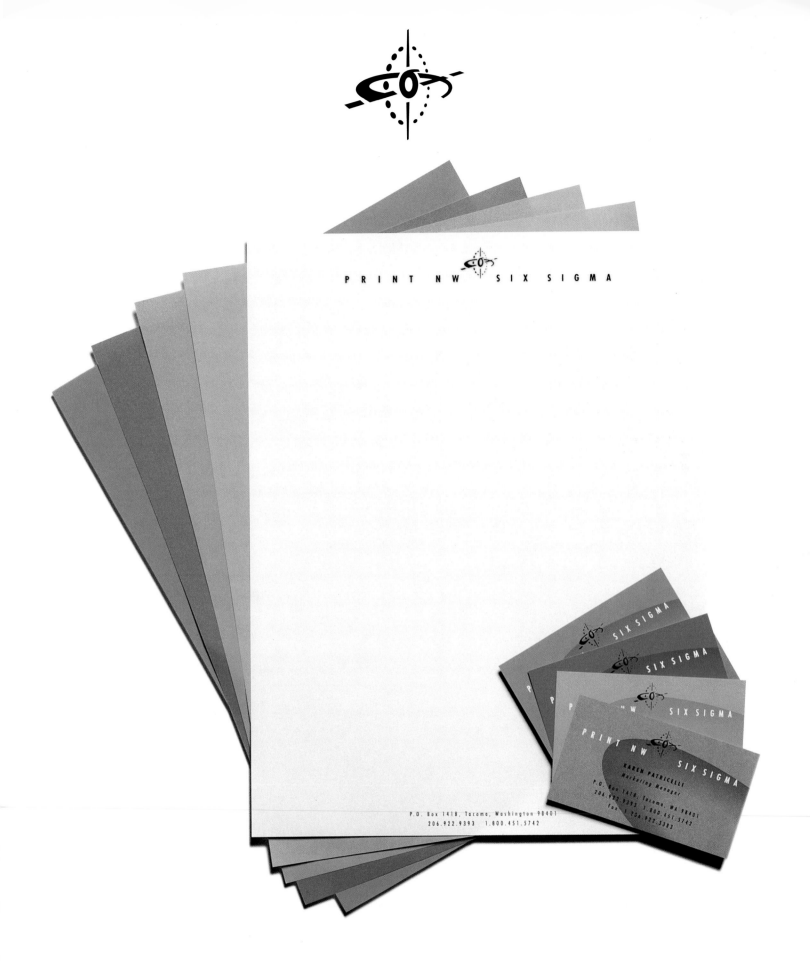

DESIGN FIRM	Hornall Anderson Design Works
ART DIRECTOR	Jack Anderson
DESIGNER	Jack Anderson, Heidi Hatlestad, Mary Hutchinson, Bruce Branson-Meyer
ILLUSTRATOR	Scott McDougall
CLIENT	Print NW/Six Sigma
PAPER/PRINTING	Neenah Classic Crest Recycled

1022 LINCOLN ROAD
MIAMI BEACH, FL 33139

1022 LINCOLN ROAD
MIAMI BEACH, FL 33139
PHONE & FAX (305) 532-2596

1022 LINCOLN ROAD
MIAMI BEACH, FL 33139
PHONE & FAX (305) 532-2596

DESIGN FIRM Dewitt Kendall – Chicago
ART DIRECTOR Dewitt Kendall
DESIGNER Dewitt Kendall
ILLUSTRATOR Dewitt Kendall
CLIENT William Wagenaar Studios
PAPER/PRINTING Passport

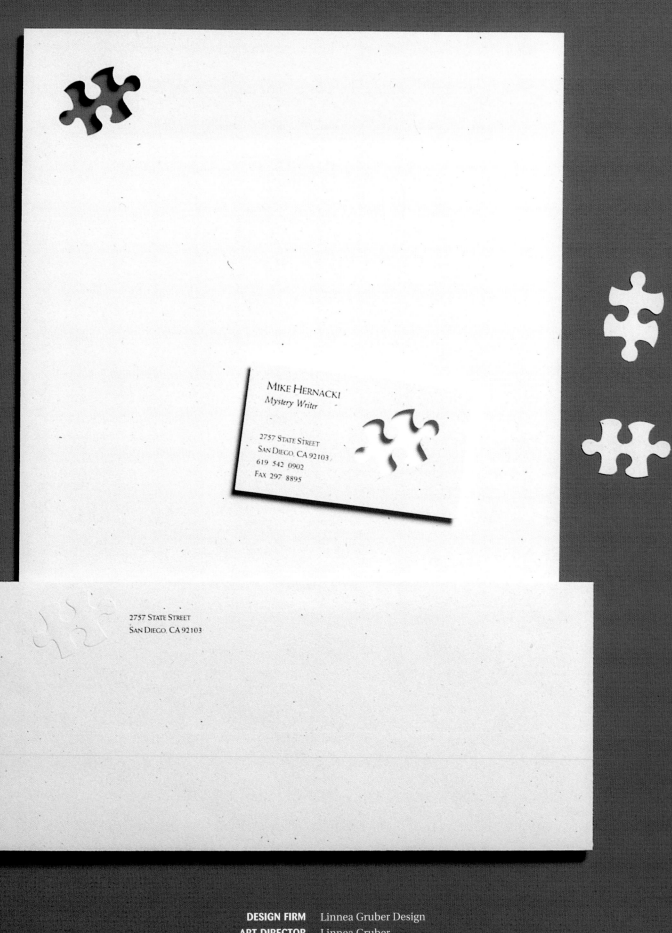

MIKE HERNACKI
Mystery Writer

2757 STATE STREET
SAN DIEGO, CA 92103
619 542 0902
FAX 297 8895

2757 STATE STREET
SAN DIEGO, CA 92103

DESIGN FIRM Linnea Gruber Design
ART DIRECTOR Linnea Gruber
DESIGNER Linnea Gruber
CLIENT Mike Hernacki
PAPER/PRINTING Speckletone, die-cut, embossed

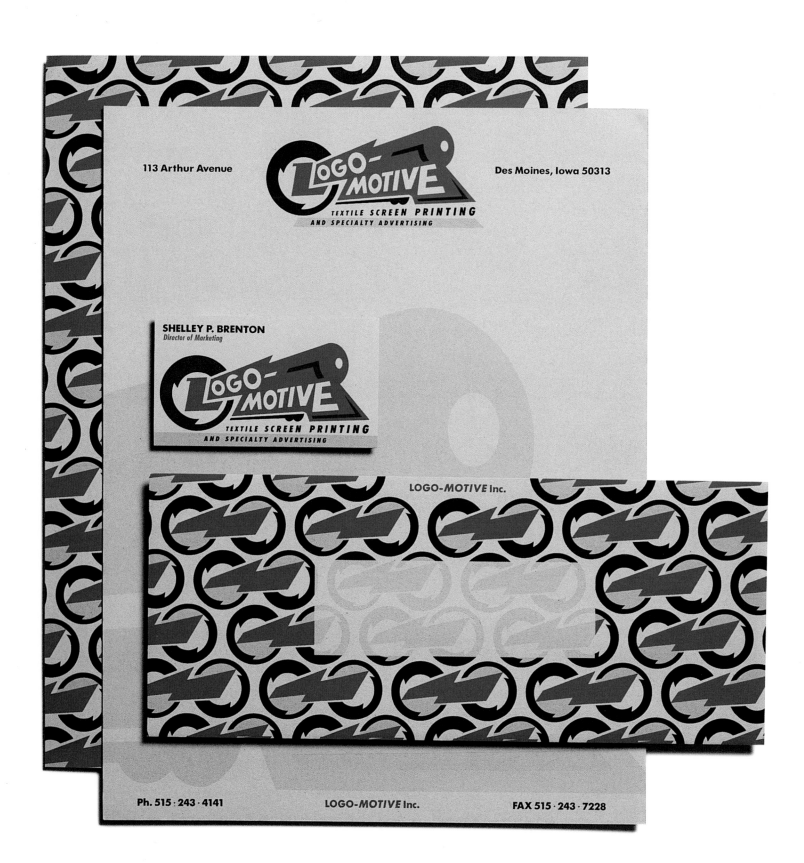

DESIGN FIRM Sayles Graphic Design
ART DIRECTOR John Sayles
DESIGNER John Sayles
ILLUSTRATOR John Sayles
CLIENT Logo-Motive
PAPER/PRINTING James River, Retreeve Gray, 2 colors

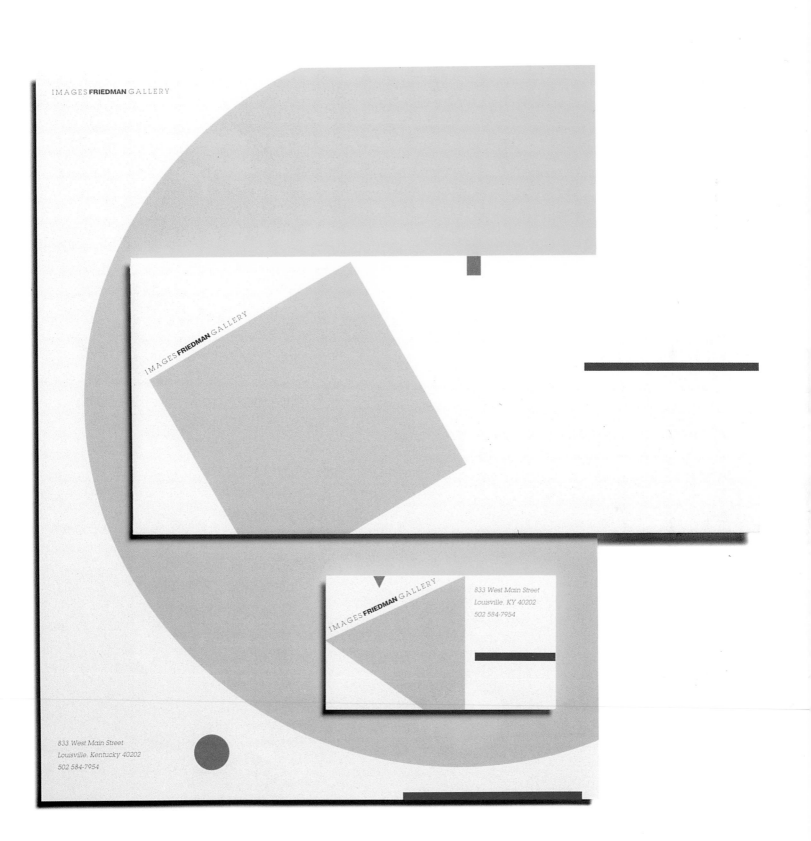

IMAGES **FRIEDMAN** GALLERY

833 West Main Street
Louisville, Kentucky 40202
502 584-7954

IMAGES **FRIEDMAN** GALLERY

833 West Main Street
Louisville, KY 40202
502 584-7954

DESIGN FIRM	Images
ART DIRECTOR	Julius Friedman
DESIGNER	Julius Friedman
ILLUSTRATOR	Julius Friedman
CLIENT	Images Friedman Gallery
PAPER/PRINTING	Simpson Starwhite Vellum

DESIGN FIRM Barbara Raab Design
ART DIRECTOR Barbara Raab Sgouros
DESIGNER Lee Ann Rhodes
CLIENT Hill Williams Design
PAPER/PRINTING Classic Crest, 2 colors

DESIGN FIRM	GrandPre and Whaley, Ltd.
ART DIRECTOR	Kevin Whaley
DESIGNER	Kevin Whaley
CLIENT	Lithoprep, Inc.
PAPER/PRINTING	Champion

DESIGN FIRM	Allan Hill
ART DIRECTOR	Allan Hill
DESIGNER	Allan Hill
CLIENT	Allan Hill
PAPER/PRINTING	Champion, Mystique Soft White

DESIGN FIRM	Sharpe Grafikworks
ART DIRECTOR	Jay Sharpe
DESIGNER	Jay Sharpe
ILLUSTRATOR	Jay Sharpe
CLIENT	Sharpe Grafikworks
PAPER/PRINTING	Frencia Speckletone

DESIGN FIRM	Ema Design
ART DIRECTOR	Thomas C. Ema
CLIENT	Kresin Wingard
PAPER/PRINTING	Kimberly Writing

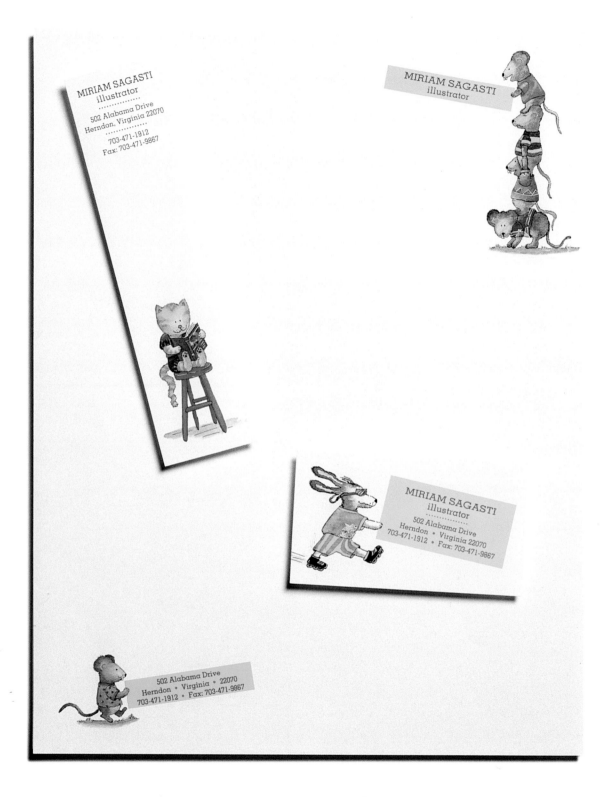

MIRIAM SAGASTI
illustrator
..............
502 Alabama Drive
Herndon, Virginia 22070
..............
703-471-1912
Fax: 703-471-9867

MIRIAM SAGASTI
illustrator

MIRIAM SAGASTI
illustrator
..............
502 Alabama Drive
Herndon • Virginia 22070
703-471-1912 • Fax: 703-471-9867

502 Alabama Drive
Herndon • Virginia • 22070
703-471-1912 • Fax: 703-471-9867

DESIGN FIRM Bi-design
ART DIRECTOR Miriam Sagasti
DESIGNER Miriam Sagasti
ILLUSTRATOR Miriam Sagasti
CLIENT Miriam Sagasti
PAPER/PRINTING Classic Crest

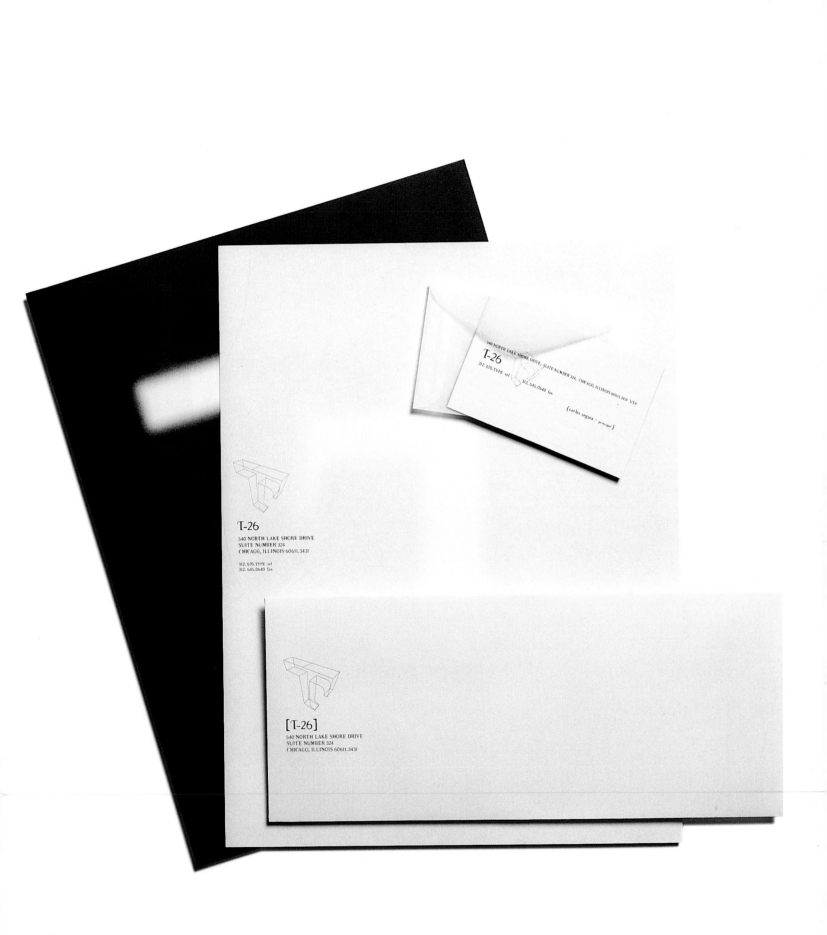

DESIGN FIRM	Segura Inc.
ART DIRECTOR	Carlos Segura
DESIGNER	Carlos Segura
ILLUSTRATOR	Carlos Segura
CLIENT	T-26
PAPER/PRINTING	Argus

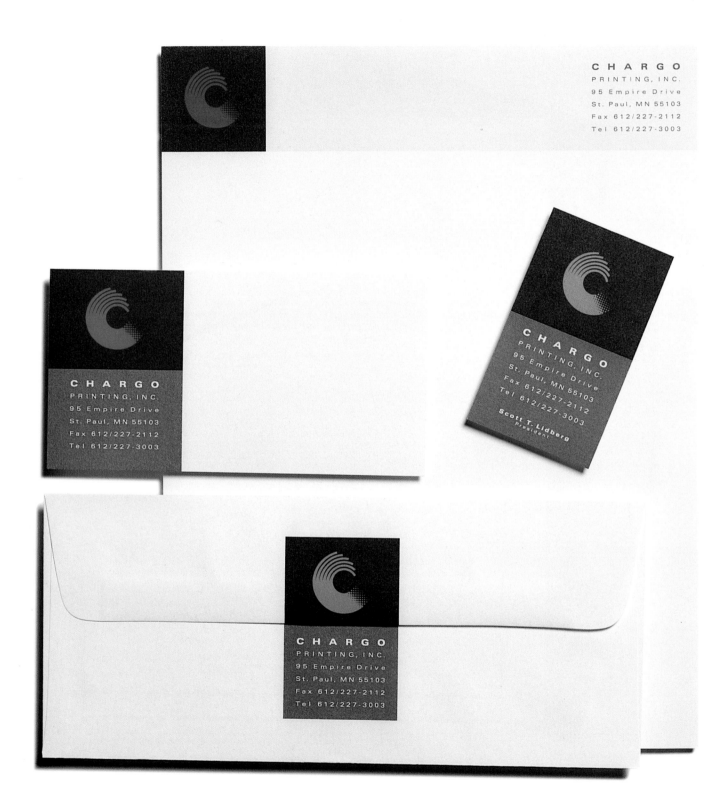

DESIGN FIRM GrandPré and Whaley, Ltd.
ART DIRECTOR Kevin Whaley
DESIGNER Kevin Whaley
CLIENT Chargo Printing, Inc.
PAPER/PRINTING Strathmore

PRINTOLOGY

PRINTOLOGY

Stefano Introini

The Science of Impression
1291 Electric Avenue, Venice, CA 90291
310.392.1878 Fax: 310.399.5151

PRINTOLOGY

The Science of Impression
1291 Electric Avenue
Venice, CA 90291

The Science of Impression
1291 Electric Avenue
Venice, CA 90291
310.392.1878 Fax: 310.399.5151

DESIGN FIRM Lorna Stovall Design
ART DIRECTOR Lorna Stovall
DESIGNER Lorna Stovall
CLIENT Printology
PAPER/PRINTING Simpson Evergreen

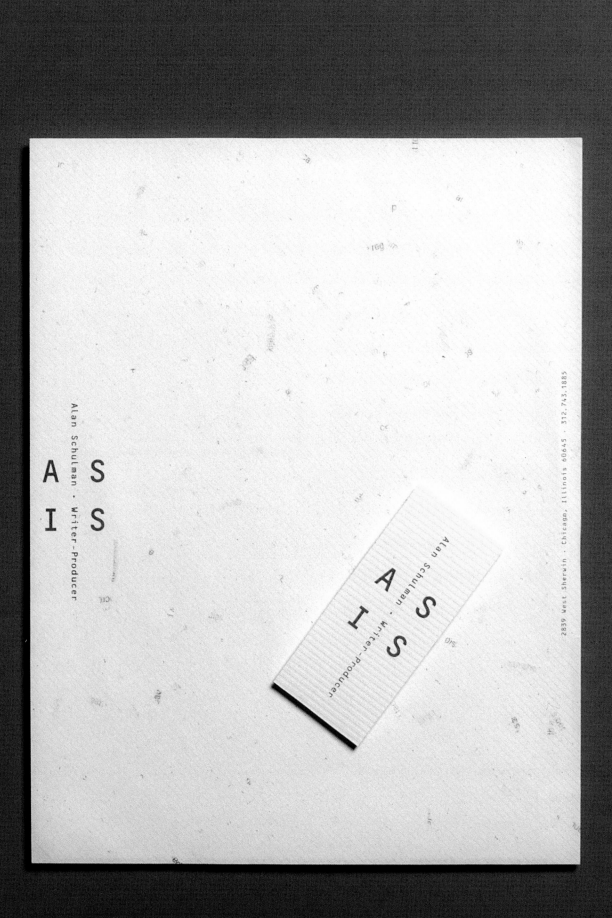

DESIGN FIRM Segura Inc.
ART DIRECTOR Carlos Segura
DESIGNER Carlos Segura
CLIENT Shulman

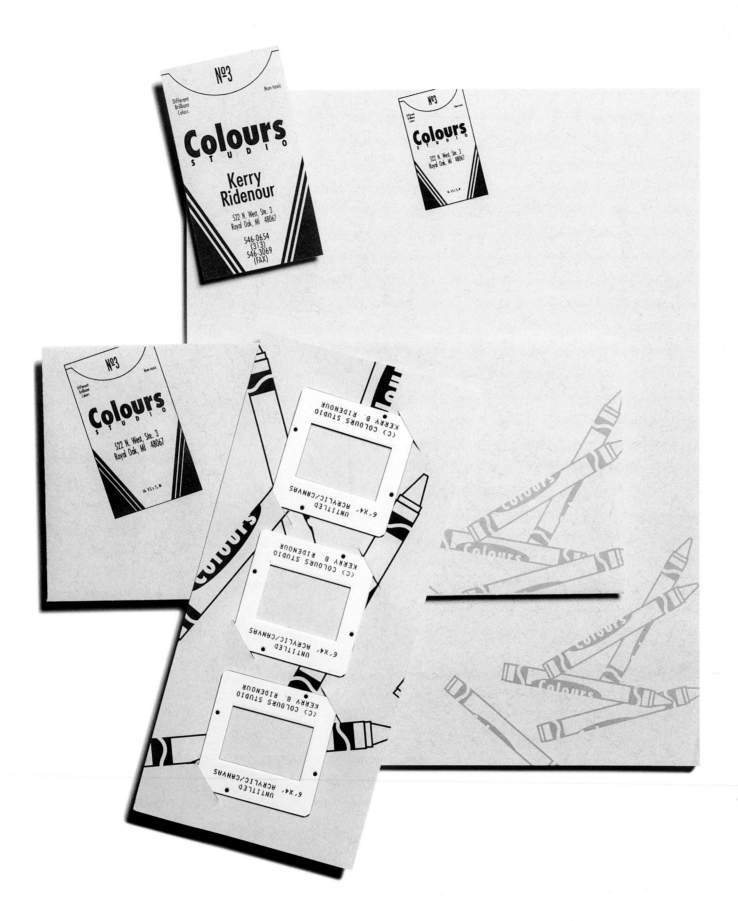

DESIGN FIRM Ridenour Advertising
ART DIRECTOR Kerry B. Ridenour
DESIGNER Kerry B. Ridenour
ILLUSTRATOR Kerry B. Ridenour
CLIENT Colours Studio

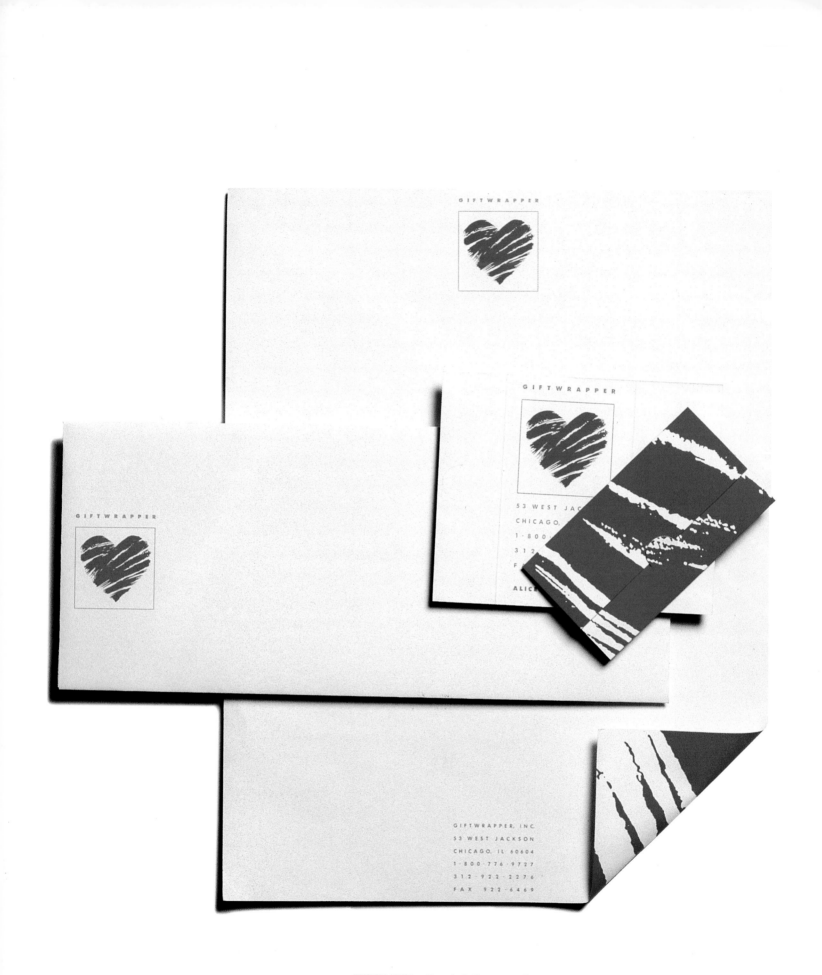

DESIGN FIRM Bartels & Company, Inc.
ART DIRECTOR David Bartels
DESIGNER Brent Wilson
ILLUSTRATOR Don Strandel
CLIENT Gift Wrapper

DESIGN FIRM	The Green House
ART DIRECTOR	Brian Green
DESIGNER	Brian Green
ILLUSTRATOR	Colin Mechan
CLIENT	Berkeley
PAPER/PRINTING	4 colors

DESIGN FIRM	Bartels & Company, Inc.
ART DIRECTOR	David Bartels
DESIGNER	Brian Barclay
ILLUSTRATOR	Brian Barclay
CLIENT	Wordsworth Typography

DESIGN FIRM	Patri-Keker Design
DESIGNER	Bobby Patri
CLIENT	Beth Clements-Gutcheon
PAPER/PRINTING	Evergreen cottonwood script

DESIGN FIRM	Nora Robbins
ART DIRECTOR	Nora Robbins
DESIGNER	Nora Robbins
CLIENT	Insight/Leslie Larocca
PAPER/PRINTING	Fox River Confetti/Kaliedascope

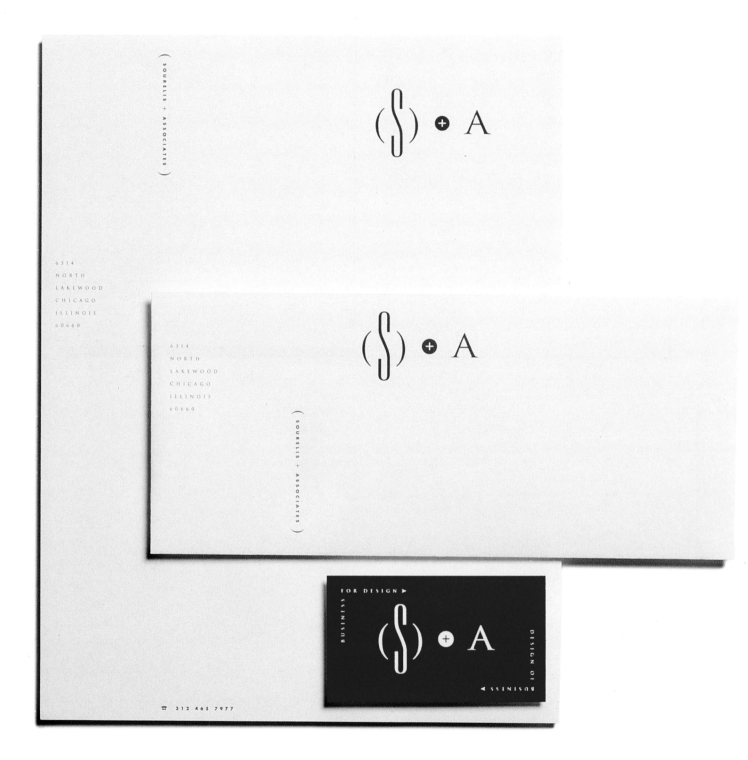

DESIGN FIRM Mark Oldach Design
ART DIRECTOR Mark Oldach
DESIGNER Mark Oldach
CLIENT Sourelis & Associates
PAPER/PRINTING Neenah Classic Crest

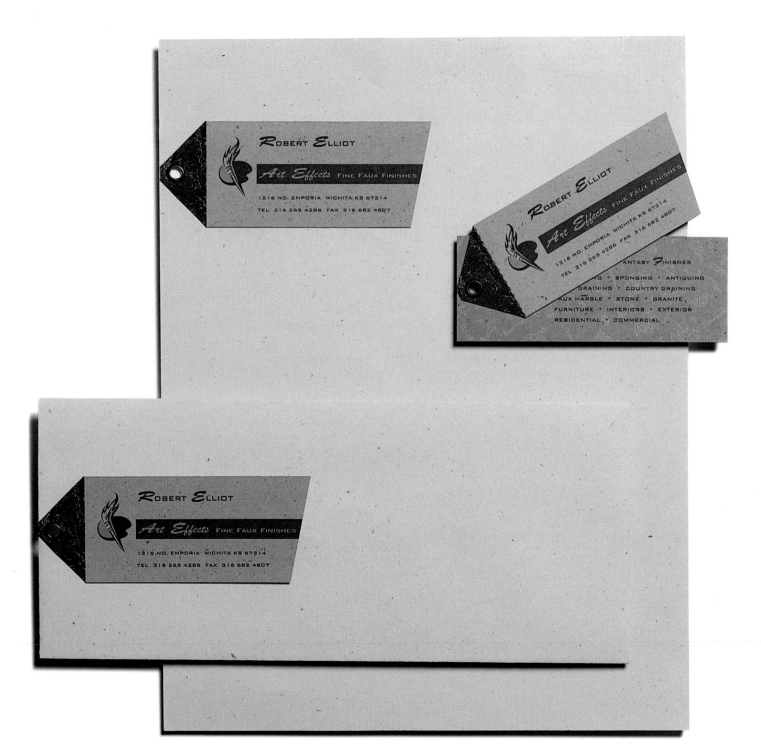

DESIGN FIRM Love Packaging Group
ART DIRECTOR Tracy Holdeman
DESIGNER Tracy Holdeman, Robert Elliot
ILLUSTRATOR Tracy Holdeman
CLIENT Art Effects
Only the business card was printed; the client hand
rivets each card, envelope, and letterhead sheet.

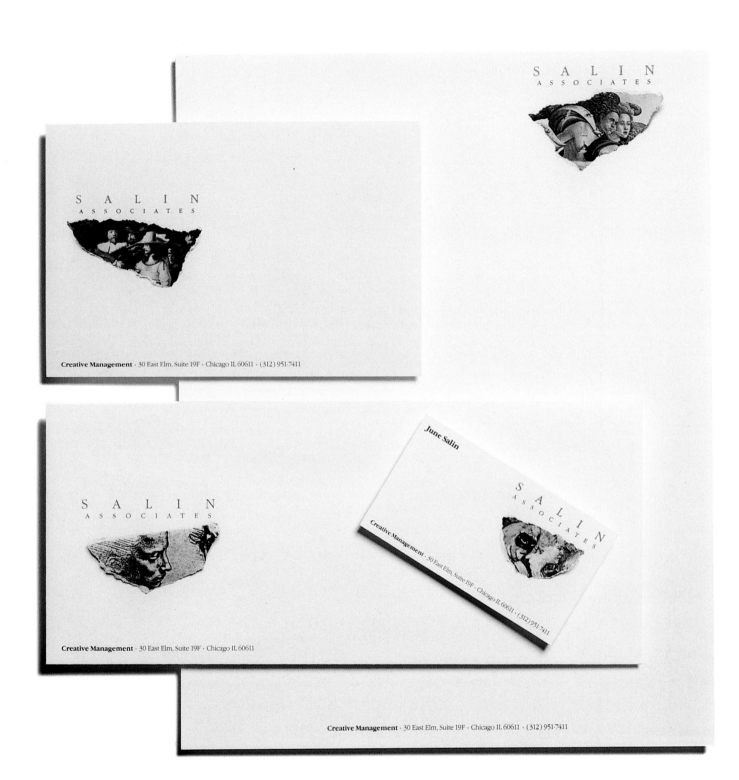

DESIGN FIRM Jon Wells Associates
ART DIRECTOR Jon Wells
DESIGNER Jon Wells
CLIENT June Salin
PAPER/PRINTING Strathmore Writing

STEREO|TYPE

Pine Square

STEREO|TYPE

266
Pine
Street

Burlington
Vermont
05401

266
Pine
Street

Kevin Andrews

Burlington
Vermont
05401

President

802
864 5495
864 6408 Fax

STEREO|TYPE

266
Pine
Street

Burlington
Vermont
05401

802
864 5495
864 6408 Fax

DESIGN FIRM Creative EDGE
DESIGNER Rick Salzman, Barbara Pitfido
CLIENT Stereo Type
PAPER/PRINTING Classic Laid

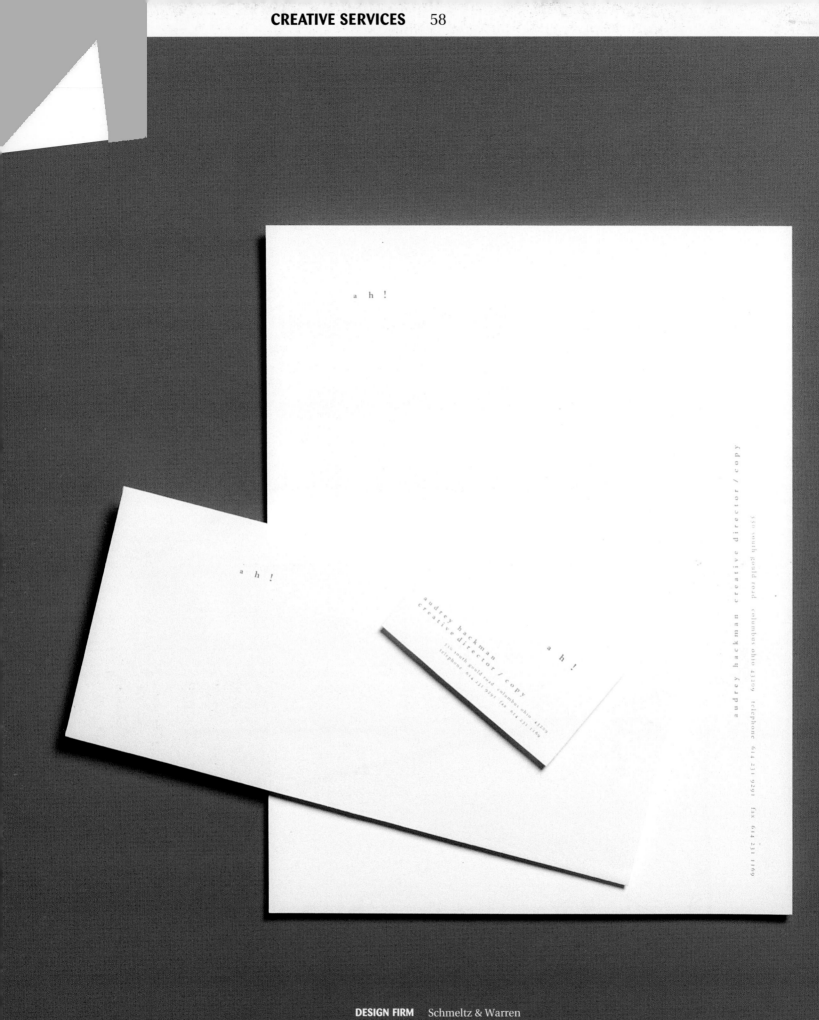

DESIGN FIRM Schmeltz & Warren
ART DIRECTOR Crit Warren
DESIGNER Crit Warren
CLIENT "Ah!" — Audrey Hackman
PAPER/PRINTING Protocol

DESIGN FIRM	Adele Bass & Co. Design		**DESIGN FIRM**	Earl Gee Design		**DESIGN FIRM**	Segura Inc.
ART DIRECTOR	Adele Bass		**ART DIRECTOR**	Earl Gee		**ART DIRECTOR**	Carlos Segura
DESIGNER	Adele Bass		**DESIGNER**	Earl Gee, Fani Chung		**DESIGNER**	Carlos Segura
ILLUSTRATOR	Adele Bass		**ILLUSTRATOR**	Earl Gee		**ILLUSTRATOR**	Carlos Segura
CLIENT	Sharynn Bass/ Advertising Copywriter		**CLIENT**	San Francisco Arts Commission		**CLIENT**	Gordon (photographer's representatives)

DESIGN FIRM	Eilts Anderson Tracy		**DESIGN FIRM**	Design Art, Inc.		**DESIGN FIRM**	Segura Inc.
ART DIRECTOR	Patrice Eilts		**ART DIRECTOR**	Norman Moore		**ART DIRECTOR**	Carlos Segura
DESIGNER	Patrice Eilts		**DESIGNER**	Norman Moore		**DESIGNER**	Carlos Segura
ILLUSTRATOR	Patrice Eilts		**CLIENT**	Interface Digital Prepress		**ILLUSTRATOR**	Carlos Segura
CLIENT	News Design Group (newspaper union)					**CLIENT**	Harry Allen/writer

STEVEN

SMITH

SCAPE

5 Hillside Drive
Toronto, Canada
M4K 2M2

Tel. (416) 467 0440
Fax.(416) 467 9195

BOB ANDERSON PHOTOGRAPHY LIMITED

INTEGRATING NATURE

AND ARCHITECTURE

ARCHITECTURE

MAHLUM
&NORDFORS
SMITH
GORDON

Architects PC

30 SW
Second Avenue
Suite 600
Portland, OR
97204

503 224 4032
503 22 0918 f

Patelier • architectural design partnership

Scott Rowland, Architect

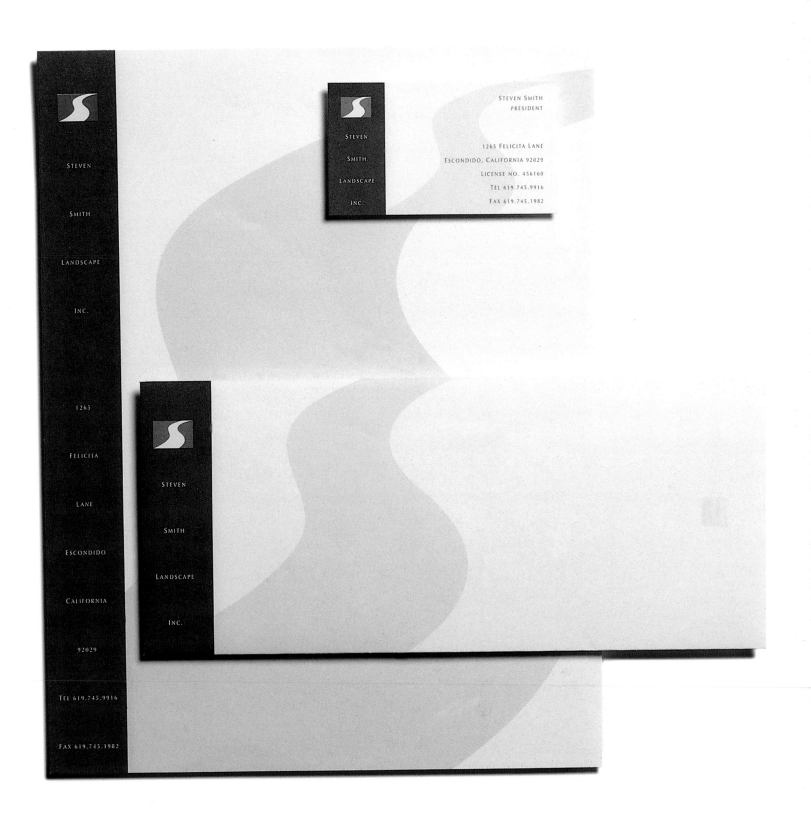

DESIGN FIRM Beauchamp Design
ART DIRECTOR Michele Beauchamp
DESIGNER Michele Beauchamp
CLIENT Steve Smith Landscape Inc.
PAPER/PRINTING Evergreen

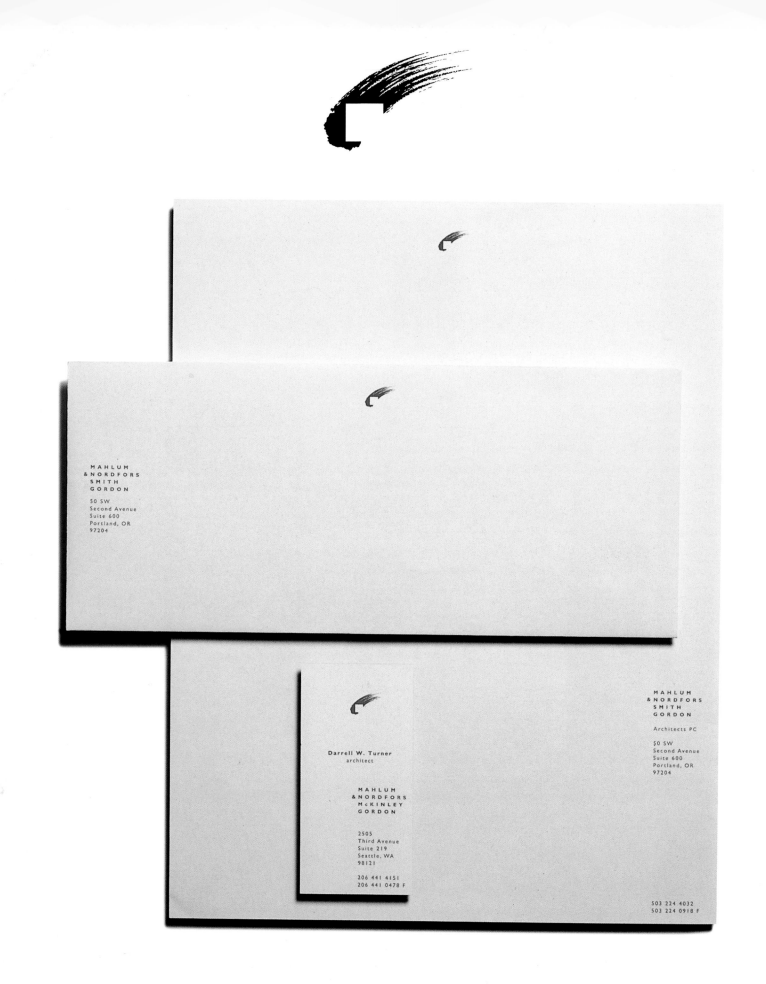

DESIGN FIRM	Hornall Anderson Design Works
ART DIRECTOR	Jack Anderson
DESIGNER	Jack Anderson, Scott Eggers, Leo Raymundo
CLIENT	Mahlum & Nordfors McKinley Gordon
PAPER/PRINTING	Monadnock Astro Lite, embossed

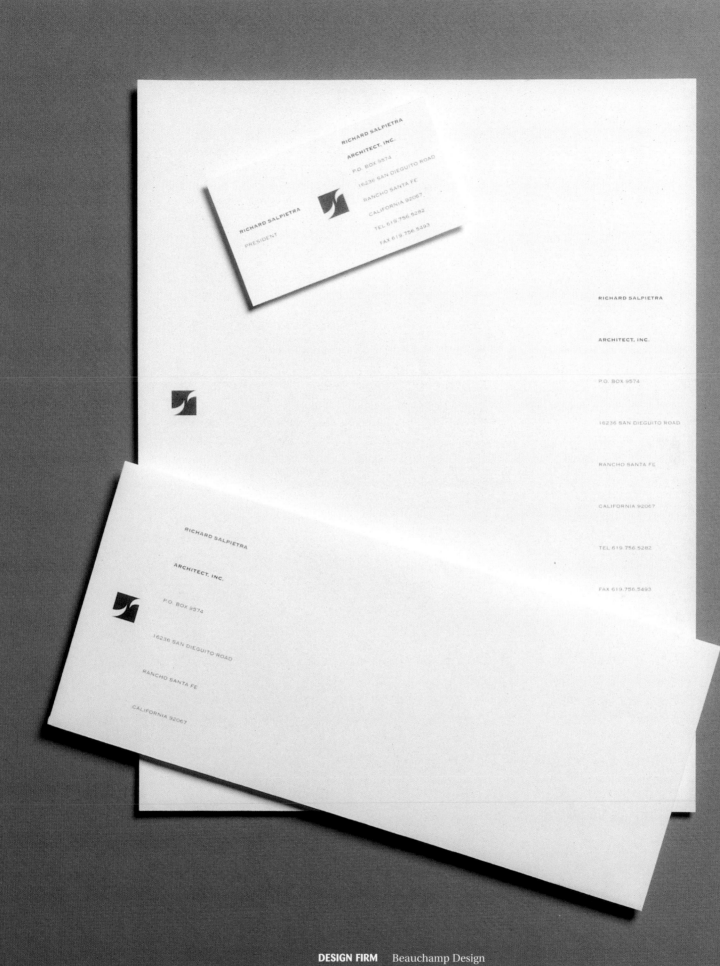

DESIGN FIRM Beauchamp Design
ART DIRECTOR Michele Beauchamp
DESIGNER Michele Beauchamp
CLIENT Richard Salpietra Architect, Inc.
PAPER/PRINTING Classic Crest

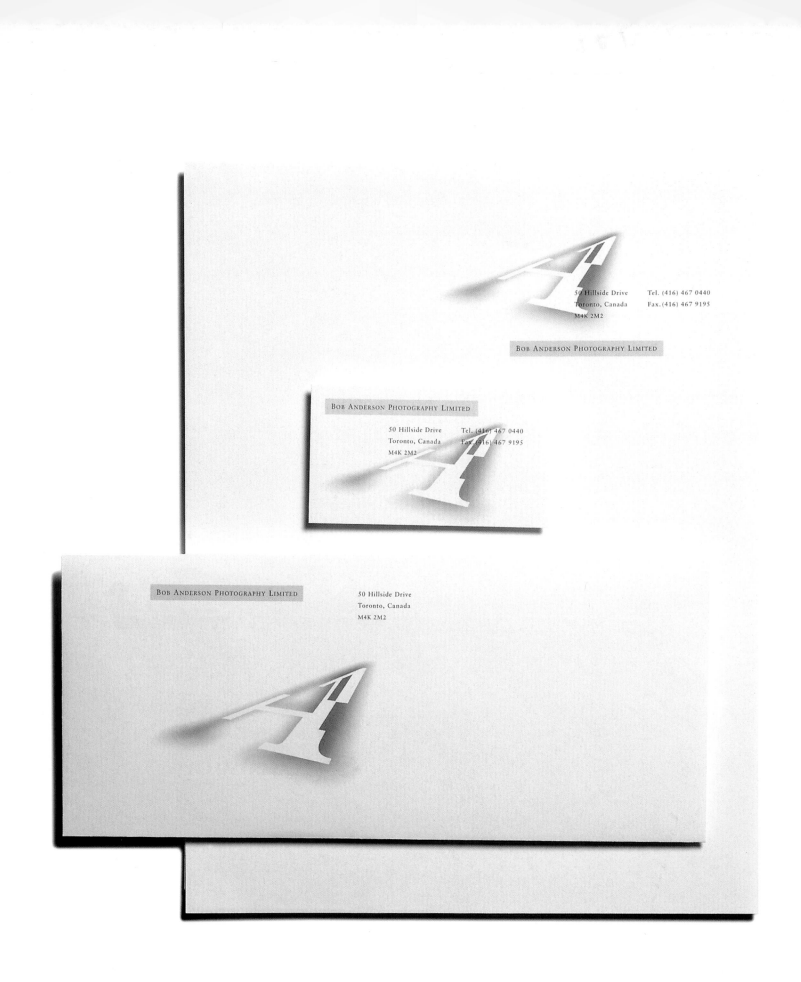

DESIGN FIRM	Eskind Waddell
ART DIRECTOR	Malcolm Waddell
DESIGNER	Nicola Lyon
CLIENT	Bob Anderson Photography Ltd.
PAPER/PRINTING	Strathmore Script

DESIGN FIRM	Choplogic
ART DIRECTOR	Walter McCord, Mary Cawein
DESIGNER	Walter McCord, Mary Cawein
ILLUSTRATOR	Walter McCord, Mary Cawein
CLIENT	Argabrite Architects
PAPER/PRINTING	Monadnock, 1 color

DESIGN FIRM	William Field Design
ART DIRECTOR	Willy Field
DESIGNER	Willy Field
ILLUSTRATOR	Peter Marquez
CLIENT	Turner, Marquez & Romero
PAPER/PRINTING	Environment

DESIGN FIRM	Musikar Design
ART DIRECTOR	Sharon R. Musikar
DESIGNER	Sharon R. Musikar, Lynn Iadarola
ILLUSTRATOR	Sharon R. Musikar
CLIENT	Archeus Studio
PAPER/PRINTING	Gilbert Writing, 2 colors

DESIGN FIRM	Bartels & Company, Inc.
ART DIRECTOR	David Bartels
DESIGNER	Mark Illig
ILLUSTRATOR	Mark Illig
CLIENT	The Lawrence Group

BOND
COMET
WESTMORELAND
+HINER

ARCHITECTS

207 West Broad Street
Richmond, Virginia 23220

BOND
COMET
WESTMORELAND
+HINER

ARCHITECTS

Sanford Bond, AIA

207 West Broad Street
Richmond, Virginia 23220

804/788-4774/FAX 788-0986

BOND
COMET
WESTMORELAND
+HINER

ARCHITECTS

Sanford Bond, AIA
Robert E. Comet, Jr., AIA
Douglas D. Westmoreland, AIA
Henry L. Hiner, AIA

Gordon B. Galusha, AIA (retired)
Fred W. Needham, AIA (retired)
Kenneth G. MacIlroy, AIA (deceased)

207 West Broad Street
Richmond, Virginia 23220

804/788-4774 FAX 788-0986

DESIGN FIRM Communication Design, Inc.
ART DIRECTOR Robert Meganck
DESIGNER Tim Priddy, Bil Cullen
CLIENT Bond Comet Westmoreland & Hiner Architects
PAPER/PRINTING Dillard

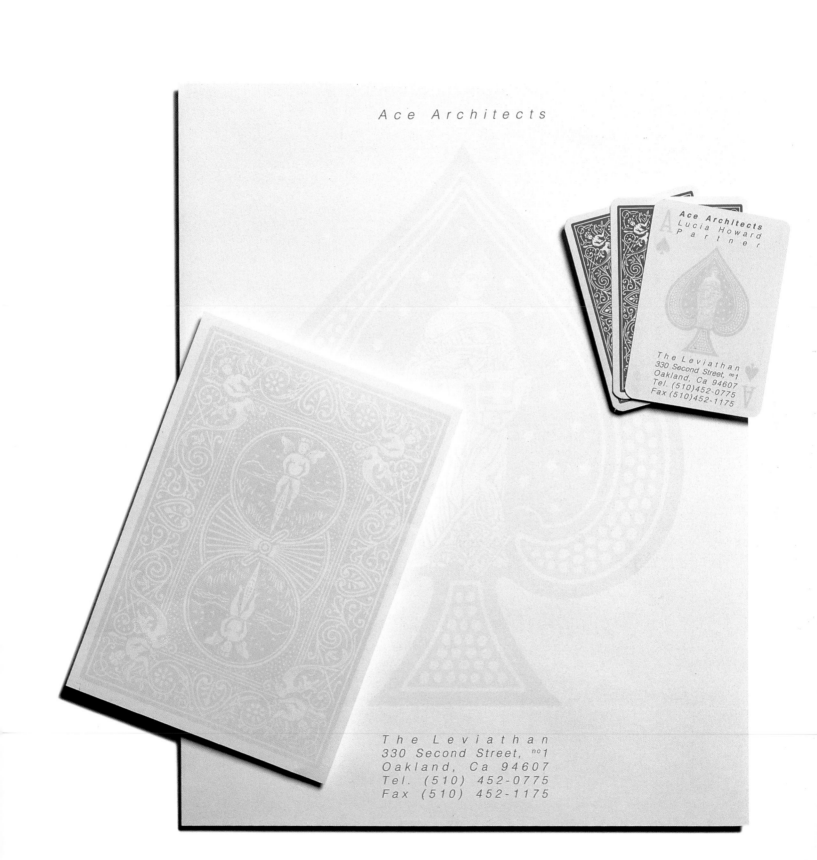

Ace Architects

Ace Architects
Lucia Howard
Partner

The Leviathan
330 Second Street, nº1
Oakland, Ca 94607
Tel. (510)452-0775
Fax (510)452-1175

The Leviathan
330 Second Street, nº1
Oakland, Ca 94607
Tel. (510) 452-0775
Fax (510) 452-1175

DESIGN FIRM Ace Architects by Judith Oaus
ILLUSTRATOR Judith Oaus
CLIENT Ace Architects
PAPER/PRINTING Ampersand

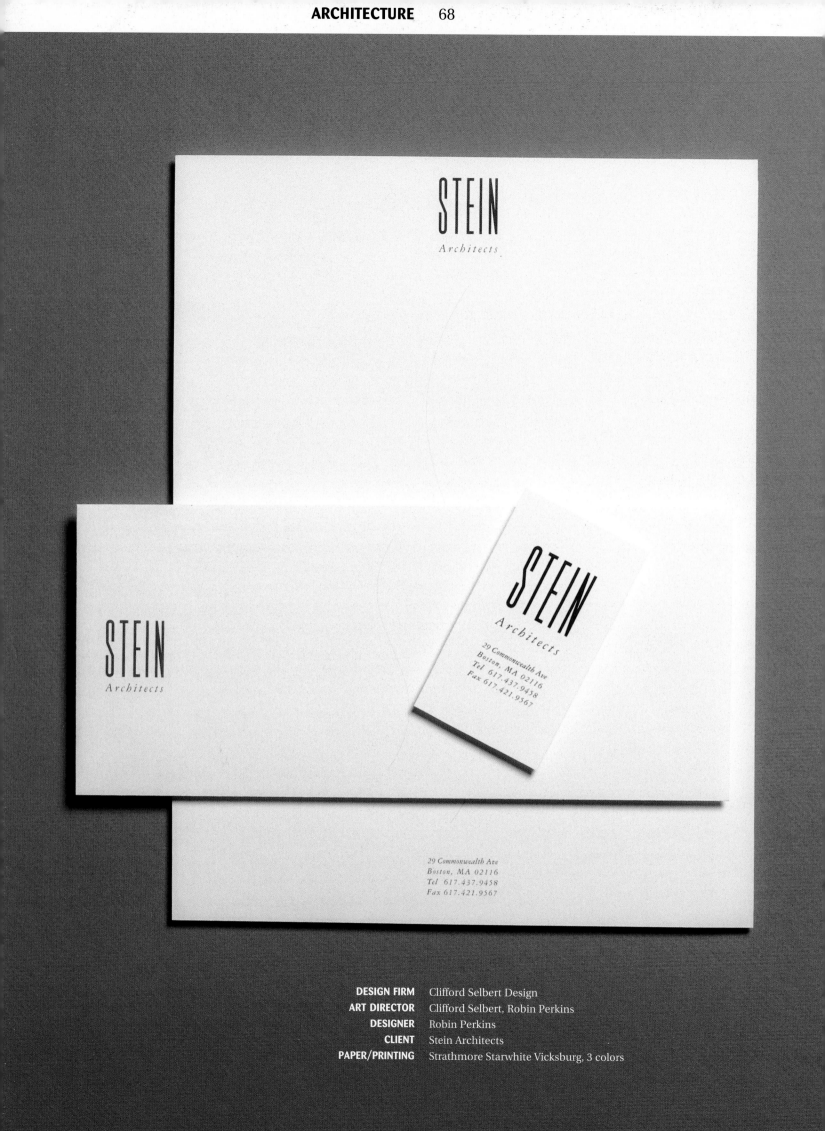

DESIGN FIRM	Clifford Selbert Design
ART DIRECTOR	Clifford Selbert, Robin Perkins
DESIGNER	Robin Perkins
CLIENT	Stein Architects
PAPER/PRINTING	Strathmore Starwhite Vicksburg, 3 colors

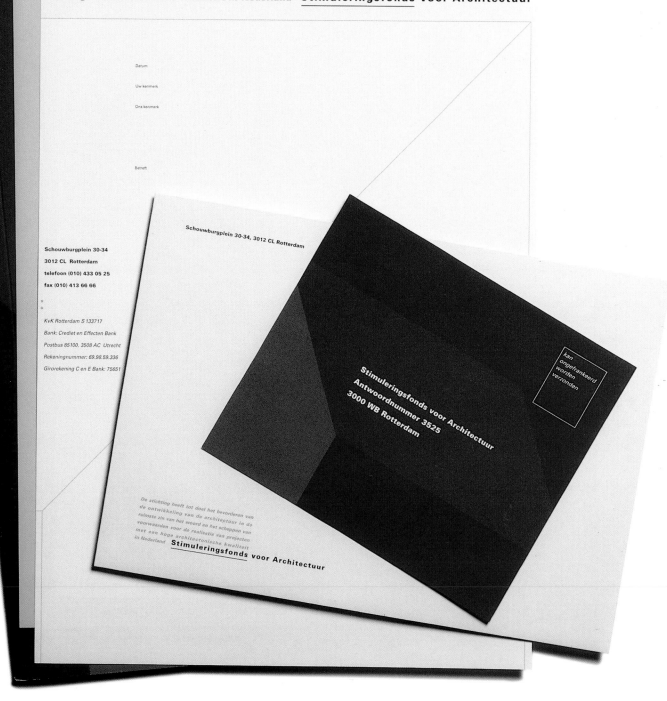

De stichting heeft tot doel het bevorderen van de ontwikkeling van de architectuur in de ruimste zin van het woord en het scheppen van voorwaarden voor de realisatie van projecten met een hoge architectonische kwaliteit in Nederland **Stimuleringsfonds voor Architectuur**

Datum

Uw kenmerk

Ons kenmerk

Betreft

Schouwburgplein 30-34

3012 CL Rotterdam

telefoon (010) 433 05 25

fax (010) 413 66 66

KvK Rotterdam S 133717

Bank: Crediet en Effecten Bank

Postbus 85100, 3508 AC Utrecht

Rekeningnummer: 69.98.59.336

Girorekening C en E Bank: 75651

Schouwburgplein 30-34, 3012 CL Rotterdam

Stimuleringsfonds voor Architectuur
Antwoordnummer 3525
3000 WB Rotterdam

kan ongefrankeerd worden verzonden

De stichting heeft tot doel het bevorderen van de ontwikkeling van de architectuur in de ruimste zin van het woord en het scheppen van voorwaarden voor de realisatie van projecten met een hoge architectonische kwaliteit in Nederland **Stimuleringsfonds** voor Architectuur

DESIGN FIRM	Proforma Rotterdam
DESIGNER	Ciaran O'Gaora
CLIENT	Stimuleringsfonds voor Architectuur
PAPER/PRINTING	Strathmore Writing Wove

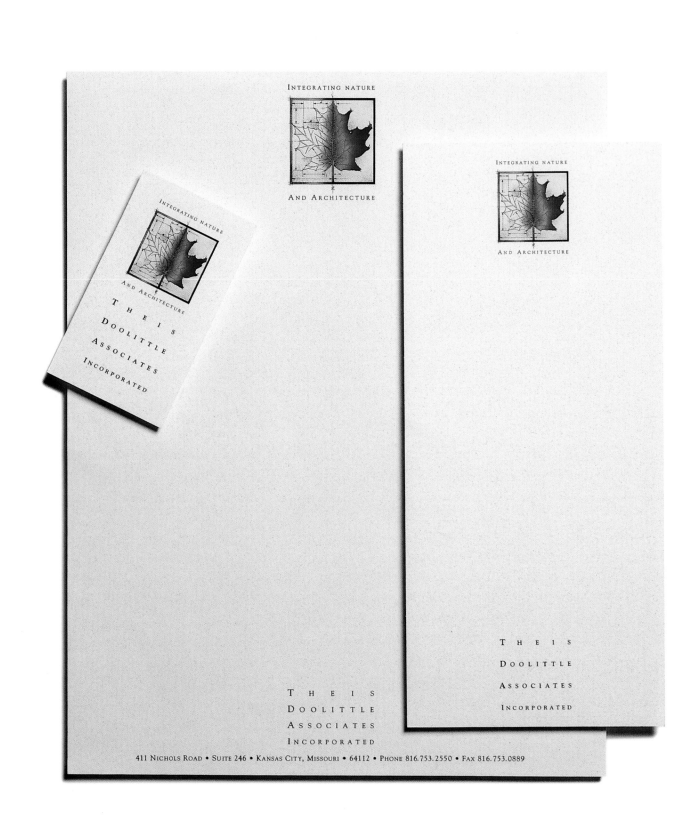

DESIGN FIRM	Eilts Anderson Tracy
ART DIRECTOR	Patrice Eilts
DESIGNER	Patrice Eilts
ILLUSTRATOR	Michael Weaver
CLIENT	Theis Doolitle Architects & Landscape Architects
PAPER/PRINTING	Passport

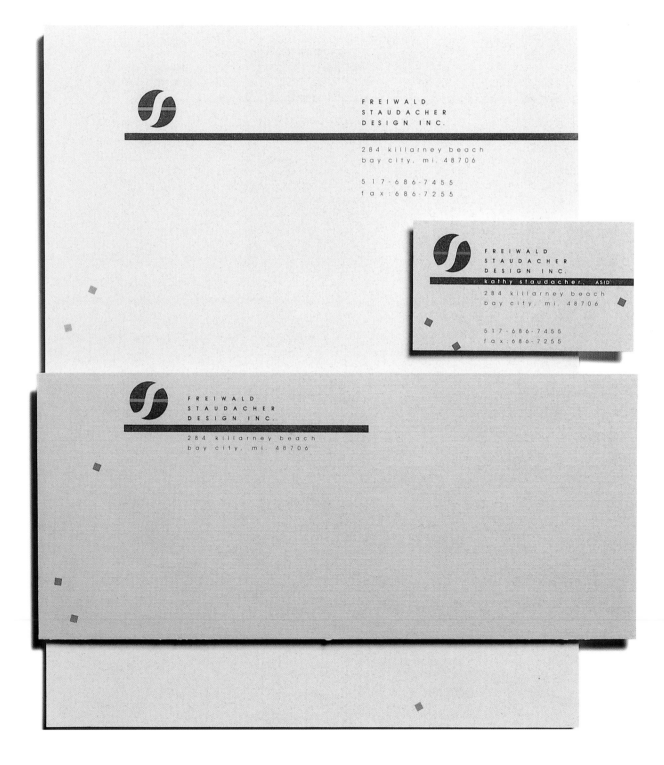

DESIGN FIRM	Heart Graphic Design
ART DIRECTOR	Clark Most
DESIGNER	Clark Most
CLIENT	Freiwald/Standecher Design Inc.
PAPER/PRINTING	Classic Linen

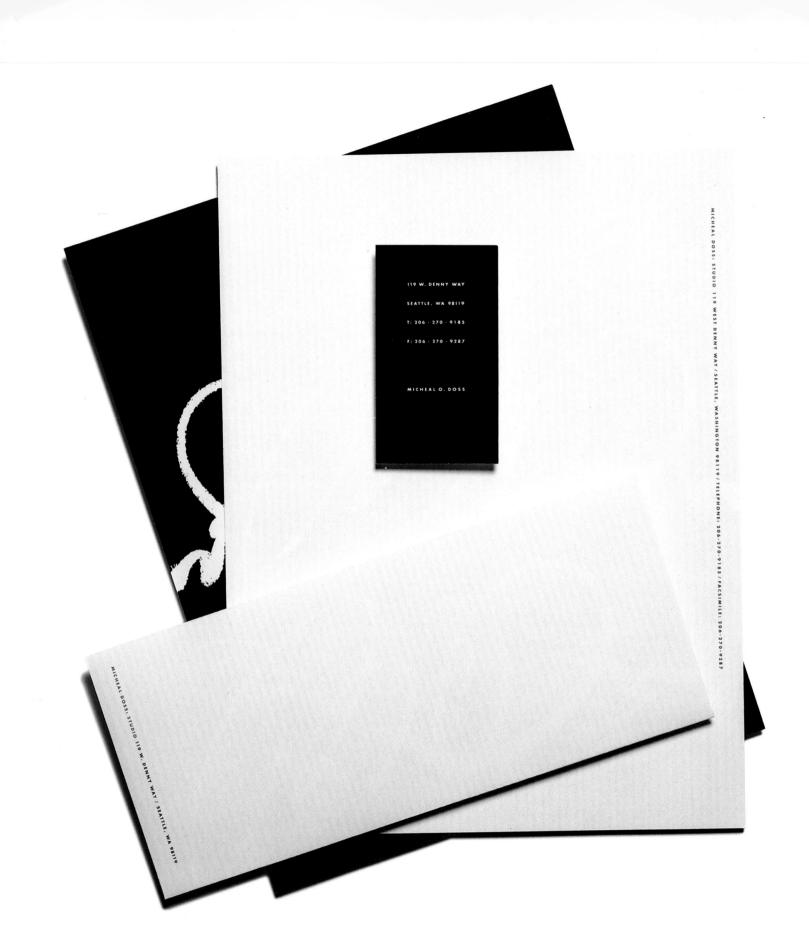

119 W. DENNY WAY

SEATTLE, WA 98119

T: 206 · 270 · 9185

F: 206 · 270 · 9287

MICHEAL O. DOSS

MICHEAL DOSS: STUDIO 119 WEST DENNY WAY / SEATTLE, WASHINGTON 98119 / TELEPHONE: 206·270·9185 / FACSIMILE: 206·270·9287

MICHEAL DOSS: STUDIO 119 W. DENNY WAY / SEATTLE, WA 98119

DESIGN FIRM	Hornall Anderson Design Works
ART DIRECTOR	Jack Anderson
DESIGNER	Jack Anderson
CLIENT	Micheal Doss

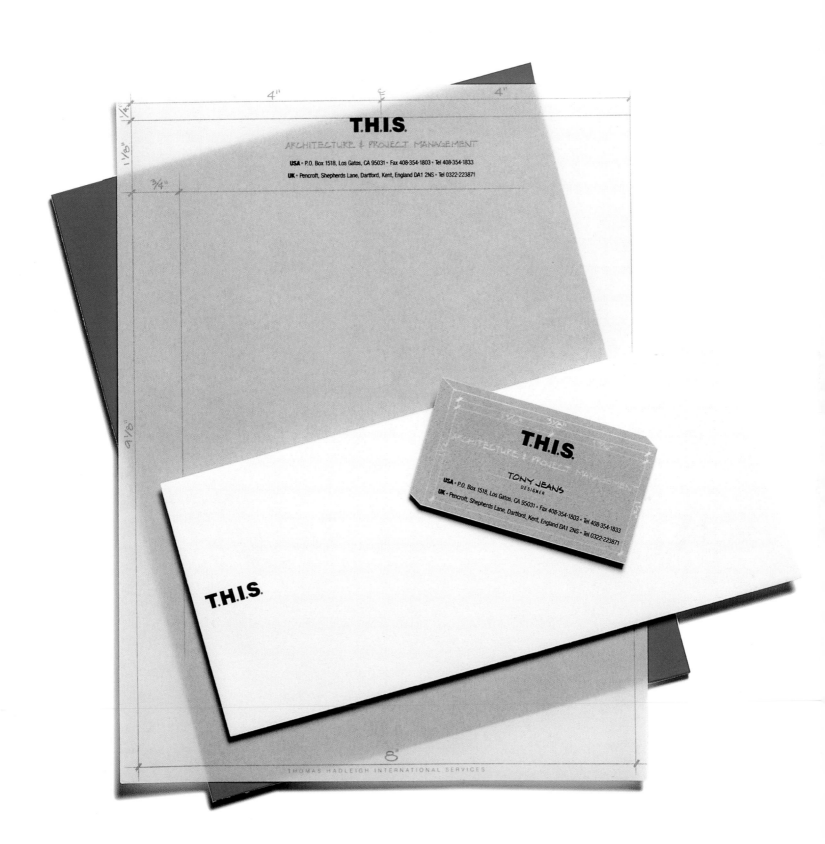

DESIGN FIRM THARP DID IT
DESIGNER Rick Tharp, Jana Heer
CLIENT Thoma Hadley International Services
PAPER/PRINTING Gilbert Paper

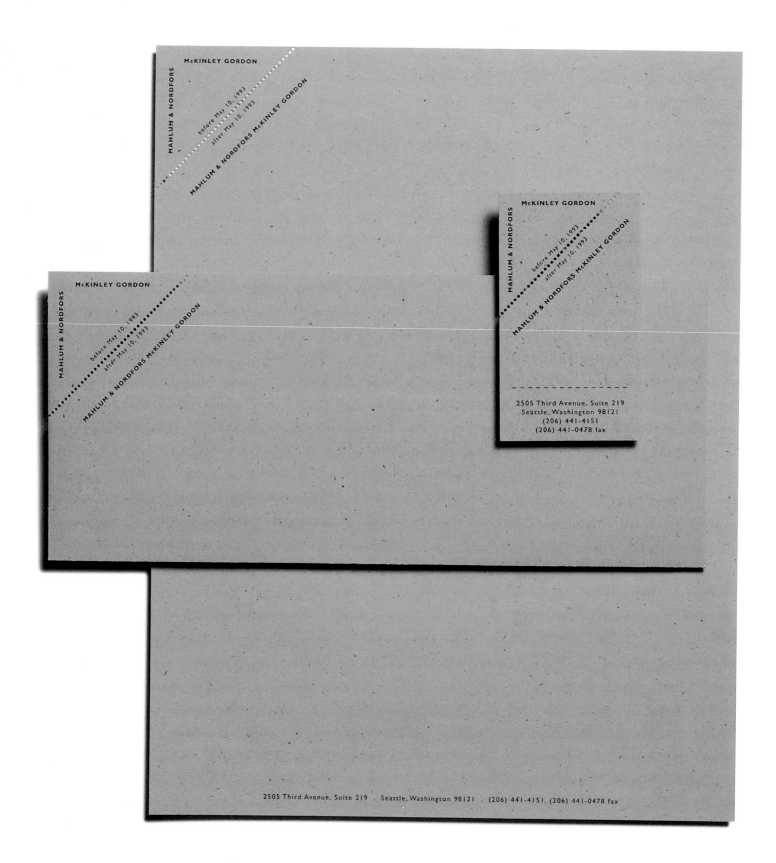

DESIGN FIRM Hornall Anderson Design Works
ART DIRECTOR Jack Anderson
DESIGNER Jack Anderson, Scott Eggers, Leo Raymundo
CLIENT Mahlum & Nordfors McKinley Gordon
PAPER/PRINTING French Speckletone, perforation

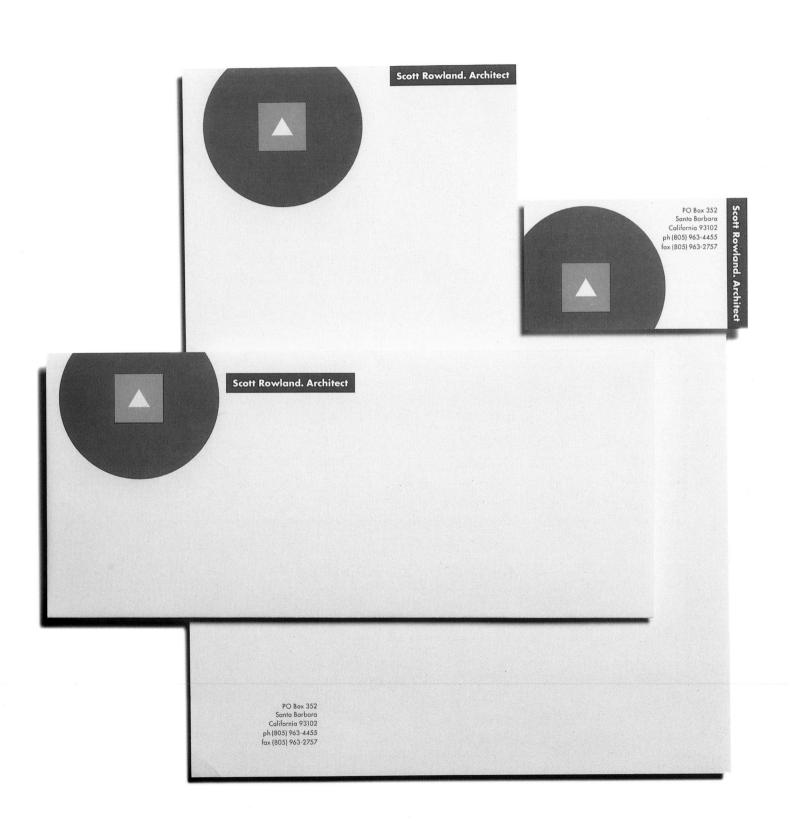

DESIGN FIRM	Puccinelli Design
ART DIRECTOR	Keith Puccinelli
DESIGNER	Keith Puccinelli, Heidi Palladino
ILLUSTRATOR	Keith Puccinelli
CLIENT	Scott Rowland
PAPER/PRINTING	Cranes Crest, to minimize the effects of the watermark on the paper, the designer underprinted opaque white beneath the image.

l'atelier • architectural design partnership

l'atelier • architectural design partnership

l'atelier • architectural design partnership

ralph c. ortiz

113 east st. joseph street • arcadia ca 91006 • 818 446 9400

113 east st. joseph street • arcadia ca 91006 • 818 446 9400 • fax 818 446 9533

DESIGN FIRM	Adele Bass & Co. Design
ART DIRECTOR	Adele Bass
DESIGNER	Adele Bass
ILLUSTRATOR	Adele Bass
CLIENT	L'aterlier
PAPER/PRINTING	Kraft Speckletone, 2 PMS

PHOTOGRAPHY FOR ADVERTISING

CAM
ERA
INC

Sammy Lopez
PHOTOGRAPHY

ROBIN HASSETT
PHOTOGRAPHY

ROBIN

5664 N. 8th Street

Fresno

California

209-4

CALIFO

Michele Barran
Photography
92 Vandam Street
New York 10013
212 675 0442

MB

PHOTOGRAPHY

PHOTO

K 50mm 1:2 JAPAN

MB
SC

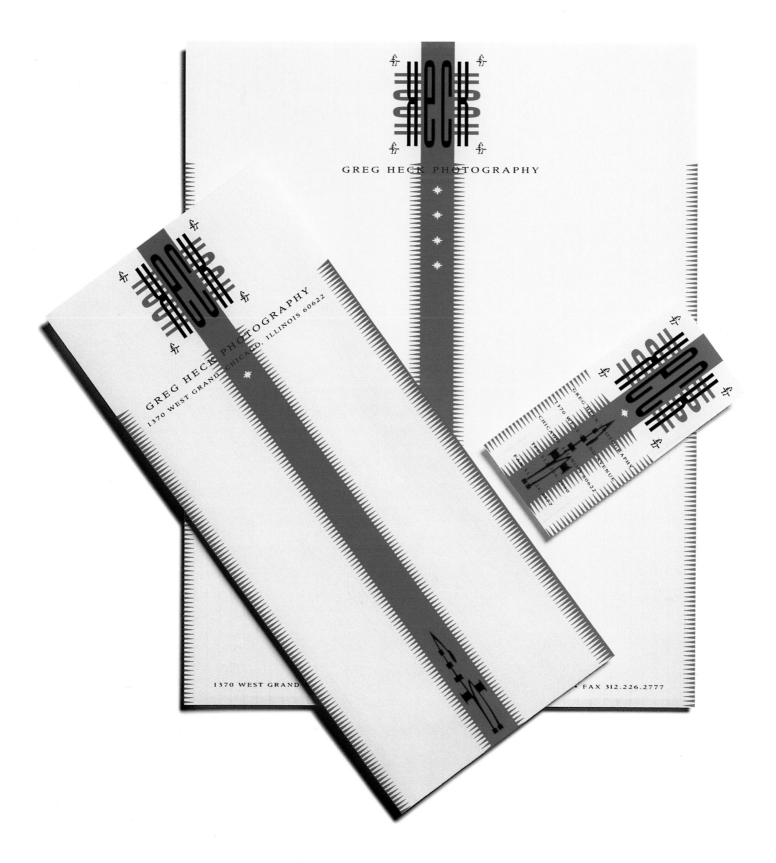

DESIGN FIRM	Segura Inc.
ART DIRECTOR	Carlos Segura
DESIGNER	Carlos Segura
ILLUSTRATOR	Carlos Segura
CLIENT	Greg Heck Photography
PAPER/PRINTING	Argus

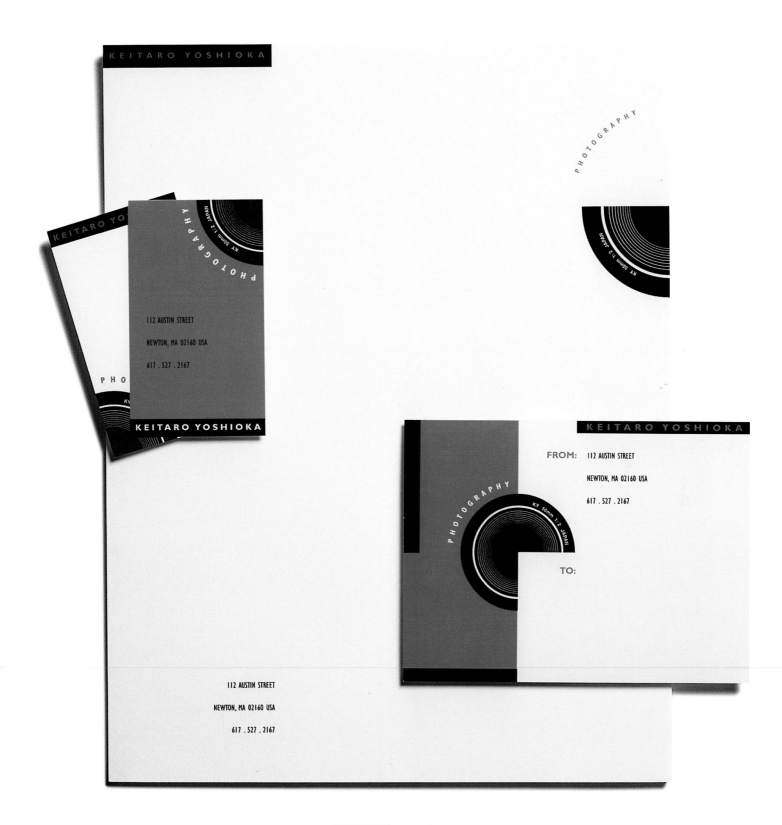

DESIGN FIRM Hawley & Armian Marketing/Design
DESIGNER Karen Emond
CLIENT Keitaro Yoshioka/Photographer
PAPER/PRINTING Strathmore Writing

DESIGN FIRM	Mike Quon Design Office
ART DIRECTOR	Mike Quon, Art Kane
DESIGNER	Mike Quon
ILLUSTRATOR	Mike Quon
CLIENT	Art Kane/Photography

DESIGN FIRM	The Design Associates
ART DIRECTOR	Victor Cheong
DESIGNER	Victor Cheong, Philip Sven
CLIENT	Kenny Ip Photography
PAPER/PRINTING	Gilbert

ART KANE STUDIO, INC.
568 BROADWAY · NEW YORK, NY 10012 · TEL. 212 925 7334 FAX 212 966 7987

KENNY IP

PHOTOGRAPHY

4TH FLOOR

17-19 HILLIER ST.

SHEUNG WAN

HONG KONG

TEL. 854-4369

FAX. 854-4521

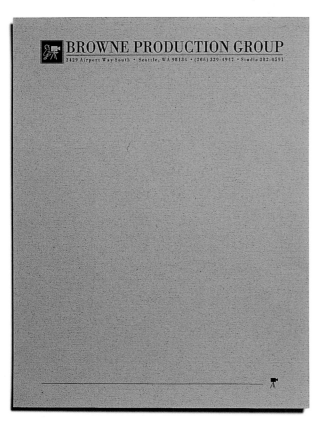

BROWNE PRODUCTION GROUP
3429 Airport Way South · Seattle, WA 98134 · (206) 329-4947 · Studio 382-0591

SEAGRAVES

P.O. BOX 55116
DALLAS, TEXAS 75215
214-748-0095

DESIGN FIRM	Walsh and Associates, Inc.
ART DIRECTOR	Miriam Lisco
DESIGNER	Michael Stearns
ILLUSTRATOR	Michael Stearns
CLIENT	Browne Production Group
PAPER/PRINTING	Classic Crest

DESIGN FIRM	Focus 2
ART DIRECTOR	Todd Hart, Shawn Freeman
DESIGNER	Todd Hart
ILLUSTRATOR	Todd Hart
CLIENT	Richard Seagraves
PAPER/PRINTING	Speckletone

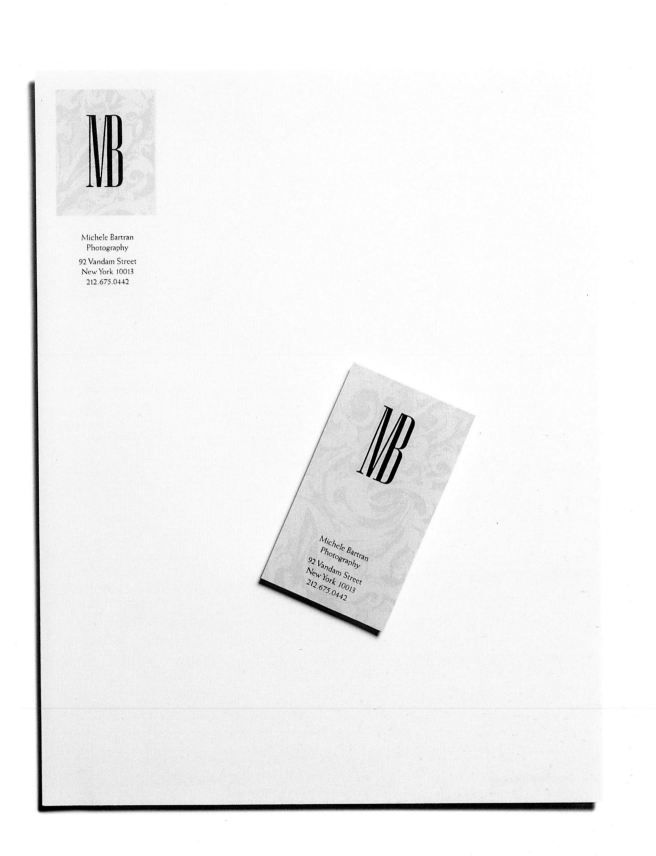

DESIGN FIRM Cheryl Waligory Design
ART DIRECTOR Cheryl Waligory
DESIGNER Cheryl Waligory
CLIENT Michele Bartran Photography
PAPER/PRINTING Strathmore Wove, 2 colors

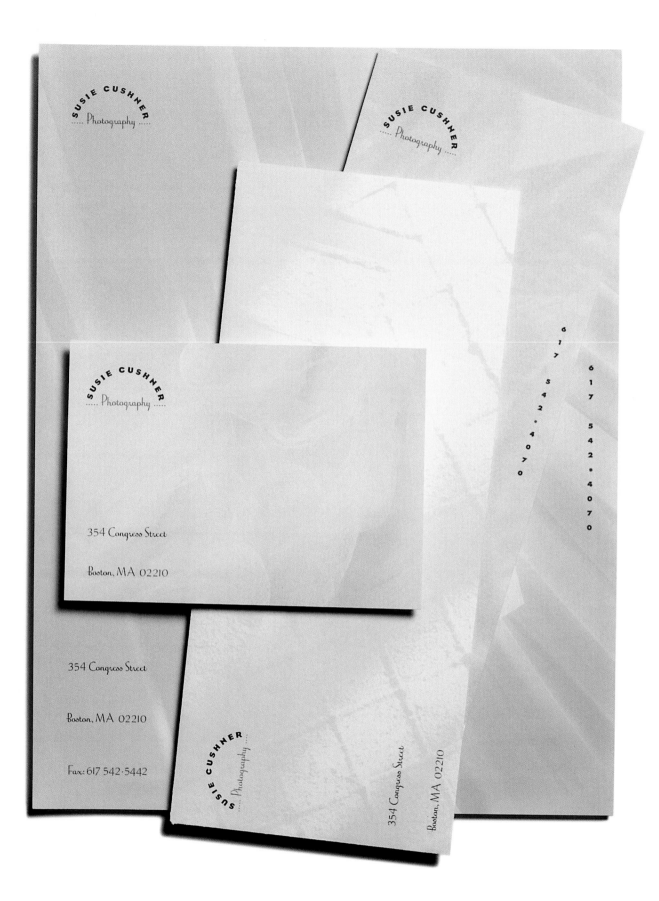

DESIGN FIRM Clifford Selbert Design
ART DIRECTOR Melanie Lowe
DESIGNER Melanie Lowe
CLIENT Susie Cushner Photography
PAPER/PRINTING Strathmore

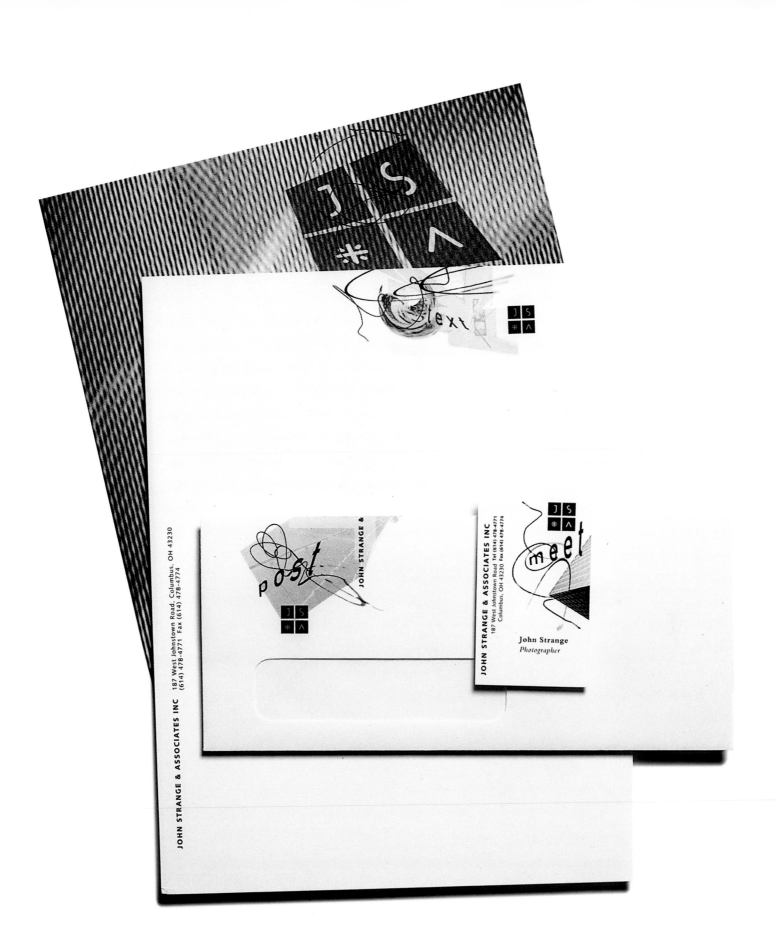

DESIGN FIRM	Schmeltz & Warren
ART DIRECTOR	Crit Warren
DESIGNER	Crit Warren
PHOTOGRAPHY	John Strange
PHOTO MANIPULATIONS	Crit Warren
CLIENT	John Strange & Associates
PAPER/PRINTING	Gilbert Esse

220 WEST RITTENHOUSE SQUARE 7A PHILADELPHIA, PA 19103 215-732-6038

DESIGN FIRM Peter Hermesmann
DESIGNER Peter Hermesmann
CLIENT Sherie Levin

DESIGN FIRM	Shields Design
ART DIRECTOR	Charles Shields
DESIGNER	Charles Shields
ILLUSTRATOR	Charles Shields
CLIENT	Robin Hassett Photography
PAPER/PRINTING	Neenah Classic Crest

DESIGN FIRM	Shields Design
ART DIRECTOR	Charles Shields
DESIGNER	Charles Shields
CLIENT	Camarad Photography
PAPER/PRINTING	Simpson Quest

DESIGN FIRM	Platinum Design
ART DIRECTOR	Vickie Peslak, Sandy Quinn
DESIGNER	Sandy Quinn
ILLUSTRATOR	Sandy Quinn
CLIENT	Red Circle Studio
PAPER/PRINTING	French Speckle Tone

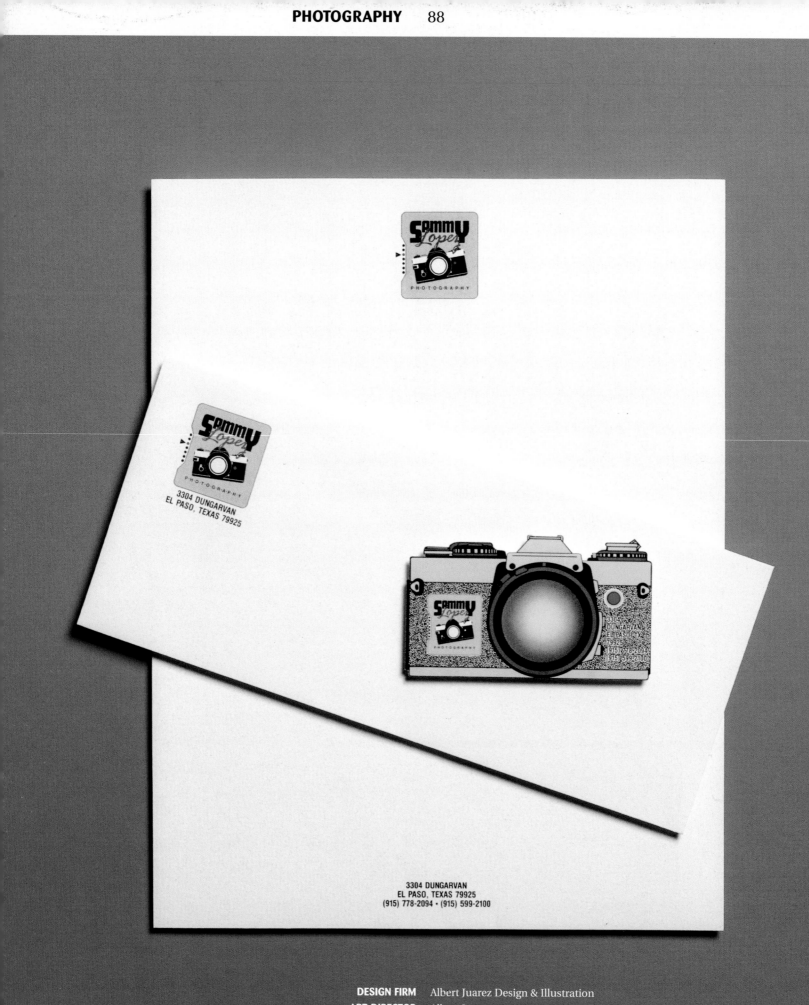

DESIGN FIRM	Albert Juarez Design & Illustration
ART DIRECTOR	Albert Juarez
DESIGNER	Albert Juarez
ILLUSTRATOR	Albert Juarez
CLIENT	Sammy Lopez Photography
PAPER/PRINTING	Gainsborough Silver Stock, 2 colors

DESIGN FIRM Segura Inc.
ART DIRECTOR Carlos Segura
DESIGNER Carlos Segura
ILLUSTRATOR Carlos Segura
CLIENT Heimo Photograpy

DESIGN FIRM Segura Inc.
ART DIRECTOR Carlos Segura
DESIGNER Carlos Segura
ILLUSTRATOR Carlos Segura
CLIENT Guy Hurka
Photography

DESIGN FIRM Eilts Anderson Tracy
ART DIRECTOR Jan Tracy
DESIGNER Jan Tracy
ILLUSTRATOR Jan Tracy
CLIENT Steve Fuller,
Photographer

DESIGN FIRM Segura Inc.
ART DIRECTOR Carlos Segura
DESIGNER Carlos Segura
ILLUSTRATOR Carlos Segura
CLIENT Anthony Arcievo
Photography

DESIGN FIRM Segura Inc.
ART DIRECTOR Carlos Segura
DESIGNER Carlos Segura
ILUSTRATOR Carlos Segura
CLIENT Heck Photography

DESIGN FIRM Hornall Anderson
Design Works
ART DIRECTOR Jack Anderson
DESIGNER Jack Anderson,
Debra Hampton,
Mary Chin Hutchison
ILLYSTRATOR Debra Hampton
CLIENT Rod Ralston
Photography

PROFESSIONAL
SERVICES

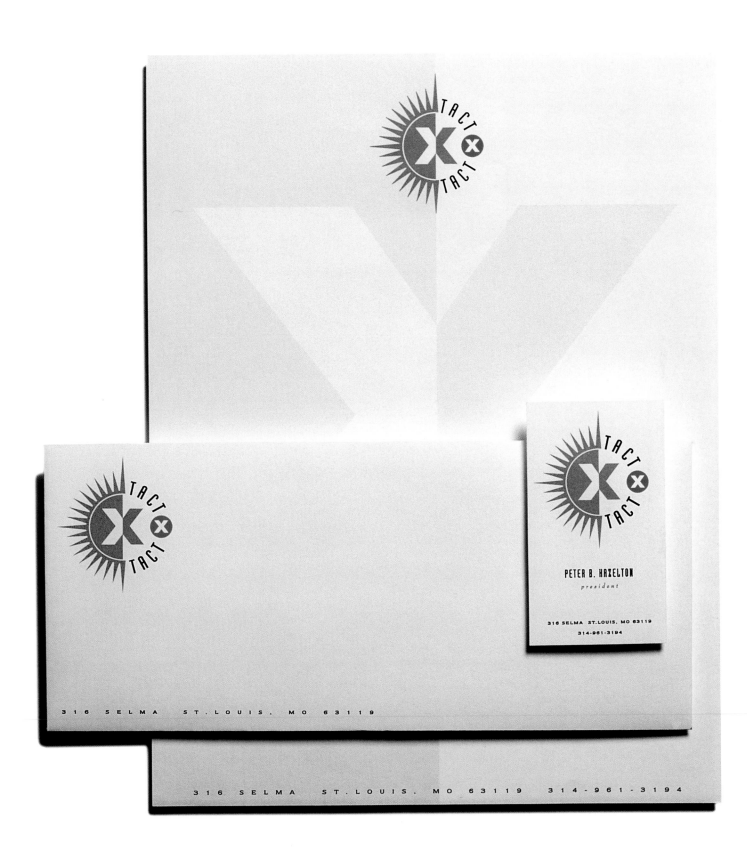

DESIGN FIRM Bartels & Company, Inc.
ART DIRECTOR David Bartels
DESIGNER Bill Gantner
ILLUSTRATOR Bill Gantner
CLIENT Tact-X

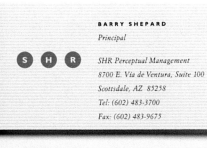

BARRY SHEPARD

Principal

SHR Perceptual Management
8700 E. Via de Ventura, Suite 100
Scottsdale, AZ 85258
Tel: (602) 483-3700
Fax: (602) 483-9675

SHR Perceptual Management
8700 E. Via de Ventura, Suite 100
Scottsdale, AZ 85258
Tel: (602) 483-3700
Fax: (602) 483-9675

DESIGN FIRM	SHR Perceptual Management
ART DIRECTOR	Barry Shepard
DESIGNER	Nathan Joseph
CLIENT	SHR Perceptual Management
PAPER/PRINTING	Simpson Starwhite Vicksburg

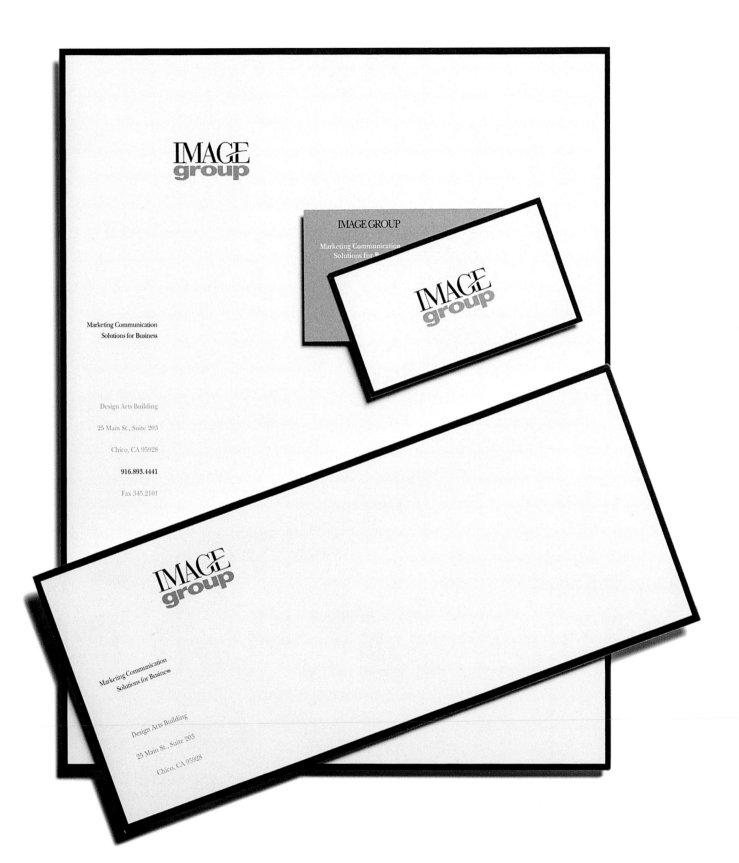

DESIGN FIRM Image Group
ART DIRECTOR Charles Osborn
DESIGNER Charles Osborn, David Zavala, Eric Sanchez
CLIENT Image Group
PAPER/PRINTING Concept

DESIGN & MARKETING
COMMUNICATIONS

RETURN TO: TMCA, Inc.
P.O. Box 50216
Columbia, SC 29250

Job #

Init Date

DESIGN & MARKETING
COMMUNICATIONS

P.O. Box 50216
Columbia • South Carolina
29250-0216 USA

Tim McKeever
President/Creative Director

DESIGN & MARKETING
COMMUNICATIONS

TIM MCKEEVER COMMUNICATION ARTS, INC.
2231 Devine Street • Suite 304 • P.O. Box 50216
Columbia • South Carolina • 29250-0216 USA
☎ 803/256-3010 803/252-0424

TIM MCKEEVER COMMUNICATION ARTS, INC.
2231 Devine Street • Suite 304 • P.O. Box 50216
Columbia • South Carolina • 29250-0216 USA
☎ 803/256-3010 803/252-0424

DESIGN FIRM	TMCA, Inc.
ART DIRECTOR	Tim McKeever
DESIGNER	Tim McKeever
CLIENT	TMCA, Inc.
PAPER/PRINTING	Neenah Classic Crest, Avon Brilliant White, 4 colors

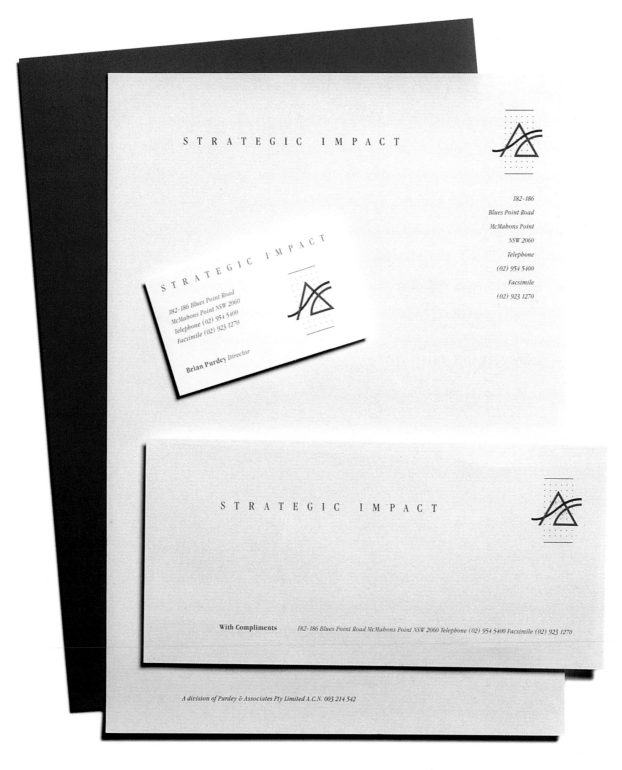

DESIGN FIRM Jenssen Design Pty. Limited
ART DIRECTOR David Jenssen
DESIGNER David Jenssen
ILLUSTRATOR Karen Lloyd-Jones
CLIENT Strategic Impact
PAPER/PRINTING Conservation White Laid

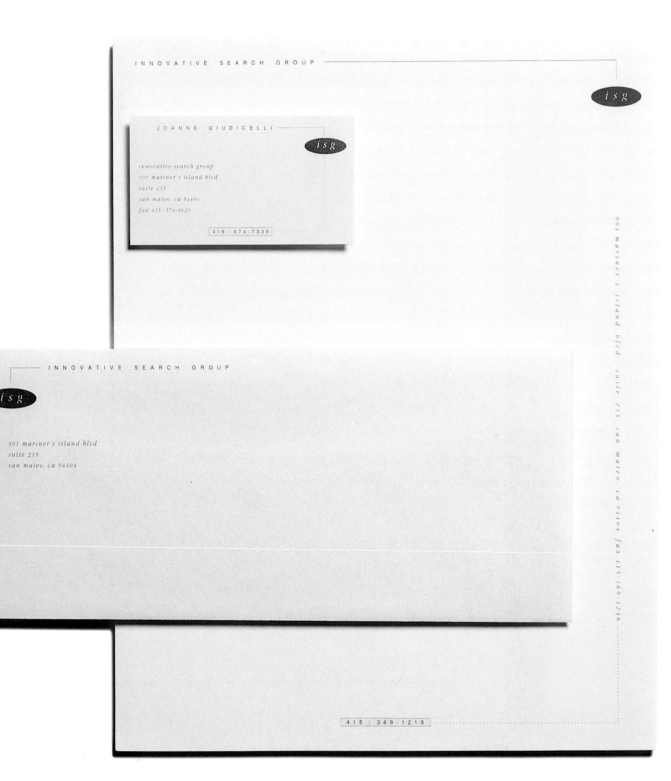

DESIGN FIRM	Dan Frazier Design
ART DIRECTOR	Dan Frazier
DESIGNER	Dan Frazier
CLIENT	Innovative Search Group
PAPER/PRINTING	Strathmore Writing

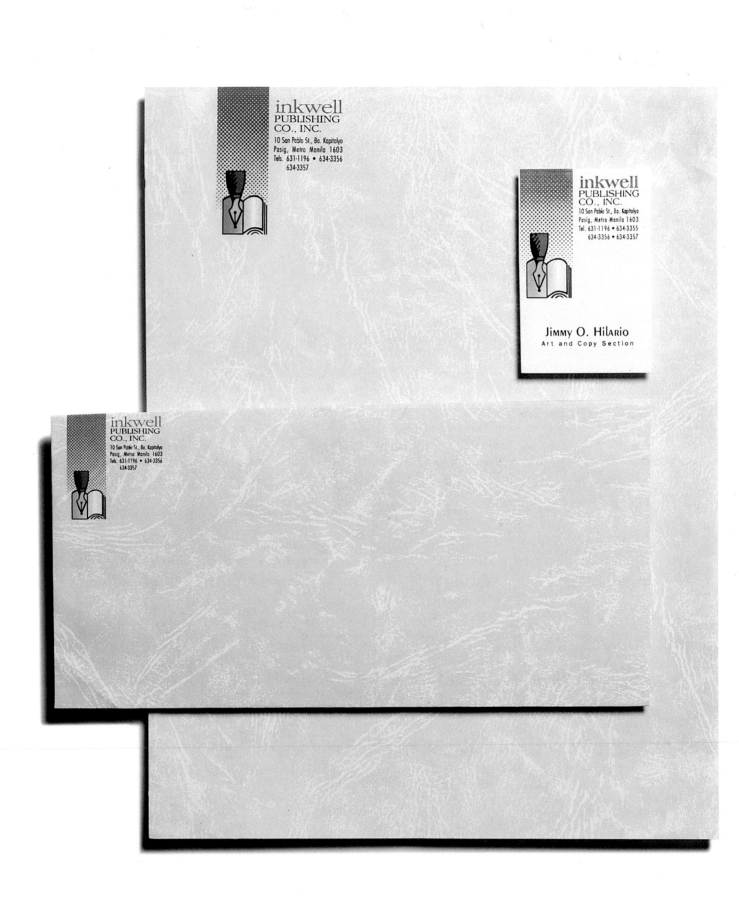

DESIGN FIRM Jim O. Hilario
DESIGNER Jim O. Hilario
ILLUSTRATOR Jim O. Hilario
CLIENT Inkwell Publishing Co., Inc.
PAPER/PRINTING Bookpaper, Classic Laid

DESIGN FIRM	i4 Design
DESIGNER	Bevery Carter
ILLUSTRATOR	Janet Mumford
CLIENT	Fineline Communications
PAPER/PRINTING	Graphika Lineal

DESIGN FIRM	Walsh and Associates, Inc.
ART DIRECTOR	Miriam Lisco
DESIGNER	Miriam Lisco
CLIENT	Concord Mortgage Corporation, Inc.
PAPER/PRINTING	Classic Crest

DESIGN FIRM	Thomas Hillman Design
ART DIRECTOR	Thomas Hillman
DESIGNER	Thomas Hillman
ILLUSTRATOR	Thomas Hillman
CLIENT	Radical Radio
PAPER/PRINTING	Strathmore Renewal

1730 Minor Avenue

Suite 103

Seattle, WA 98101

Phone:

206/467-8000

Fax:

206/467-6932

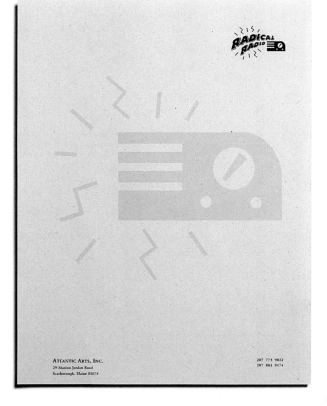

ATLANTIC ARTS, INC.
29 Marion Jordan Road
Scarborough, Maine 04074

207 773 9022
207 883 9174

TECHNICAL
PUBLISHING
SERVICES

750 Bryant Street, Suite 200 San Francisco, California 94107 T. (415) 512-1000 F. (415) 512-1555

AN INSURANCE CORPORATION

104 WEST
9TH STREET
SUITE 200
KANSAS CITY
MISSOURI
64105

PHONE
816•421•3355

FACSIMILE
816•421•1736

DESIGN FIRM	Jim Ales Design
ART DIRECTOR	Jim Ales
DESIGNER	Jim Ales
ILLUSTRATOR	Tim Clark
CLIENT	Technical Publishing Services
PAPER/PRINTING	Strathmore

DESIGN FIRM	Eilts Anderson Tracy
ART DIRECTOR	Jan Tracy
DESIGNER	Jan Tracy
ILLUSTRATOR	Jan Tracy
CLIENT	Embry & Company
PAPER/PRINTING	Evergreen

GATTORNA
STRATEGY

Gattorna Strategy
Consultants Pty Ltd
Inc in NSW
1 James Place North Sydney
NSW 2060 Australia
Tel: (02) 959 3899
Fax: (02) 959 3990

131 Rokeby Road
Subiaco
WA 6008 Australia
Tel: (09) 381 3580
Fax: (09) 382 2519

708C Swanson Road
Swanson
PO Box 83163 Edmonton
Auckland 8 New Zealand
Tel: (09) 833 9991
Fax: (09) 833 9992

33 South Montilla
San Clemente
CA 92672
USA
Tel: (714) 498 9440
Fax: (714) 492 1152

Dr John L Gattorna
Chairman

Gattorna Strategy
Consultants Pty Ltd
Inc in NSW
1 James Place North Sydney
NSW 2060 Australia
Tel: (02) 959 3899
Fax: (02) 959 3990

GATTORNA
STRATEGY

DESIGN FIRM	Jenssen Design Pty. Limited
ART DIRECTOR	David Jenssen
DESIGNER	David Jenssen
ILLUSTRATOR	David Jenssen, Yahyeh Abouloukme
CLIENT	Gattorna Strategy Consultants Pty. Ltd.
PAPER/PRINTING	Strathmore Writing, Bright White Laid

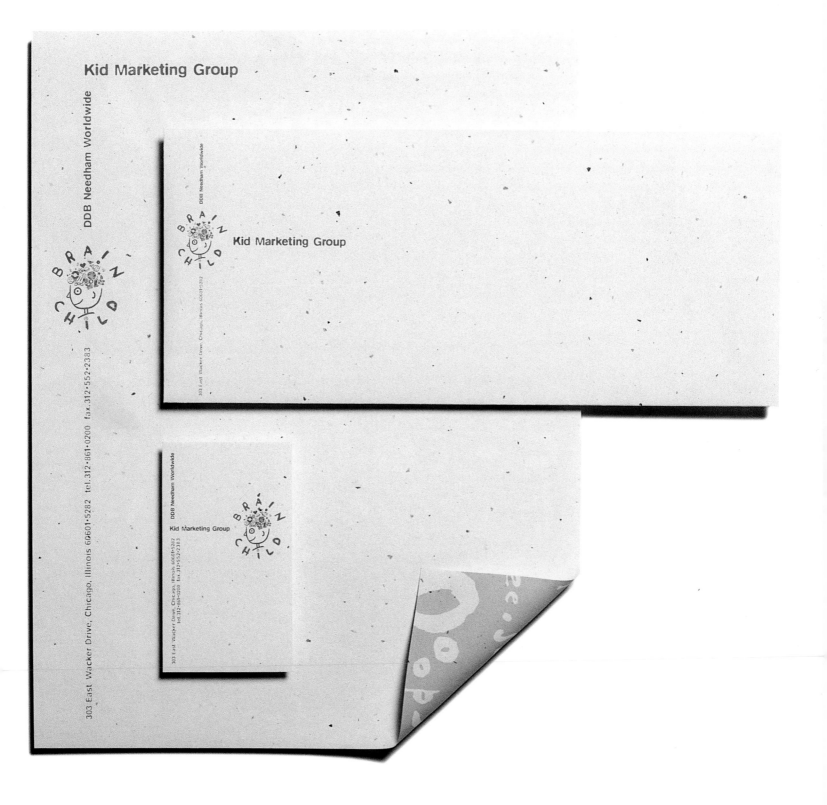

DESIGN FIRM Segura Inc.
ART DIRECTOR Carlos Segura
DESIGNER Carlos Segura
ILLUSTRATOR John Stepping
CLIENT Brain Child
PAPER/PRINTING Argus

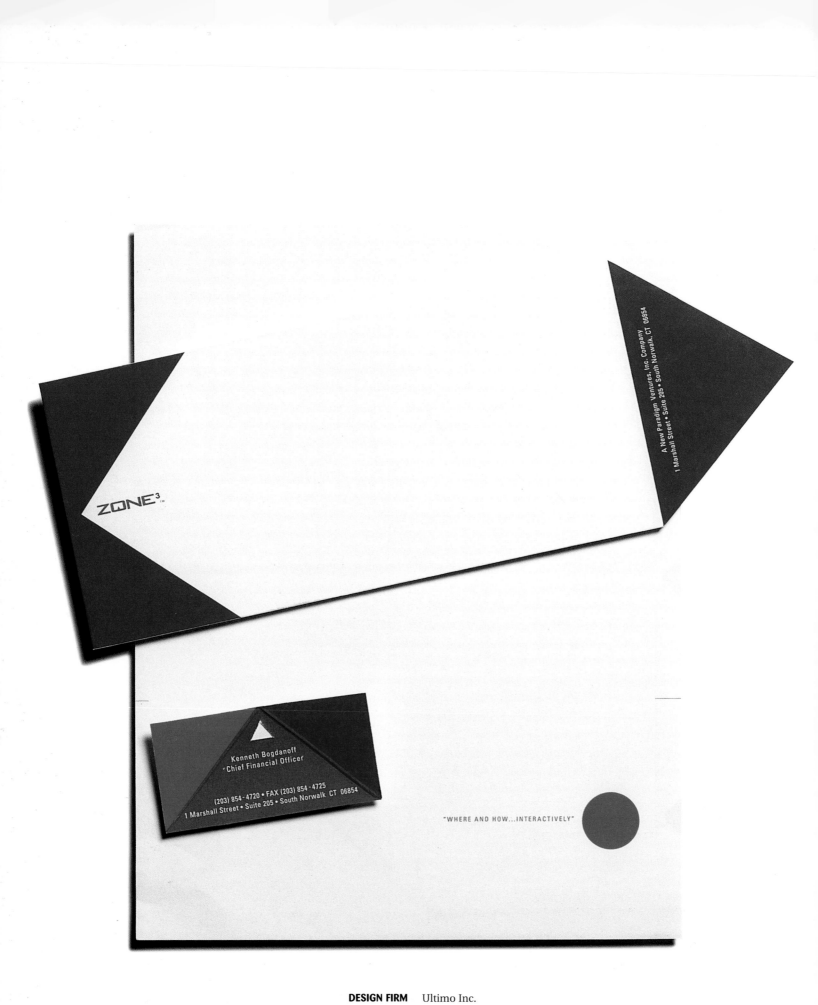

DESIGN FIRM Ultimo Inc.
ART DIRECTOR Clare Ultimo
DESIGNER Joanne Obarowski, Clare Ultimo
CLIENT Zone 3
PAPER/PRINTING Finch Paper

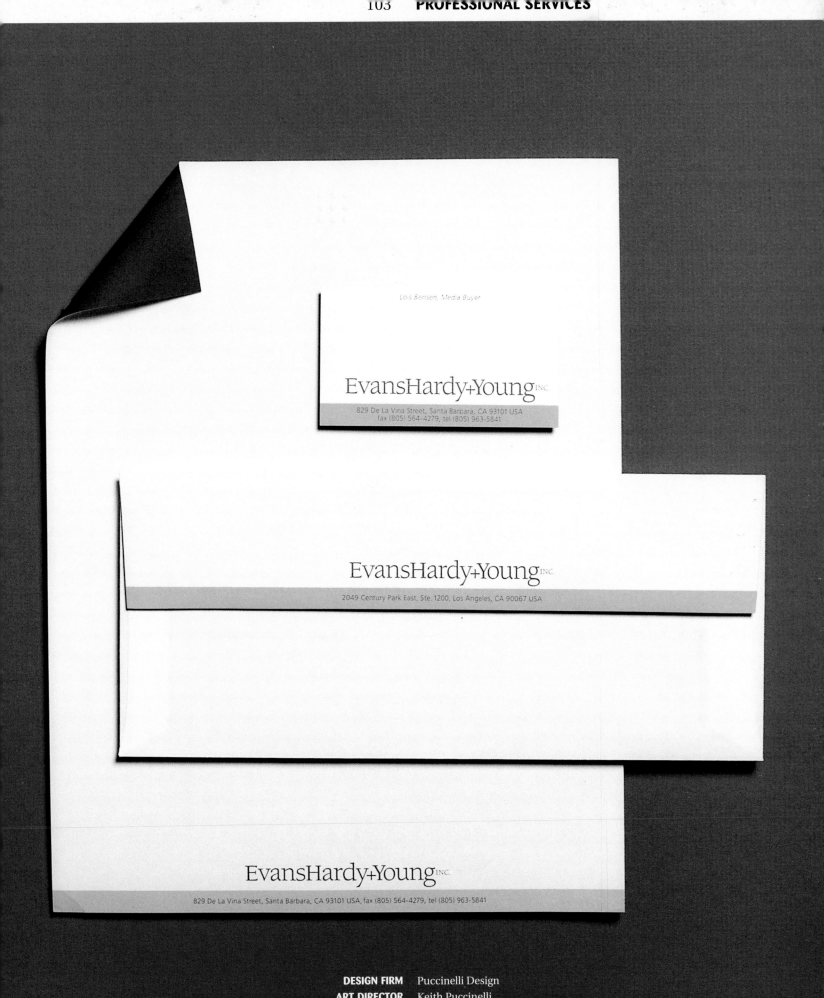

DESIGN FIRM Puccinelli Design
ART DIRECTOR Keith Puccinelli
DESIGNER Keith Puccinelli, Heidi Palladino
ILLUSTRATOR Keith Puccinelli
CLIENT Evans, Hardy & Young
PAPER/PRINTING Gilbert Neo

DESIGN FIRM	O&J Design, Inc.
ART DIRECTOR	Andrzej J. Olejniczak
DESIGNER	Andrzej J. Olejniczak
CLIENT	Corporate Communication Group
PAPER/PRINTING	Starwhite Vicksburg/4 colors

DESIGN FIRM	Heart Graphic Design
ART DIRECTOR	Clark Most
DESIGNER	Joan Most
CLIENT	English Training Consultants
PAPER/PRINTING	Cottonwood/Evergreen

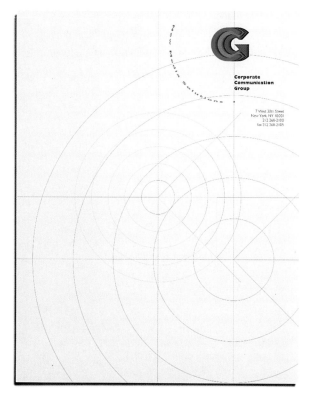

DESIGN FIRM	Shields Design
ART DIRECTOR	Charles Shields
DESIGNER	Charles Shields
CLIENT	The Ken Roberts Company/ Four Star Books
PAPER/PRINTING	Neenah Classic Crest

DESIGN FIRM	The Design Associates
ART DIRECTOR	Victor Cheong
DESIGNER	Victor Cheong, Philip Sven
CLIENT	THS Productions
PAPER/PRINTING	Conqueror, foil stamp

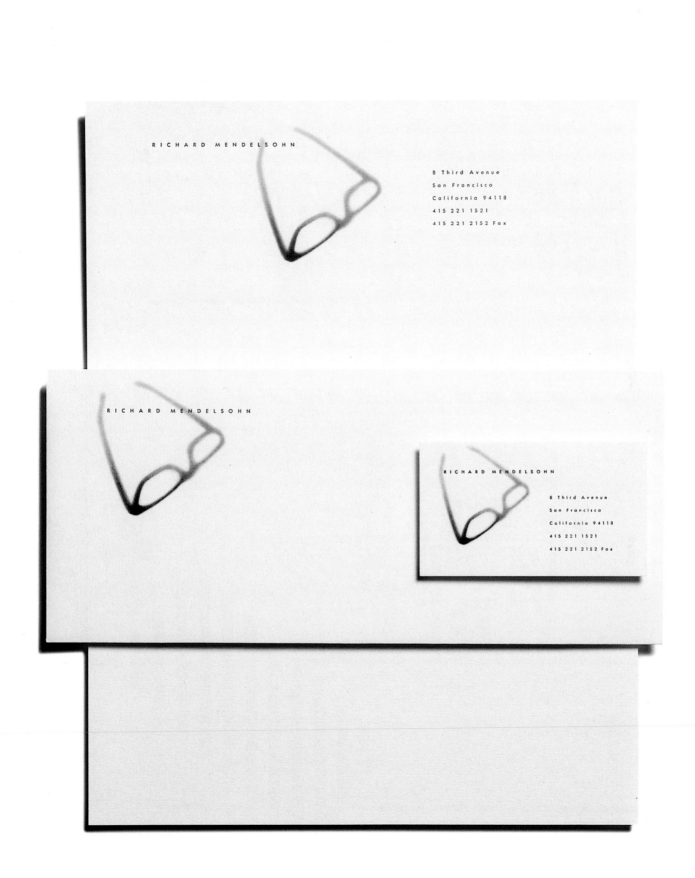

DESIGN FIRM	Debra Nichols Design
ART DIRECTOR	Debra Nichols
DESIGNER	Debra Nichols, Kelan Smith
ILLUSTRATOR	Mark Schroeder
CLIENT	Richard Mendelsohn

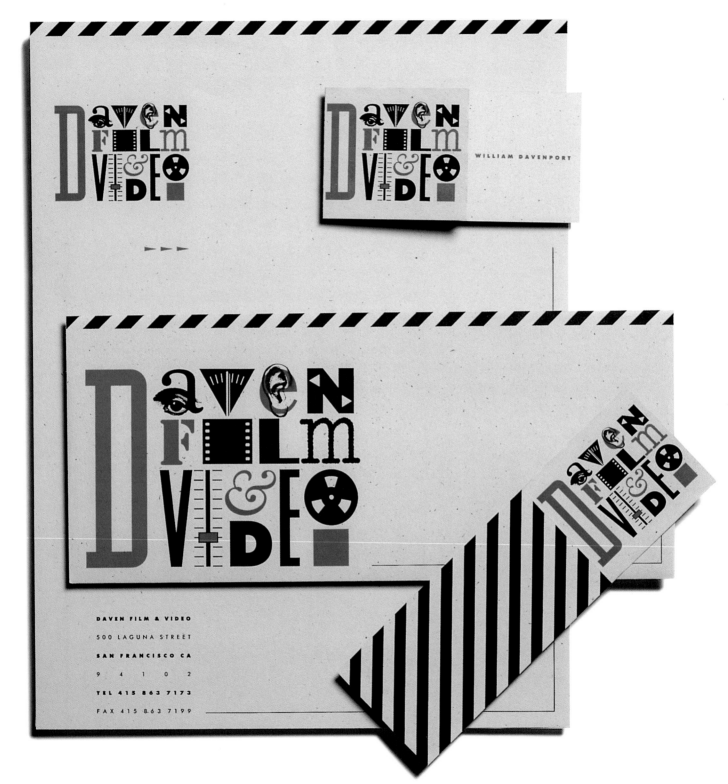

DESIGN FIRM	Earl Gee Design
ART DIRECTOR	Earl Gee
DESIGNER	Earl Gee
ILLUSTRATOR	Earl Gee
CLIENT	Daven Film & Video
PAPER/PRINTING	Speckletone Natural text

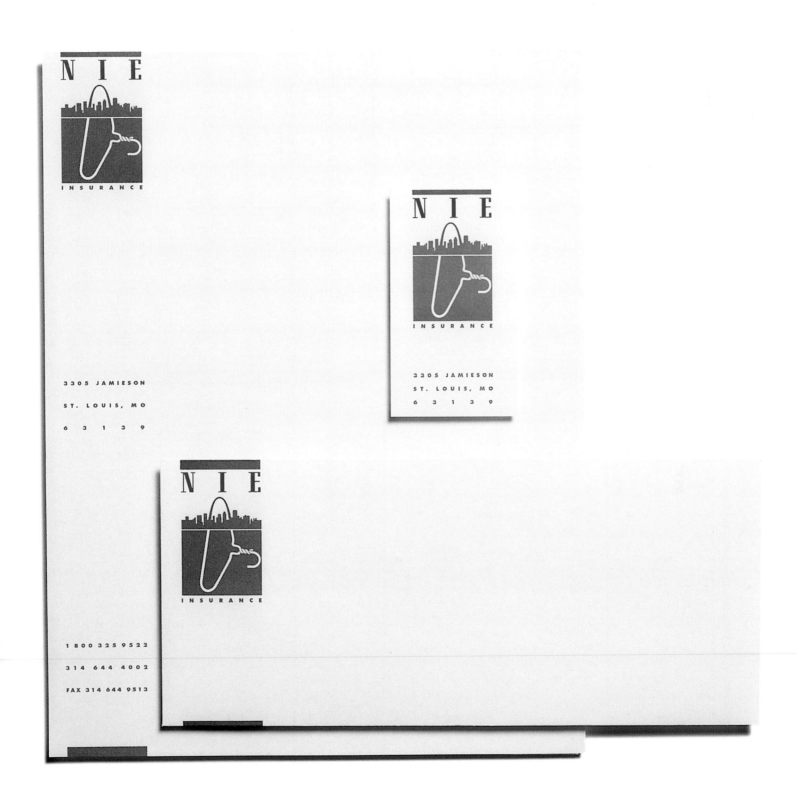

DESIGN FIRM Bartels & Company, Inc.
ART DIRECTOR David Bartels
DESIGNER Aaron Segall
ILLUSTRATOR Aaron Segall
CLIENT NIE Insurance

DESIGN FIRM	Smith Group Communications	**DESIGN FIRM**	Source/Inc.
ART DIRECTOR	Thom Smith, Gregg Frederickson	**ART DIRECTOR**	Michael Livolsi
DESIGNER	Thom Smith, Gregg Frederickson	**DESIGNER**	Source Staff
ILLUSTRATOR	Gregg Frederickson	**CLIENT**	Source/Inc.
CLIENT	Lightman & Associates	**PAPER/PRINTING**	Strathmore Writing
PAPER/PRINTING	Protocol Writing		

DESIGN FIRM	Hornall Anderson Design Works	**DESIGN FIRM**	Ellen Kendrick Creative, Inc.
ART DIRECTOR	Jack Anderson	**ART DIRECTOR**	Ellen K. Spalding
DESIGNER	Jack Anderson, David Bates, Mary	**DESIGNER**	Ellen K. Spalding
ILLUSTRATOR	Hermes, Julia LaPine	**ILLUSTRATOR**	Ellen K. Spalding
CLIENT	Yutaka Sasaki	**CLIENT**	Lexington Rare Coin Investments, Inc.
PAPER/PRINTING	Travel Services of America	**PAPER/PRINTING**	Simpson Gainsborough black and metallic
	Simpson Environment		green registered to sculptured brass die

BROOKS MARKETING LTD.
475 Cleveland Avenue N., Suite 315
Saint Paul, Minnesota 55104
Fax: 612 / 645-5250
Tel: 612 / 645-1282

BROOKS MARKETING LTD.
475 Cleveland Avenue N., Suite 315
Saint Paul, Minnesota 55104

MICHAEL BROOKS **BROOKS MARKETING LTD.**
475 Cleveland Avenue N., Suite 315
Saint Paul, Minnesota 55104
Fax: 612 / 645-5250
Tel: 612 / 645-1282

DESIGN FIRM	GrandPré and Whaley, Ltd.
ART DIRECTOR	Kevin Whaley
DESIGNER	Kevin Whaley
CLIENT	Brooks Marketing, Ltd.
PAPER/PRINTING	Strathmore

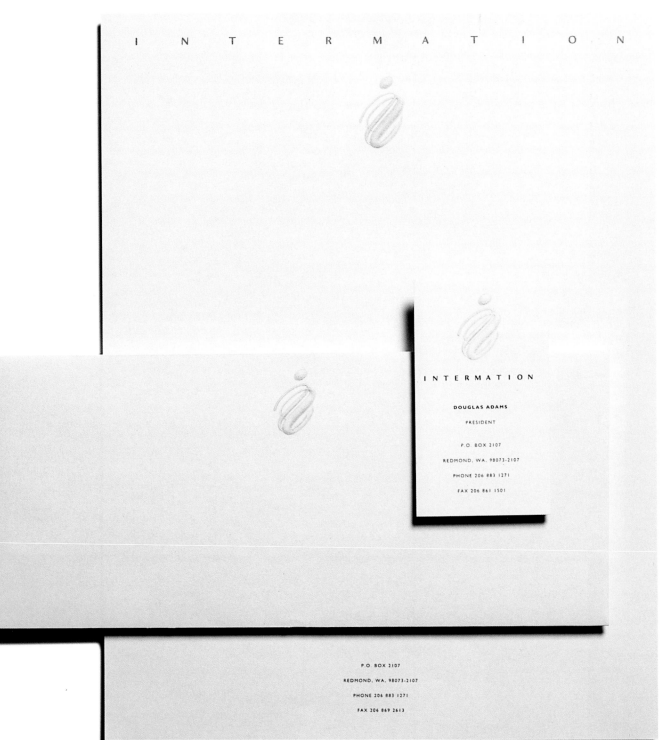

DESIGN FIRM Hornall Anderson Design Works

ART DIRECTOR Jack Anderson

DESIGNER Jack Anderson, Julia LaPine, Jill Bustamante

CLIENT Intermation

PAPER/PRINTING Monadnock Astro Lite White, embossed

Stanley Hui

corebookwork

6th floor
89 Wellington Street
Central, Hong Kong
Tel 544 · 1641
Fax 543 · 0141

corebookwork

7th floor A1
89 Wellington Street
Central, Hong Kong
Tel 5 · 441 · 641
Fax 5 · 430 · 141

Client

Invoice

Date

Phototypesetting

Desktop Output

19498

corebookwork

6th floor
89 Wellington Street
Central, Hong Kong
Tel 5 · 441 · 641
Fax 5 · 430 · 141

E&OE

Total HK$

All payment will be settled within one month from the date of invoice
Cheque should be crossed and made payable to **Core Bookwork Company**

DESIGN FIRM	The Design Associates
ART DIRECTOR	Victor Cheong
DESIGNER	Victor Cheong, Philip Sven
CLIENT	Corebookwork Company
PAPER/PRINTING	Conqueror

Feigin Associates, Inc.

Judith J. Feigin

Feigin Associates, Inc.
4 Brighton Lane
Gaithersburg, MD 20877
301/ 948-0878

4 Brighton Lane
Gaithersburg, MD 20877
301-840-9813
fax 301-869-1759

DESIGN FIRM	Musikar Design
ART DIRECTOR	Sharon R. Musikar
DESIGNER	Sharon R. Musikar
ILLUSTRATOR	Sharon R. Musikar
CLIENT	Feigin Associates, Inc.
PAPER/PRINTING	Classic Crest, 2 colors

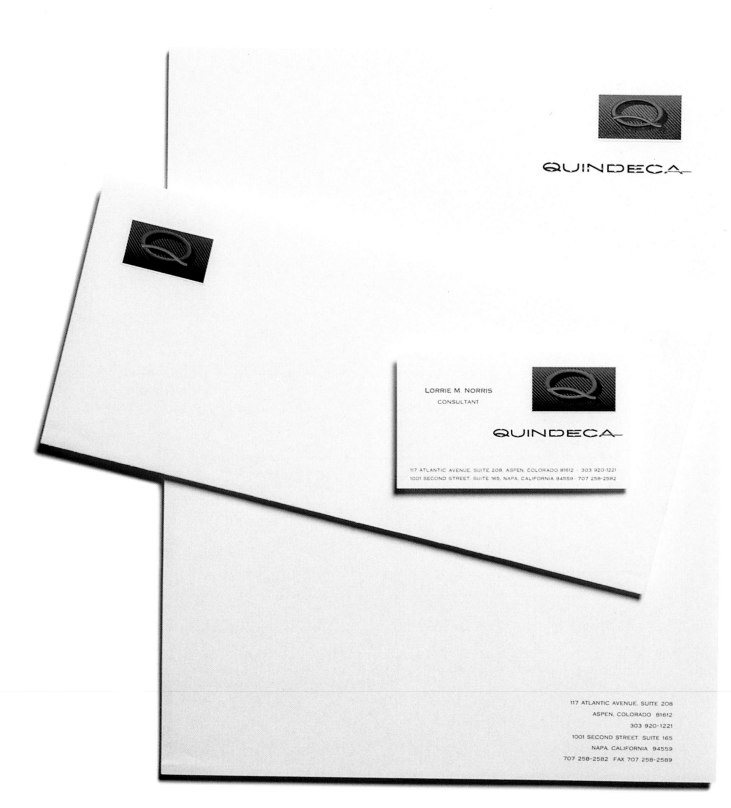

DESIGN FIRM	Ortega Design Studio
ART DIRECTOR	Joann Ortega, Susann Ortega
DESIGNER	Susann Ortega, Joann Ortega
ILLUSTRATOR	Susann Ortega
TYPE DESIGN	Joann Oretga
CLIENT	Quindeca Corporation
PAPER/PRINTING	Enhance, foil stamp, emboss/deboss

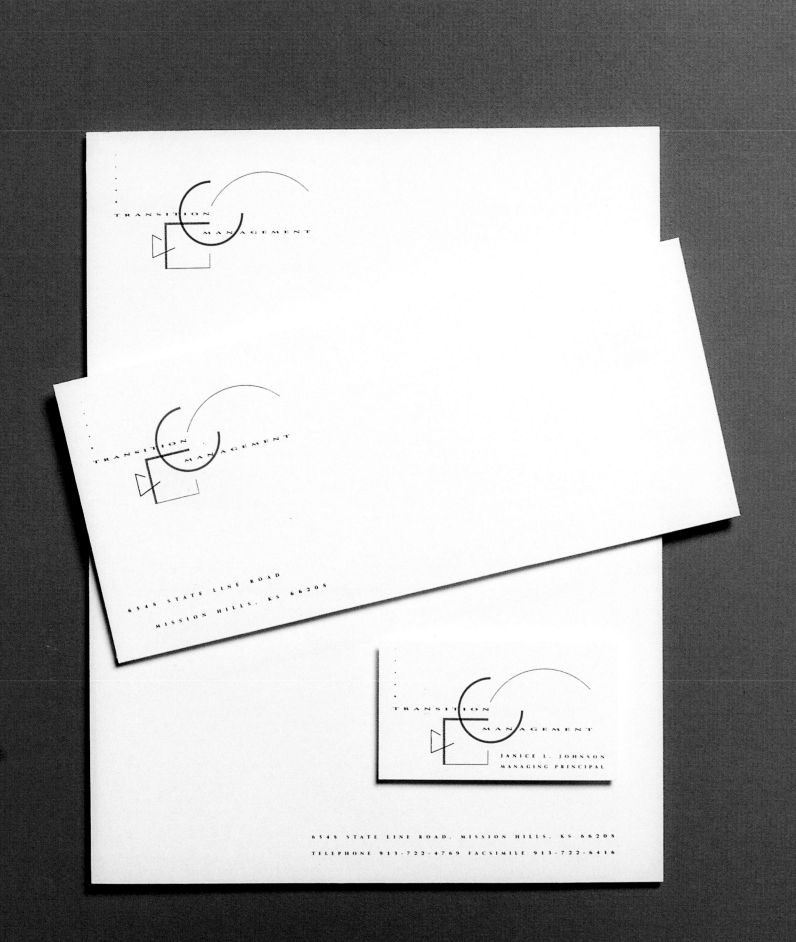

DESIGN FIRM	Eilts Anderson Tracy
ART DIRECTOR	Jan Tracy
DESIGNER	Jan Tracy
ILLUSTRATOR	Jan Tracy
CLIENT	Transition Management
PAPER/PRINTING	Vicksburg/Instyprints

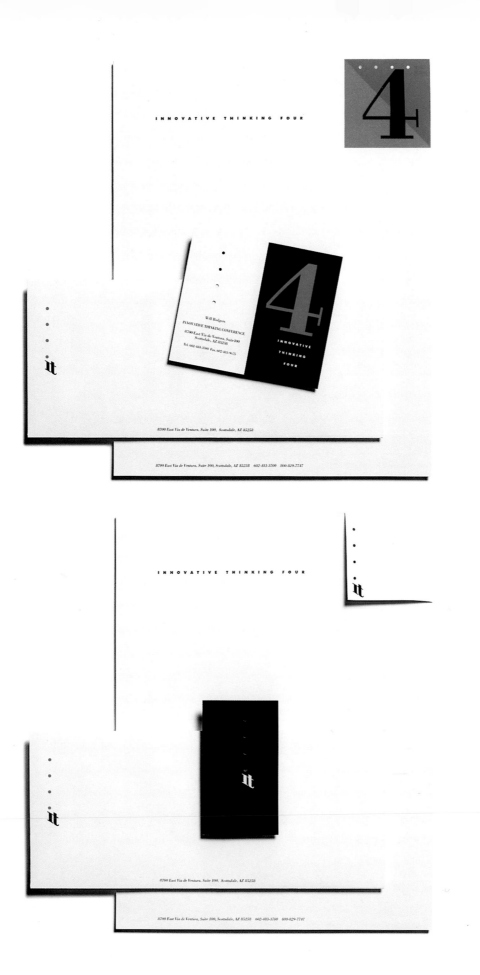

DESIGN FIRM SHR Perceptual Management
ART DIRECTOR Barry Shepard
DESIGNER Mike Shanks
CLIENT SHR Perceptual Management
PAPER/PRINTING Curtis Brightwater Aretsian

DESIGN FIRM Bruce Yelaska
Design
ART DIRECTOR Bruce Yelaska
DESIGNER Bruce Yelaska
CLIENT Consumer Direct
Access

DESIGN FIRM Fountainhead Graphics
ART DIRECTOR William A. Donabedian
DESIGNER William A. Donabedian
ILLUSTATOR William A. Donabedian
CLIENT Veale & Associates, Inc.

DESIGN FIRM Lipson Alport Glass &
Associates
ART DIRECTOR Jeff Rich
DESIGNER Keith Shupe
CLIENT Coregis

DESIGN FIRM Riley Design
Associates
ART DIRECTOR Daniel Riley
DESIGNER Daniel Riley
ILLUSTRATOR Daniel Riley
CLIENT Boy Oh Boy
Productions

DESIGN FIRM Design Art, Inc.
ART DIRECTOR Norman Moore
DESIGNER Norman Moore
CLIENT Tim Neece
Management

DESIGN FIRM Rickabaugh Graphics
ART DIRECTOR Mark Krumel
DESIGNER Mark Krumel
ILLUSTRATOR Tony Meuser
CLIENT Huntington Banks

DESIGN FIRM	The Weller Institute
	for the Cure of
	Design, Inc.
ART DIRECTOR	Don Weller
DESIGNER	Don Weller
ILLUSTRATOR	Don Weller
CLIENT	Western Exposure

DESIGN FIRM	Schowalter² Design
ART DIRECTOR	Toni Schowalter
DESIGNER	Ilene Price,
	Toni Schowalter
CLIENT	Green Point Bank

DESIGN FIRM	Adam, Filippo & Associates
ART DIRECTOR	Robert A. Adam
DESIGNER	Sharon L. Bretz,
	Barbara Peak Long
CLIENT	Tuscarora Inc.

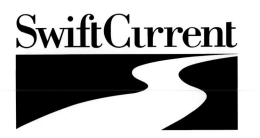

DESIGN FIRM	Palmquist &
	Palmquist Design
ART DIRECTOR	Kurt & Denise
	Palmquist
DESIGNER	Kurt & Denise
	Palmquist
CLIENT	Swiftcurrent (film
	and video production
	company)

DESIGN FIRM	MacVicar Design &
	Communications
ART DIRECTOR	John Vance
DESIGNER	William A. Gordon
CLIENT	Newsletter Services, Inc.

DESIGN FIRM	Schowalter² Design
ART DIRECTOR	Toni Schowalter
DESIGNER	Ilene Price, Toni Schowalter
CLIENT	Towers Perrin

DESIGN FIRM Lambert Design
Studio
ART DIRECTOR Christie Lambert
DESIGNER Joy Cathey
CLIENT Ideas & Solutions

DESIGN FIRM Aslan Grafix
ART DIRECTOR Tracy Grubbs
DESIGNER Tracy Grubbs
CLIENT Argadine Publishing

DESIGN FIRM TW Design
DESIGNER Jordan Patsios
CLIENT MARCAM
Corporation

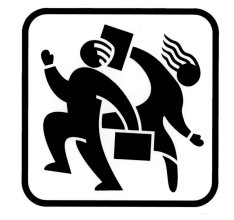

DESIGN FIRM Riley Design
Associates
ART DIRECTOR Daniel Riley
DESIGNER Daniel Riley
ILLUSTRATOR Daniel Riley
CLIENT Hiring Resources

DESIGN FIRM Lambert Design
Studio
ART DIRECTOR Christie Lambert
DESIGNER Christie Lambert,
Joy Cathey
ILLUSTRATOR Joy Cathey
CLIENT ProjectWorks

DESIGN FIRM Vaughn Wedeen Creative
ART DIRECTOR Steve Wedeen
DESIGNER Lisa Graff
ILLUSTRATOR Lisa Graff
COMPUTER PRODUCTION Chip Wyly
CLIENT Stratecom

CHICO PHYSICAL
REHABILITATION CLINIC

Philadelphia Square
140 B Independence Circle
Chico, CA 95926
(916) 345-2122

Schenck
CHIROPRACTIC

The Massage Therapy Center Inc.
2130 S. Sepulveda Blvd. #207
Los Angeles, CA 90025
(213) 444-4949

CPRC

HEALTHCARE, EDUCATION
& NONPROFIT

National
Institutional
Pharmacy
Services
Inc.

NIPSI

Vicki Dillon

Tom Denny

Chris Chadwick

Karen Blumeyer

Paul Bermont

David Bartels

Anne Albrecht

STEERING COMMITTEE

Beth A. Louis

Clarence C. Barksdale

CO CHAIRS

Edward J. McMillan

HONORARY CHAIR

ZOO
'93

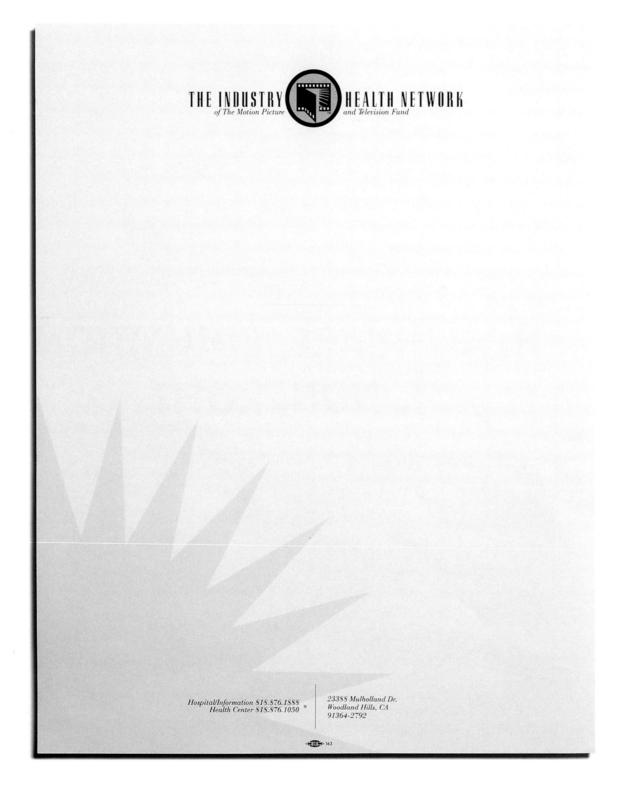

DESIGN FIRM Vrontikis Design Office
ART DIRECTOR Petrula Vrontikis
DESIGNER Kim Sage
CLIENT MPTF Industry Health Network
PAPER/PRINTING Classic Crest Solar White

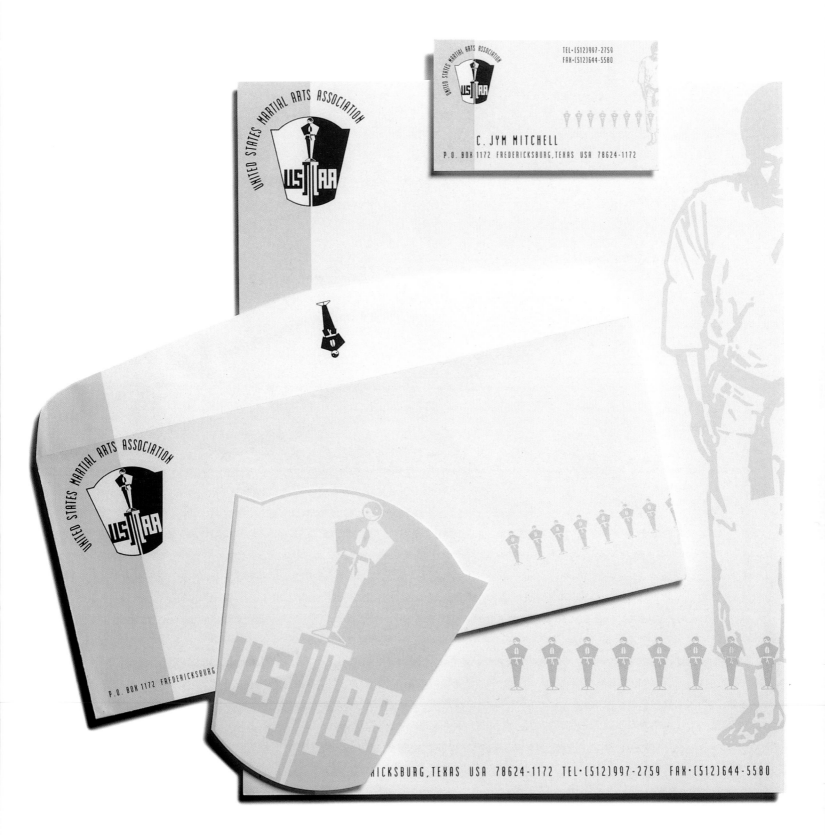

DESIGN FIRM Romeo Empire Design
ART DIRECTOR Vincent Romeo
DESIGNER Vincent Romeo
ILLUSTRATOR Vincent Romeo
CLIENT United States Martial Arts Association
PAPER/PRINTING Mohawk Superfine

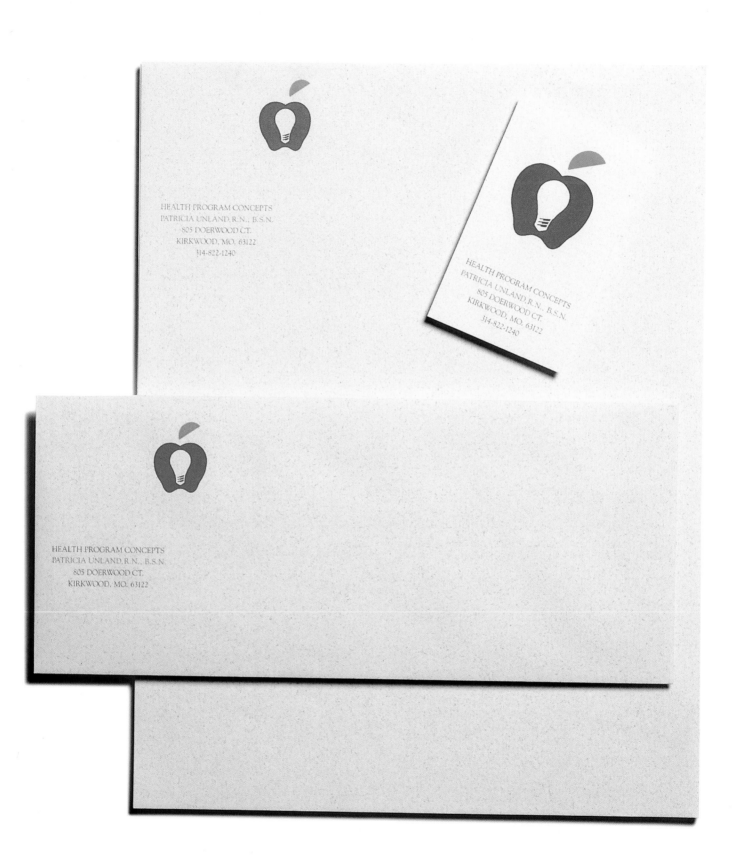

DESIGN FIRM	Bartels & Company, Inc.
ART DIRECTOR	David Bartels
DESIGNER	Chuck Hart
ILLUSTRATOR	Chuck Hart
CLIENT	Health Program Concepts

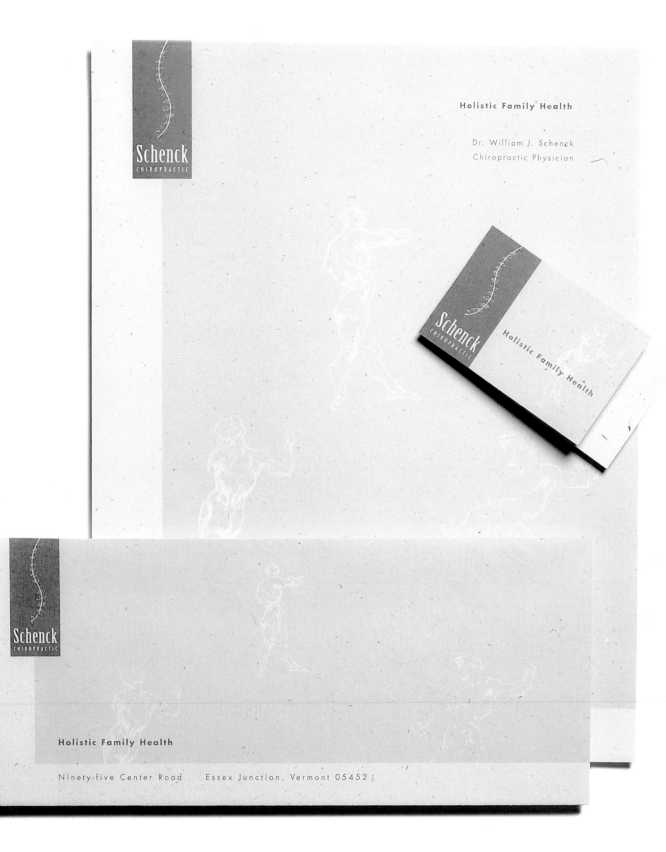

DESIGN FIRM Creative EDGE
DESIGNER Rick Salzman, Barbara Pitfido
CLIENT Schenck Chiropractic
PAPER/PRINTING Strathmore Renewal

FAX 432-7713

(515) 432-7700

P.O. BOX 367

BOONE, IOWA 50036

P.O. BOX 367

BOONE, IOWA 50036

DR. SHEILA MCGUIRE

MEDICAL SCIENTIST

P.O. BOX 367

BOONE, IOWA 50036

(515) 432-7700

FAX 432-7713

DESIGN FIRM Sayles Graphic Design
ART DIRECTOR John Sayles
DESIGNER John Sayles
ILLUSTRATOR John Sayles
CLIENT Iowa Health Research Institute
PAPER/PRINTING James River, Graphika Vellum White, 2 colors

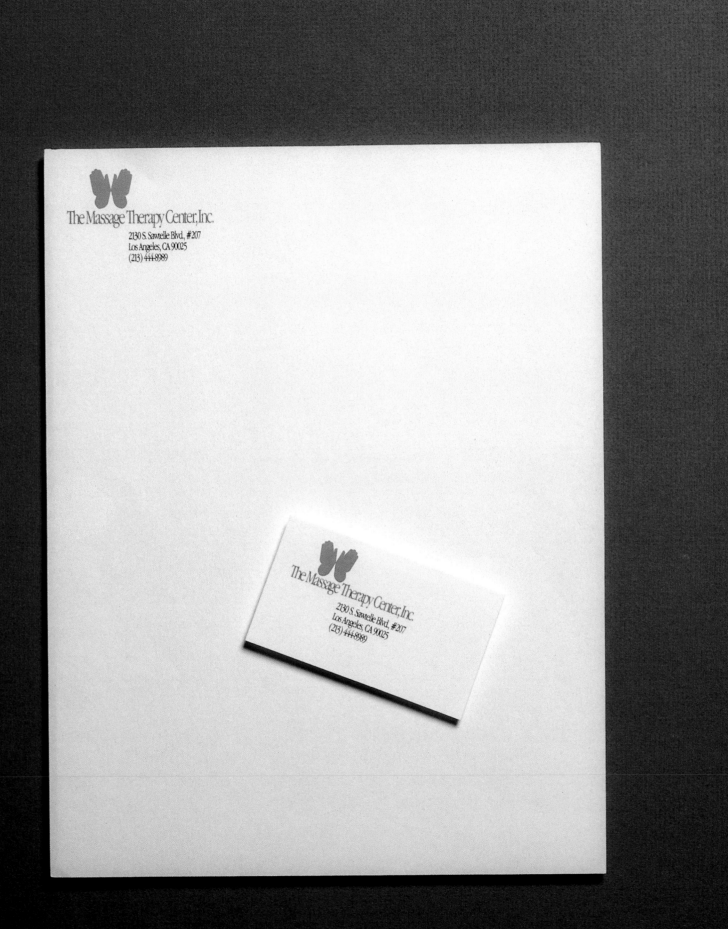

DESIGN FIRM Ilan Geva & Friends
ART DIRECTOR Ilan Geva
DESIGNER Ilan Geva
CLIENT The Massage Therapy Center

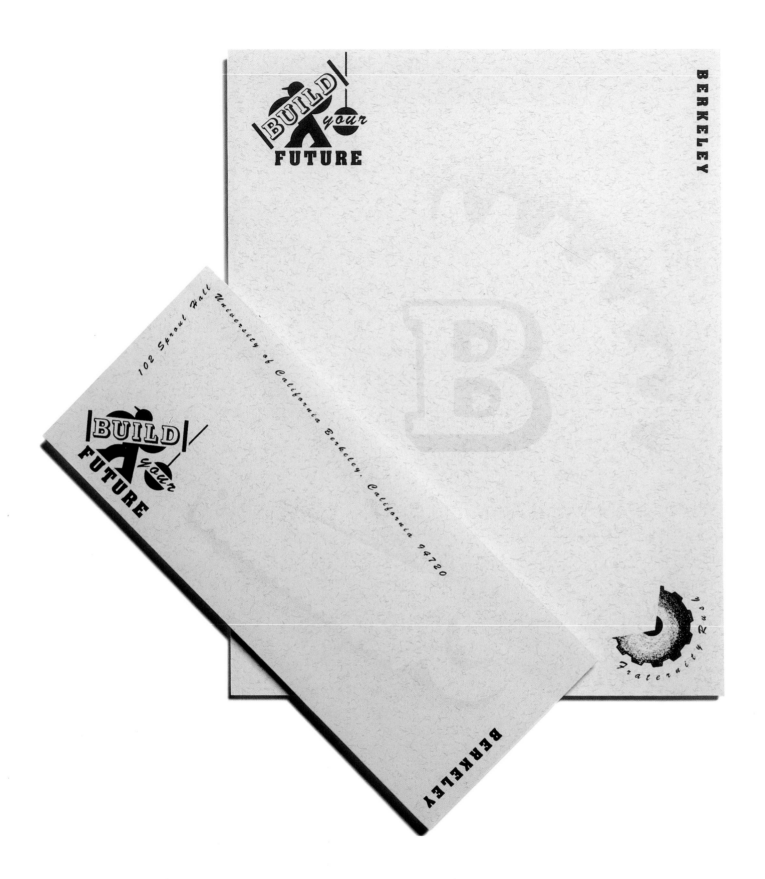

DESIGN FIRM	Sayles Graphic Design
ART DIRECTOR	John Sayles
DESIGNER	John Sayles
ILLUSTRATOR	John Sayles
CLIENT	University of California, Berkeley
PAPER/PRINTING	James River, Tuscan Terra Gray, 2 colors

DESIGN FIRM	The Marketing & Design Group
ART DIRECTOR	Howard Levy
DESIGNER	Howard Levy
CLIENT	Dr. Gerald Rosenfeld, Dentist
PAPER/PRINTING	Neenah Classic, linen-engraved in 2 colors

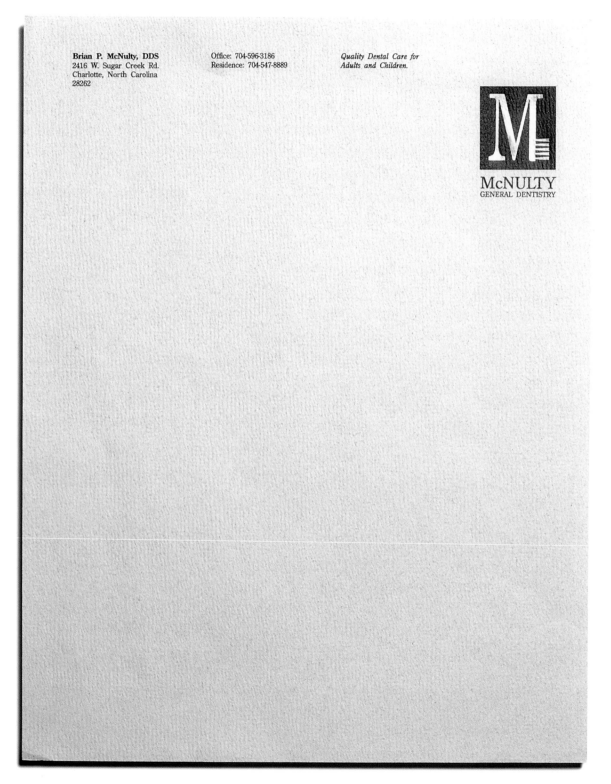

DESIGN FIRM Turner Design
ART DIRECTOR Bert Turner
DESIGNER Bert Turner
ILLUSTRATOR Bert Turner
CLIENT Dr. Brian McNulty
PAPER/PRINTING Simpson Gainsborough Silver

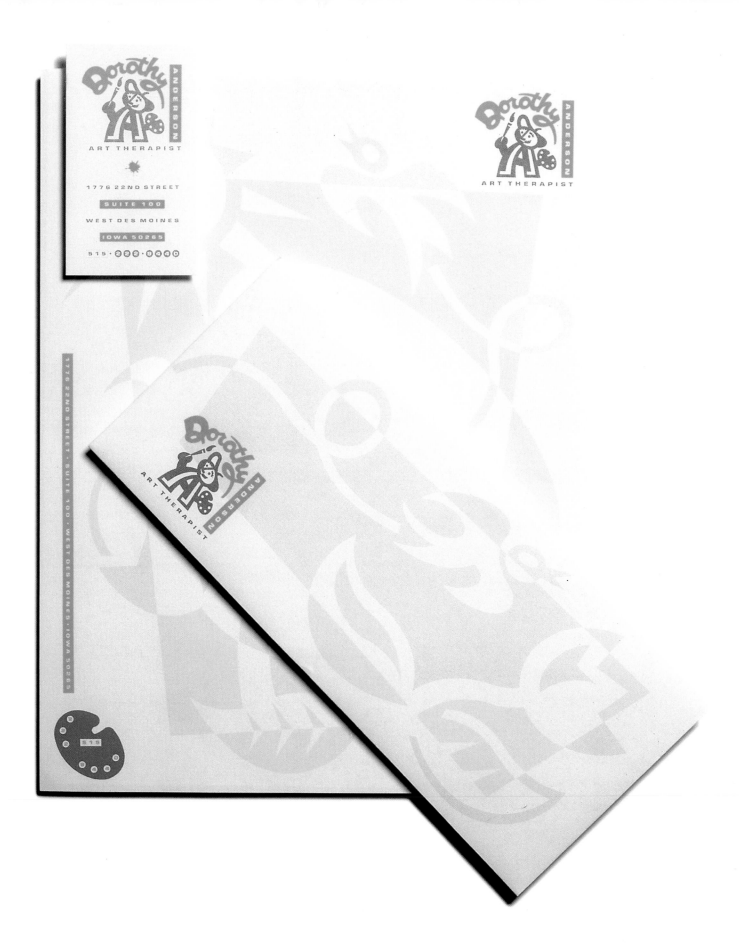

DESIGN FIRM Sayles Graphic Design
ART DIRECTOR John Sayles
DESIGNER John Sayles
ILLUSTRATOR John Sayles
CLIENT Dorothy Anderson, Art Therapist
PAPER/PRINTING Gilbert Paper, White, 2 colors

Friends Of The Zoo

Friends of the
Washington Park Zoo

4001 S.W. Canyon Road
Portland, OR 97221-2799
(503) 226-1561
FAX (503) 226-6836

Friends Of The Zoo

Friends of the
Washington Park Zoo

4001 S.W. Canyon Road
Portland, OR 97221-2799
(503) 226-1561
FAX (503) 226-6836

Margie Mee Pate
Executive Director

"Caring Now for
the Future of Life"

Friends Of The Zoo

Friends of the
Washington Park Zoo

4001 S.W. Canyon Road
Portland, OR 97221-2799

"Caring Now for the Future of Life"

"Caring Now for the Future of Life"

DESIGN FIRM	Smith Group Communications
ART DIRECTOR	Gregg Frederickson
DESIGNER	Lena James
ILLUSTRATOR	Lena James
CLIENT	Friends of the Zoo
PAPER/PRINTING	Classic Crest

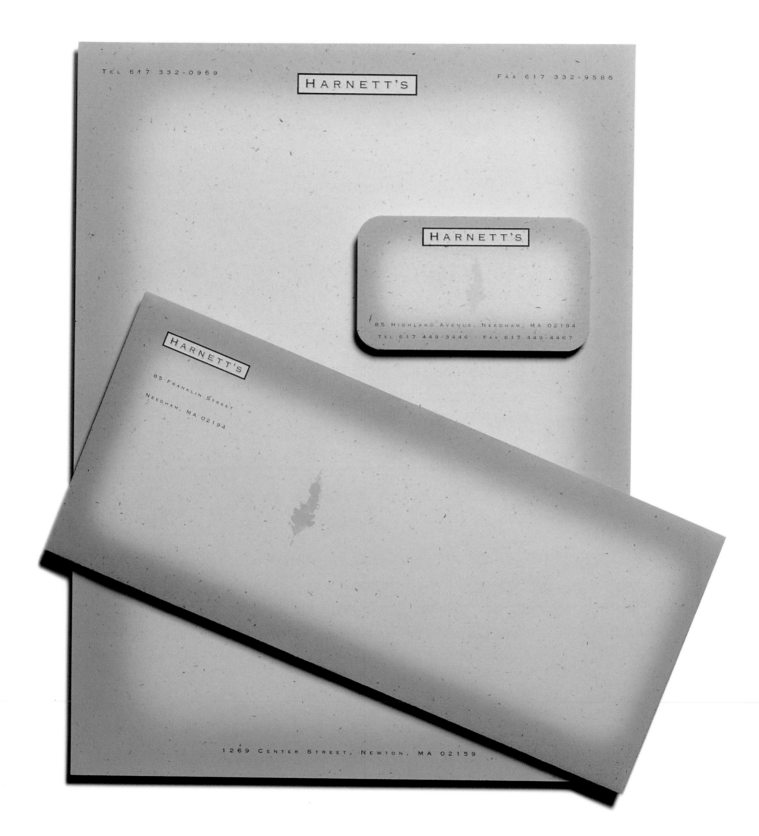

DESIGN FIRM Clifford Selbert Design
ART DIRECTOR Melanie Lowe
DESIGNER Melanie Lowe
CLIENT Harnett's
PAPER/PRINTING Champion Benefit

National
Institutional
Pharmacy
Services
Inc.

7619 S. University

Suite B

Lubbock, TX 79423

806 · 745 · 0271

Fax: 806 · 748 · 1712

National
Institutional
Pharmacy
Services
Inc.

National April Bonds, R.Ph.
Institutional *Pharmacy Manager*
Pharmacy
Services
Inc.

12758 Cimarron Path
Suite 126
San Antonio, TX 78249
210 · 690 · 0607
Fax: 210 · 694 · 0998
800 · 793 · 0607

DESIGN FIRM	Vaughn Wedeen Creative
ART DIRECTOR	Rick Vaughn
DESIGNER	Dan Flynn
CLIENT	National Institutional Pharmacy Service Inc.
PAPER/PRINTING	Starwhite Vicksburg Archiva

CHICO PHYSICAL
REHABILITATION CLINIC

Philadelphia Square
140 B Independence Circle
Chico, CA 95926
(916) 345-2122

CPRC

CHICO PHYSICAL
REHABILITATION CLINIC

Philadelphia Square
140 B Independence Circle
Chico, CA 95926

CPRC

CHICO PHYSICAL
REHABILITATION CLINIC

Cheri Rolandelli
Exercise Physiologist

Philadelphia Square
140 B Independence Circle
Chico, CA 95926
(916) 345-2122

CPRC

DESIGN FIRM	Image Group
ART DIRECTOR	David Zavala, Eric Sanchez
DESIGNER	David Zavala, Eric Sanchez
ILLUSTRATOR	David Zavala, Eric Sanchez
CLIENT	Child Physical Rehabilitation Clinic
PAPER/PRINTING	Classic Linen

DESIGN FIRM	Handler Design Ltd.
ART DIRECTOR	Bruce Handler
DESIGNER	Bruce Handler
ILLUSTRATOR	Ray Ringston III
CLIENT	Martial Arts Institute of America
PAPER/PRINTING	Strathmore Bond

DESIGN FIRM	Image Group
ART DIRECTOR	David Zavala, Eric Sanchez
DESIGNER	David Zavala, Eric Sanchez
ILLUSTRATOR	David Zavala
CLIENT	Assistance Dog Institute
PAPER/PRINTING	Concept

39-47 Court Street • White Plains, N.Y. 10601 • (914) 428-0085 ■ 717 A Bedford Road • Bedford Hills, N.Y. 10507 • (914) 666-2345

 Institute for Media Arts

c/o Journalism Dept., Columbia College · 600 S. Michigan Ave. · Chicago, IL 60605 · Phone and FAX (312) 663-5375

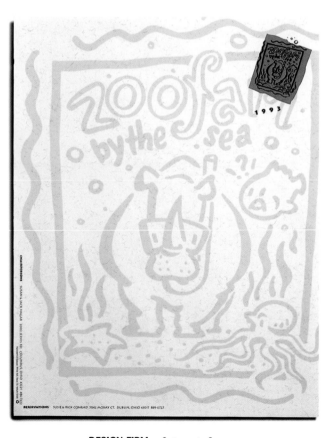

DESIGN FIRM	Jon Wells Associates
DESIGNER	Jon Wells
ILLUSTRATOR	Institute for Media Arts
CLIENT	Curtis Brightwater

DESIGN FIRM	Integrate Inc.
ART DIRECTOR	Stephen Quinn
DESIGNER	Darryl Levering
ILLUSTRATOR	Darryl Levering
CLIENT	Columbus Zoo

Community Partnership
of Santa Clara County

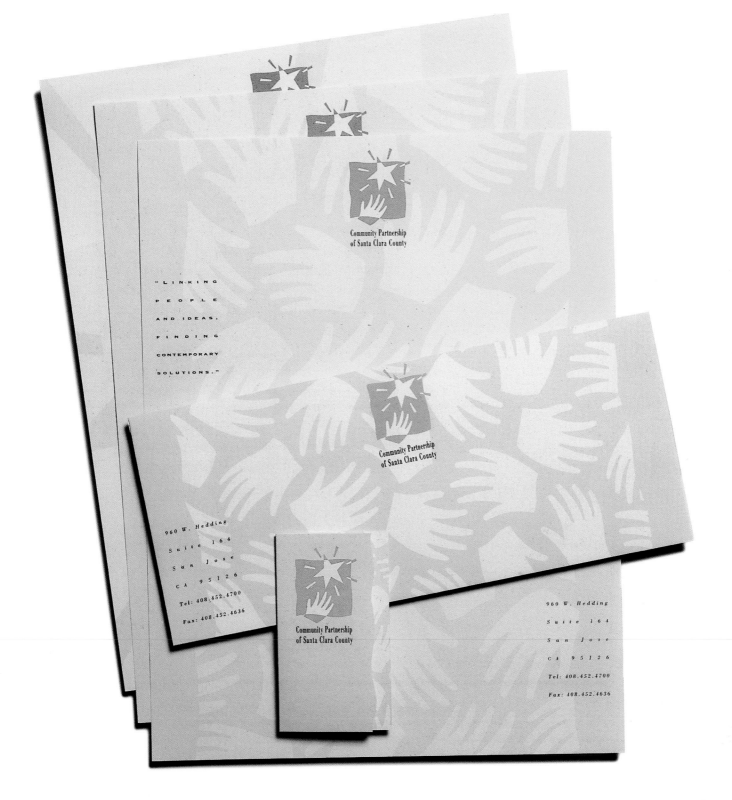

DESIGN FIRM Earl Gee Design
ART DIRECTOR Fani Chung
DESIGNER Fani Chung
ILLUSTRATOR Earl Gee, Fani Chung
CLIENT Community Partnership of Santa Clara County
PAPER/PRINTING Speckletone Cream text

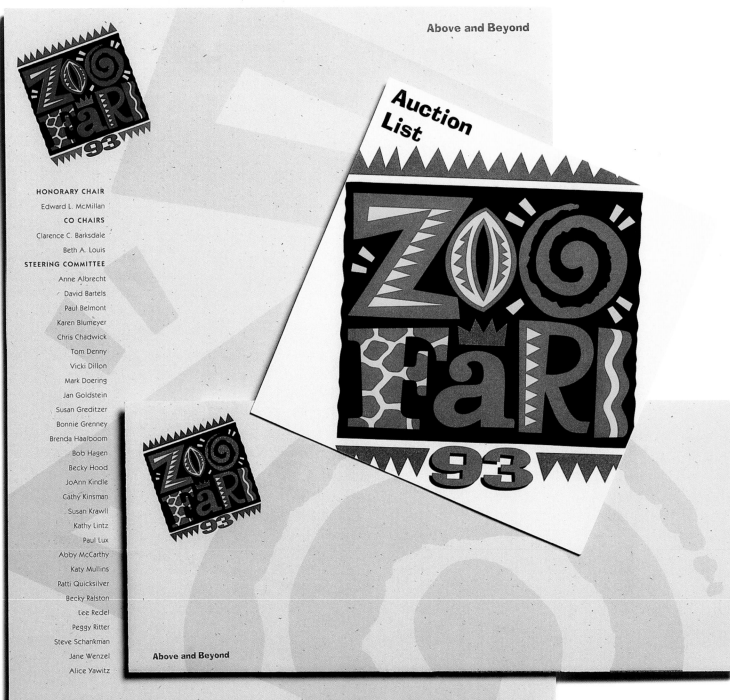

Above and Beyond

Auction List

HONORARY CHAIR
Edward L. McMillan
CO CHAIRS
Clarence C. Barksdale
Beth A. Louis
STEERING COMMITTEE
Anne Albrecht
David Bartels
Paul Belmont
Karen Blumeyer
Chris Chadwick
Tom Denny
Vicki Dillon
Mark Doering
Jan Goldstein
Susan Greditzer
Bonnie Grenney
Brenda Haalboom
Bob Hagen
Becky Hood
JoAnn Kindle
Cathy Kinsman
Susan Krawll
Kathy Lintz
Paul Lux
Abby McCarthy
Katy Mullins
Patti Quicksilver
Becky Ralston
Lee Redel
Peggy Ritter
Steve Schankman
Jane Wenzel
Alice Yawitz

Above and Beyond

SAINT LOUIS ZOO FRIENDS ASSOCIATION SAINT LOUIS ZOO FOREST PARK SAINT LOUIS MISSOURI 63110

DESIGN FIRM	Bartels & Company
ART DIRECTOR	David Bartels
DESIGNER	Brian Barclay
ILLUSTRATOR	Brian Barclay
CLIENT	St. Louis Zoo/Zoofari '93

Pittsburgh Public Theater
ASSOCIATION

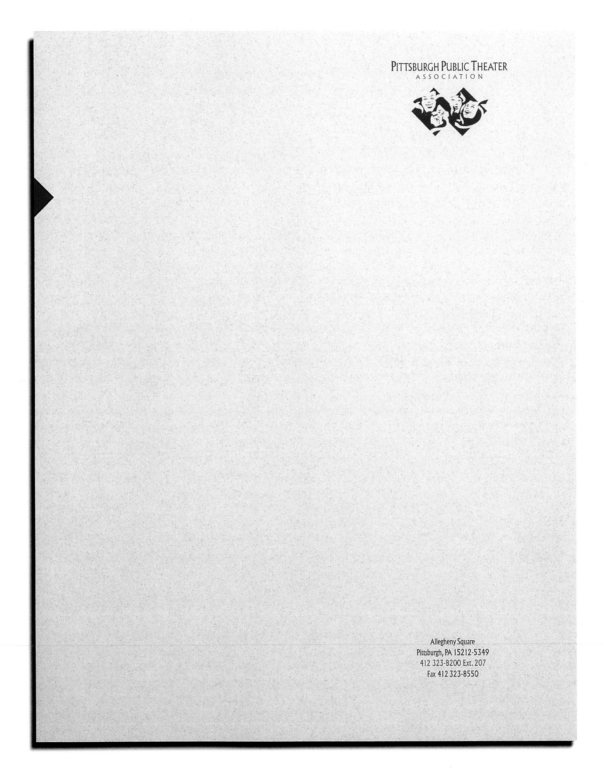

Allegheny Square
Pittsburgh, PA 15212-5349
412 323-8200 Ext. 207
Fax 412 323-8550

DESIGN FIRM	Adam, Filippo & Associates
ART DIRECTOR	Robert A. Adam
DESIGNER	Adam, Filippo & Associates
CLIENT	Pittsburgh Public Theater Association

Australian Institute of Spatial
Information Sciences and Technology

Panorama Avenue Bathurst
PO Box 143 Bathurst NSW Australia 2795
Telephone (61) 063 32 8250
Facsimile (61) 063 31 8095

Australian Institute of Spatial
Information Sciences and Technology

Panorama Avenue Bathurst
PO Box 143 Bathurst NSW Australia 2795
Telephone (063) 32 8200
Facsimile (063) 32 8366
Int. Prefix (61 - 63)

With Compliments

Australian Institute of Spatial
Information Sciences and Technology
Panorama Avenue Bathurst
PO Box 143 Bathurst NSW Australia 2795
Telephone (063) 32 8408
Private (063) 37 5310
Facsimile (063) 32 8366
Int. Prefix (61 - 63)

David L. Mills
Manager

DESIGN FIRM	Jenssen Design Pty. Limited
ART DIRECTOR	David Jenssen
DESIGNER	David Jenssen, Karen Lloyd Jones
ILLUSTRATOR	Karen Lloyd Jones
CLIENT	Australian Institute of Spatial Information Sciences and Technology
PAPER/PRINTING	Conqueror Laid White

DESIGN FIRM	Schowalter² Design
ART DIRECTOR	Toni Schowalter
DESIGNER	Toni Schowalter
CLIENT	Judy Freedman, Yoga Instructor

DESIGN FIRM	MacVicar Design & Communications
ART DIRECTOR	John Vance
DESIGNER	William A. Gordon
CLIENT	Association of Universities for Research in Astronomy, Inc.

DESIGN FIRM	Adam Filippo & Associates
ART DIRECTOR	Robert A. Adam, Ralph James Russini
DESIGNER	Sharon L. Bretz, Barbara Peak Long
CLIENT	Forbes Health System

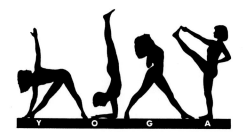

DESIGN FIRM	The Weller Institute for the Cure of Design, Inc.
ART DIRECTOR	Don Weller
DESIGNER	Don Weller
ILLUSTRATOR	Don Weller
CLIENT	Todd Ware Massage

DESIGN FIRM	Turner Design
ART DIRECTOR	Bert Turner
DESIGNER	Bert Turner
ILLUSTRATOR	Bert Turner
CLIENT	Jack King, D.D.S.

DESIGN FIRM	Riley Design Associates
ART DIRECTOR	Daniel Riley
DESIGNER	Daniel Riley
ILLUSTRATOR	Daniel Riley
CLIENT	Navarra Biomedical Services

DESIGN FIRM Luis Fitch Diseño
ART DIRECTOR Luis Fitch
DESIGNER Luis Fitch
CLIENT Ohio Heart
Association

DESIGN FIRM Design Art, Inc.
ART DIRECTOR Norman Moore
DESIGNER Norman Moore
CLIENT Humanitas Foundation

DESIGN FIRM Design Art, Inc.
ART DIRECTOR Norman Moore
DESIGNER Norman Moore
CLIENT Beverly Glen Play Group

DESIGN FIRM Sommese Design
ART DIRECTOR Kristin Sommese
DESIGNER Kristin Sommese
ILLUSTRATOR Kristin Sommese
CLIENT Penn State Panhellenic
Council, "Women's
Awareness Week"

DESIGN FIRM Eilts Anderson Tracy
ART DIRECTOR Patrice Eilts
DESIGNER Patrice Eilts
ILLUSTRATOR Patrice Eilts
CLIENT Lakemary Center

DESIGN FIRM Delmarva Power Corp.
Comm.
ART DIRECTOR Christy Macintyre
DESIGNER John Alfred
ILLUSTRATOR Wayne Parmenter
CLIENT Wilmington Library

DESIGN FIRM Ramona Hutko
Design
ART DIRECTOR Ramona Hutko
DESIGNER Ramona Hutko
CLIENT American Red Cross,
Rochester Chapter

DESIGN FIRM Richard Danne &
Associates Inc.
ART DIRECTOR Richard Danne
DESIGNER Gayle Shimoun,
Richard Danne
CLIENT American Academy
on Physician and
Patient

DESIGN FIRM The Great American
Logo Company
ART DIRECTOR Gregg Frederickson
DESIGNER Gregg Frederickson
CLIENT Ewing Institute of
Therapeutic Massage

DESIGN FIRM New Idea Design Inc.
DESIGNER Ron Boldt
ILLUSTRATOR Ron Boldt
CLIENT Midwest Children's
Chest Physicians

DESIGN FIRM Schowalter² Design
ART DIRECTOR Toni Schowalter
DESIGNER Ilene Price, Toni
Schowalter
ILLUSTRATOR Ilene Price, Toni
Schowalter
CLIENT Towers Perrin

DESIGN FIRM Frank D'Astolfo
Design
ART DIRECTOR Frank D'Astolfo
DESIGNER Frank D'Astolfo
CLIENT Visual and
Performing Arts,
Rutgers University,
New Jersey

FOOD/BEVERAGE

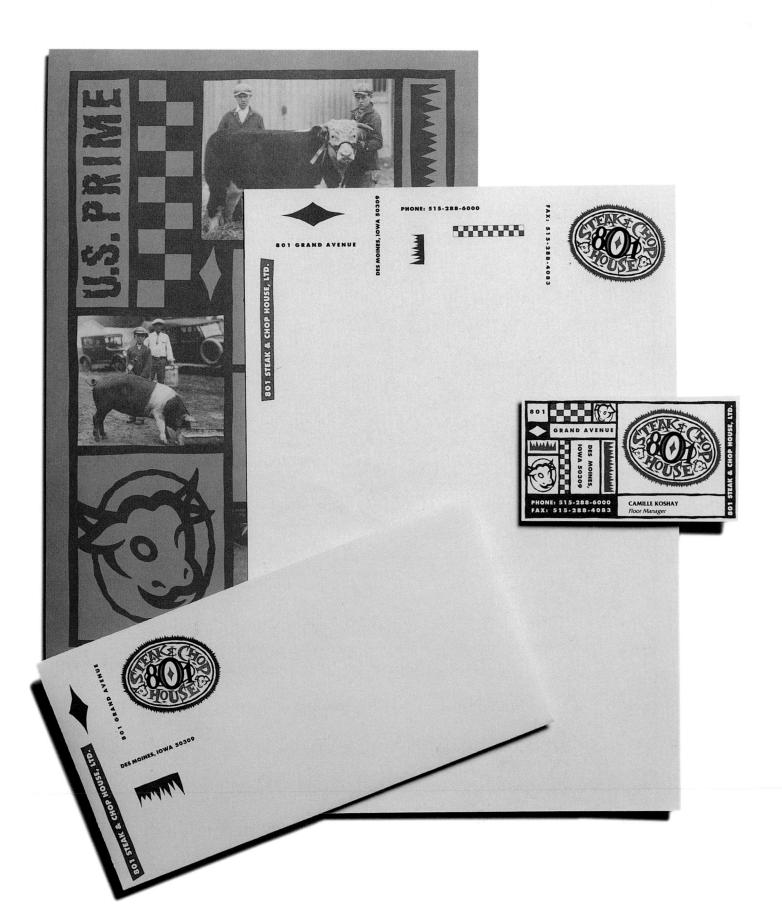

DESIGN FIRM Sayles Graphic Design
ART DIRECTOR John Sayles
DESIGNER John Sayles
ILLUSTRATOR John Sayles
CLIENT 801 Steak & Chop House
PAPER/PRINTING James River, Retreeve Tan, 2 colors

HAPPY VALLEY BREWERY, 2570 BOULEVARD OF THE GENERALS, BUILDING 100, SUITE 122, NORRISTOWN, PA 19403 (215) 630-8710, FAX 215-630-8134

DESIGN FIRM	Sommese Design
ART DIRECTOR	Lanny Sommese, Kristin Sommese
DESIGNER	Kristin Sommese
ILLUSTRATOR	Lanny Sommese
CLIENT	Happy Valley Brew
PAPER/PRINTING	Classic Linen

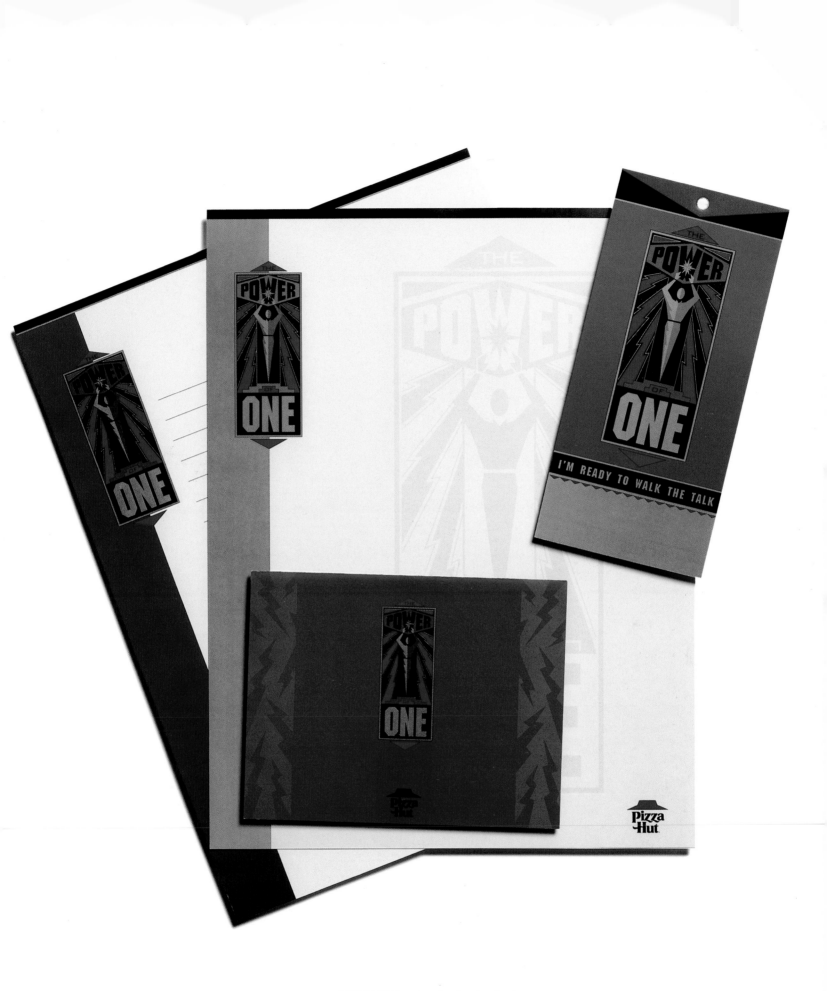

DESIGN FIRM Creative Services by Pizza Hut
ART DIRECTOR Lisa Voss, Lori Cox
DESIGNER Lisa Voss
ILLUSTRATOR Lisa Voss
CLIENT Pizza Hut
PAPER/PRINTING Mead offset enamel, metallic purple and gold

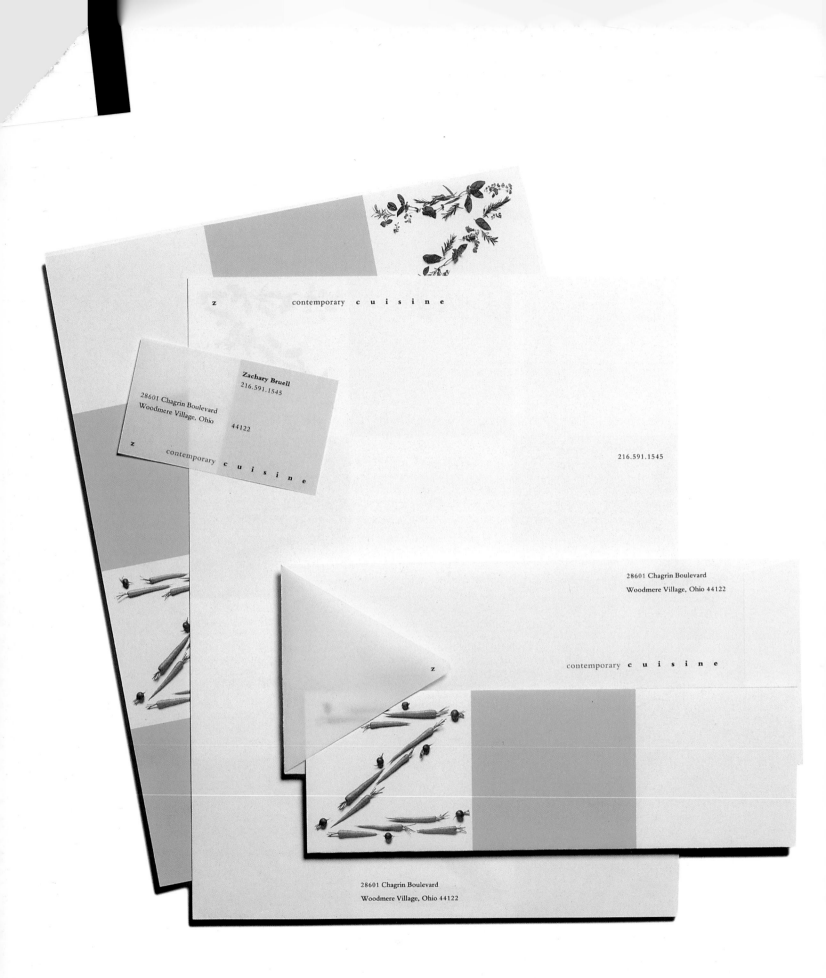

z contemporary *c u i s i n e*

Zachary Bruell
216.591.1545

28601 Chagrin Boulevard
Woodmere Village, Ohio

44122

z contemporary *c u i s i n e*

216.591.1545

28601 Chagrin Boulevard
Woodmere Village, Ohio 44122

contemporary *c u i s i n e*

z

28601 Chagrin Boulevard
Woodmere Village, Ohio 44122

DESIGN FIRM	Nesnadny & Schwartz
ART DIRECTOR	Joyce Nesnadny, Mark Schwartz
DESIGNER	Joyce Nesnadny
CLIENT	Z Contemporary Cuisine
PAPER/PRINTING	Crane's (letterhead), Neenah (envelope, 2/2)

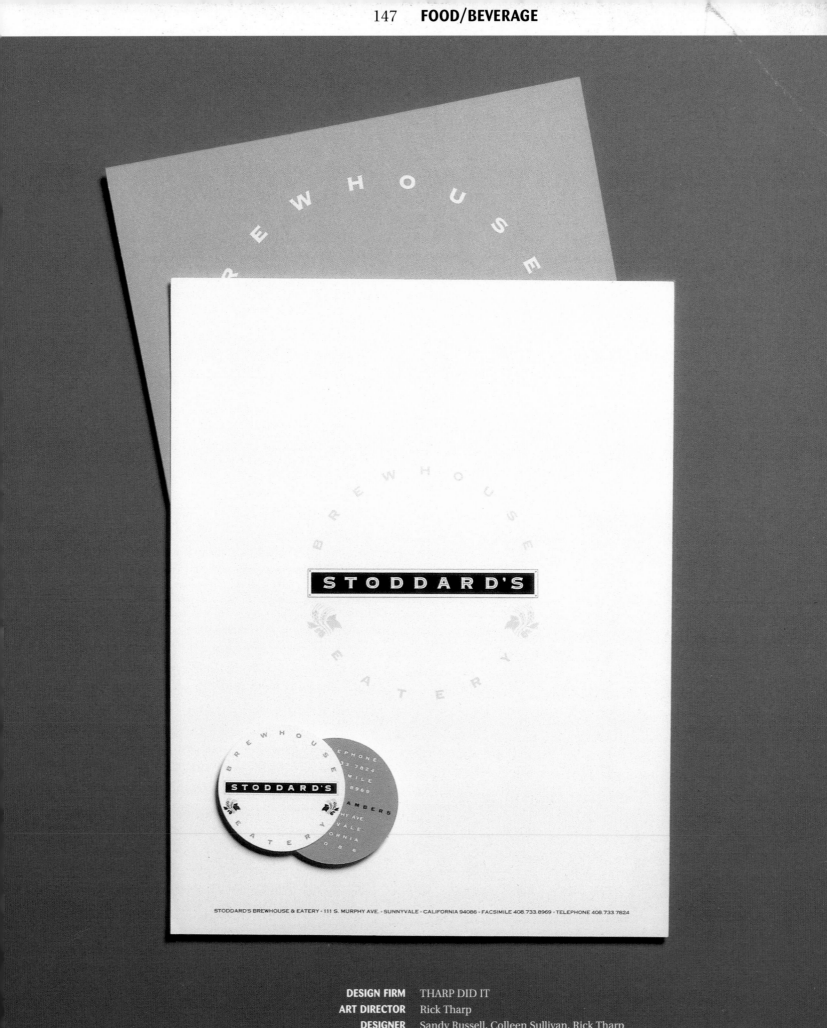

DESIGN FIRM	THARP DID IT
ART DIRECTOR	Rick Tharp
DESIGNER	Sandy Russell, Colleen Sullivan, Rick Tharp
CLIENT	Stoddard's Brewhouse & Eatery
PAPER/PRINTING	Simpson

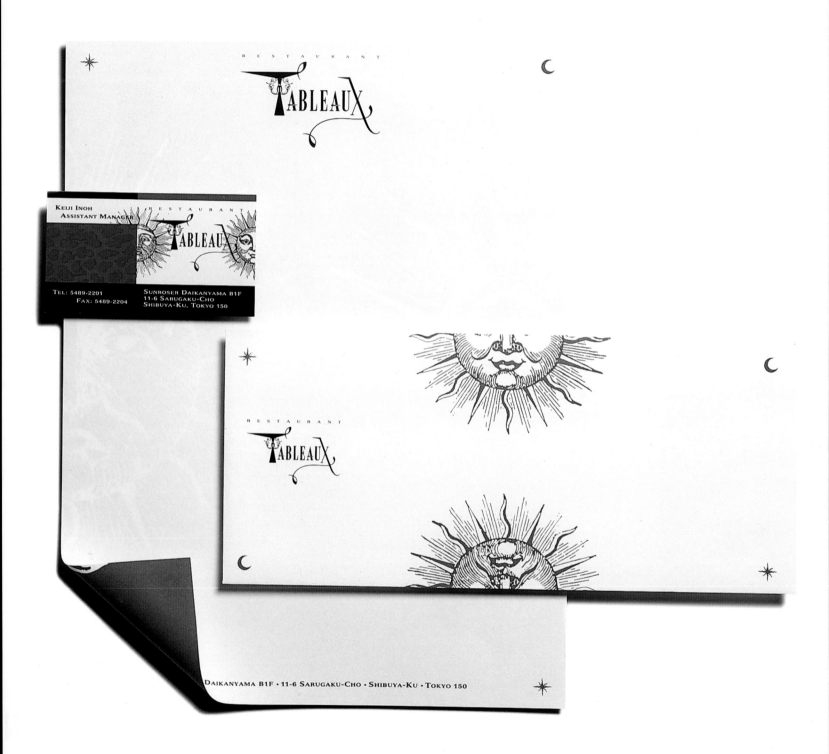

DESIGN FIRM	Vrontikis Design Office
ART DIRECTOR	Petrula Vrontikis
DESIGNER	Kim Sage
CLIENT	Tableaux
PAPER/PRINTING	Classic Crest Solar White

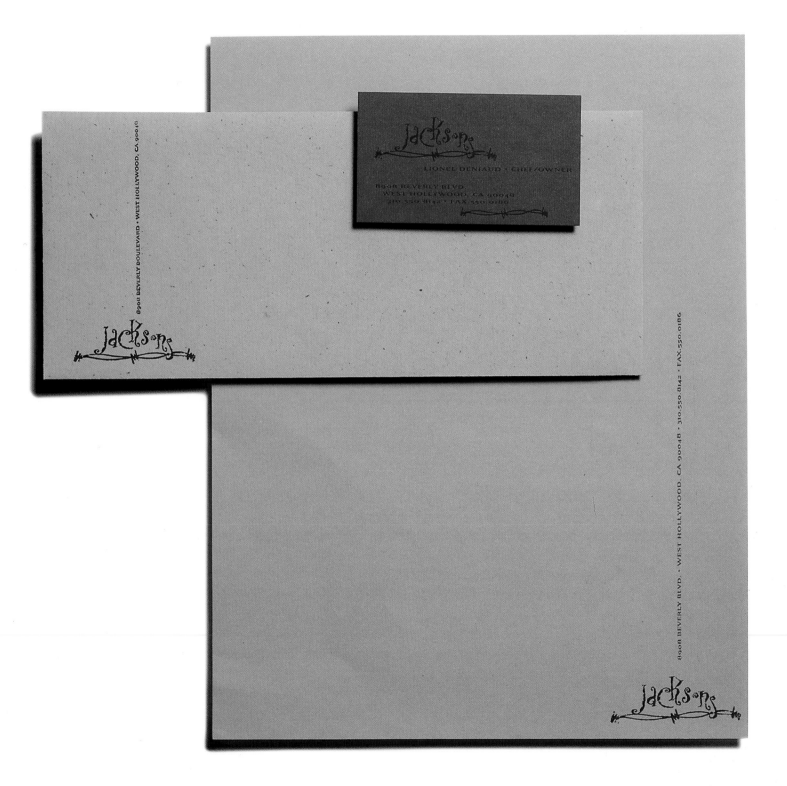

DESIGN FIRM	Vrontikis Design Office
ART DIRECTOR	Petrula Vrontikis
DESIGNER	Kim Sage
CLIENT	Jacksons
PAPER/PRINTING	French Durotone

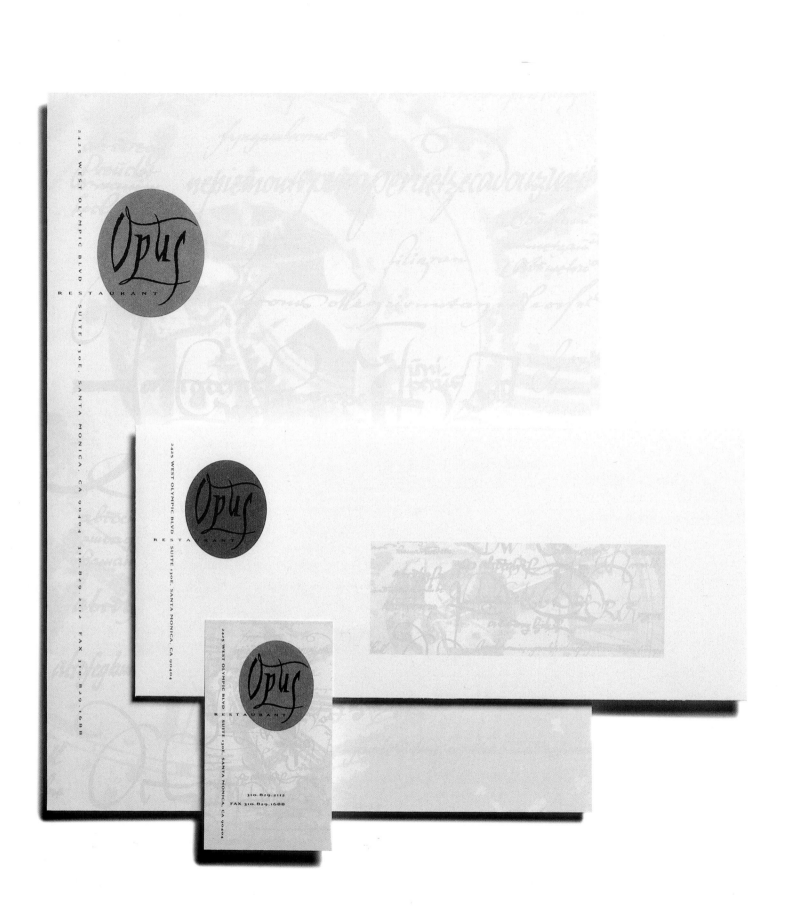

DESIGN FIRM Let Her Press
ART DIRECTOR Heather Van Haaften, Lorna Stovall
DESIGNER Lorna Stovall, Heather Van Haaften
CLIENT L'Orfe/Opus Restaurant
PAPER/PRINTING Starwhite Vicksberg

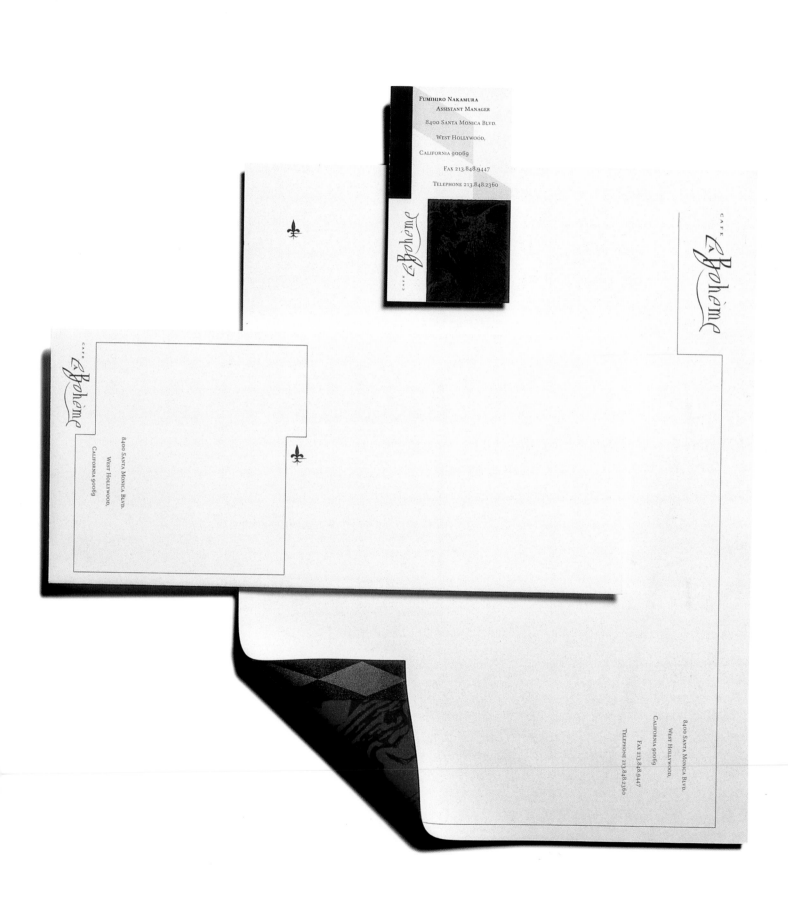

DESIGN FIRM Vrontikis Design Office
ART DIRECTOR Petrula Vrontikis
DESIGNER Kim Sage, Lorna Stovall
CLIENT Café La Boheme
PAPER/PRINTING Simpson Starwhite Vicksburg

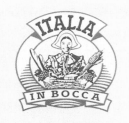

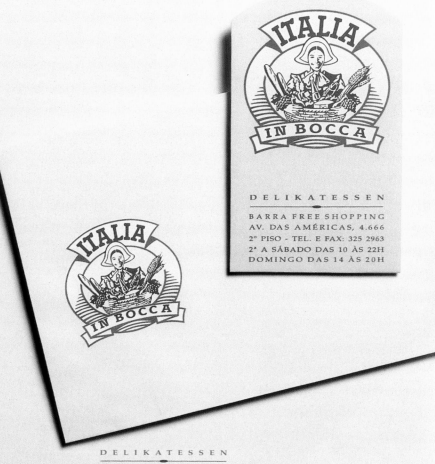

DESIGN FIRM Animus Comunicacaō
ART DIRECTOR Rique Nitzsche
DESIGNER Rique Nitzsche, Felicio Torres
ILLUSTRATOR Antonino Homobono
CLIENT Italia in Bocca
PAPER/PRINTING Alta Alvura (letterhead and envelope), Opaline (Business card)

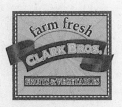

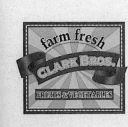

Office

5 Concourse Parkway

Suite 3100

Atlanta, Georgia

30328

Bryan V. Clark

Office
5 Concourse Parkway
Suite 3100
Atlanta, Georgia 30328
☎ (404) 804-5830

Farm
Route 6
Moultrie, Georgia 31768
☎ (912) 985-1444

Office

5 Concourse Parkway

Suite 3100

Atlanta, Georgia

30328

☎ (404) 804-5830

Farm

Route 6

Moultrie, Georgia

31768

☎ (912) 985-1444

DESIGN FIRM Coker Golley Ltd.
ART DIRECTOR Frank Golley, June Coker
DESIGNER Julia Mahood
CLIENT Clark Brothers

Joan Deccio Wickham
Food Stylist & Culinary Instructor

Joan Deccio Wickham
Food Stylist & Culinary Instructor

P.O. Box 442
Vashon, WA
98070
206-463-3647
Fax 206-463-9223

Joan Deccio Wickham
Food Stylist & Culinary Instructor
P.O. Box 442
Vashon, WA
98070

P.O. Box 442

Vashon, WA

98070

206-463-3647

Fax 206-463-9223

DESIGN FIRM	Walsh and Associates, Inc.
ART DIRECTOR	Miriam Lisco
DESIGNER	Katie Dolejsi
CLIENT	Joan Deccio Wickham
PAPER/PRINTING	Classic Crest Recycled

S T A R S
OAKVILLE
CAFE

STARS
OAKVILLE
CAFE

7848 St. Helena Highway 29
P.O. Box 410
Oakville, California 94562
RESERVATIONS 707-944-8905
FAX 707-944-0469

StarTeam, Ltd.
TEL 415-897-7560
FAX 415-897-8191

Stars Restaurant
TEL 415-861-7827
FAX 415-861-6706

S T A R S
OAKVILLE
CAFE

DESIGN FIRM Debra Nichols Design
ART DIRECTOR Debra Nichols
DESIGNER Debra Nichols, Roxanne Malek
CLIENT Stars Restaurant

NUTRITION 2000

NUTRITION 2000

STEVEN G. HASTINGS
Director of Marketing

136 Chesterfield
Industrial Blvd

Chesterfield
Missouri 63005

Tel: 314.537.9715
Fax: 314.537.0137

NUTRITION 2000

NUTRITION 2000

136 Chesterfield Industrial Blvd · Chesterfield, Missouri 63005 · Tel: 314.537.9715 Fax: 314.537.0137

DESIGN FIRM	Reliv, Inc.
ART DIRECTOR	Jay Smith
DESIGNER	Jay Smith
ILLUSTRATOR	Cindy Wrobel
CLIENT	Nutrition 2000
PAPER/PRINTING	Hopper Proterra, 3 PMS

DESIGN FIRM Stephen Divoky
ART DIRECTOR Stephen Divoky
DESIGNER Stephen Divoky
CLIENT Traditions Catering

DESIGN FIRM Schowalter[2] Design
ART DIRECTOR Toni Schowalter
DESIGNER Ilene Price, Toni Schowalter
ILLUSTRATOR Ilene Price, Toni Schowalter
CLIENT Anne Semmes
PAPER/PRINTING Strathmore Writing

P.O. Box 77209 Seattle, WA 98177-0209 Tel. 368-9257 FAX 368-9258

Anne Semmes

FOOD CONSULTANT

55 Cambridge Drive • Short Hills, New Jersey 07078 • 201.376.5595

The only way to pig out in style.

DESIGN FIRM Designs N Logos
ART DIRECTOR Douglas Martini
DESIGNER Douglas Martini
ILLUSTRATOR Douglas Martini
CLIENT Divine Swine
PAPER/PRINTING Classic Linen, White Enamel

DESIGN FIRM Image Group
ART DIRECTOR David Zavala
DESIGNER David Zavala
CLIENT Ricardo's Restaurant
PAPER/PRINTING Strathmore Renewal

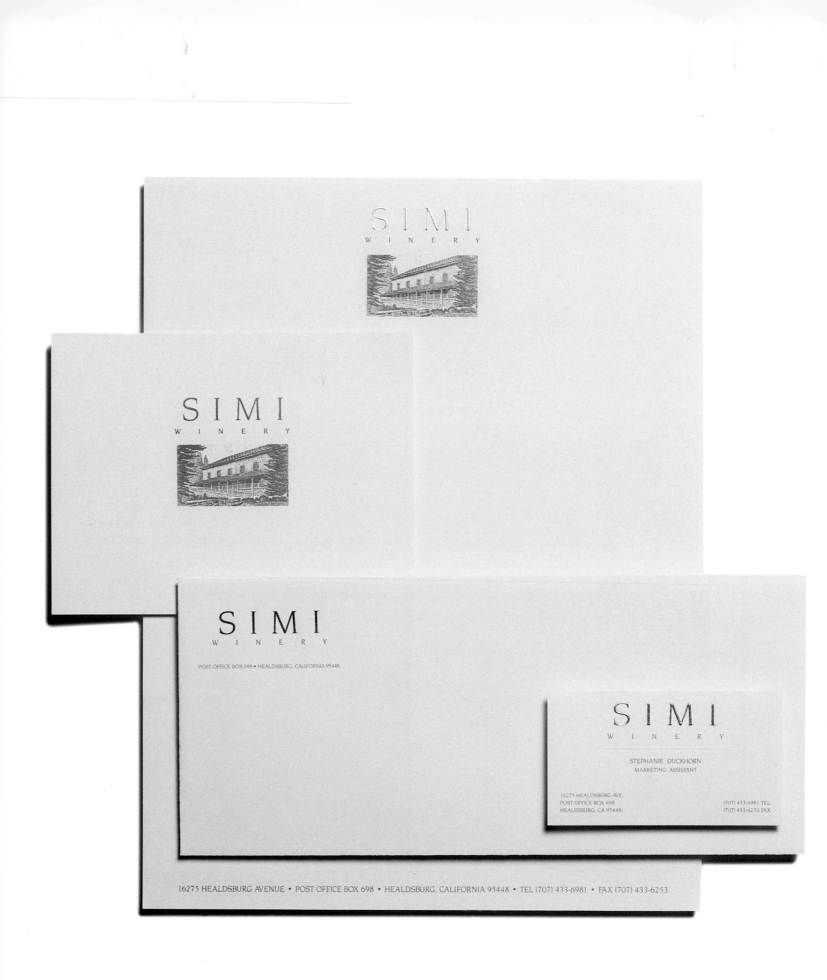

DESIGN FIRM Ortega Design Studio
ART DIRECTOR Susann Ortega, Joann Ortega
DESIGNER Susann Ortega
ILLUSTRATOR Robert Swartly
CLIENT Simi Winery
PAPER/PRINTING Enhance

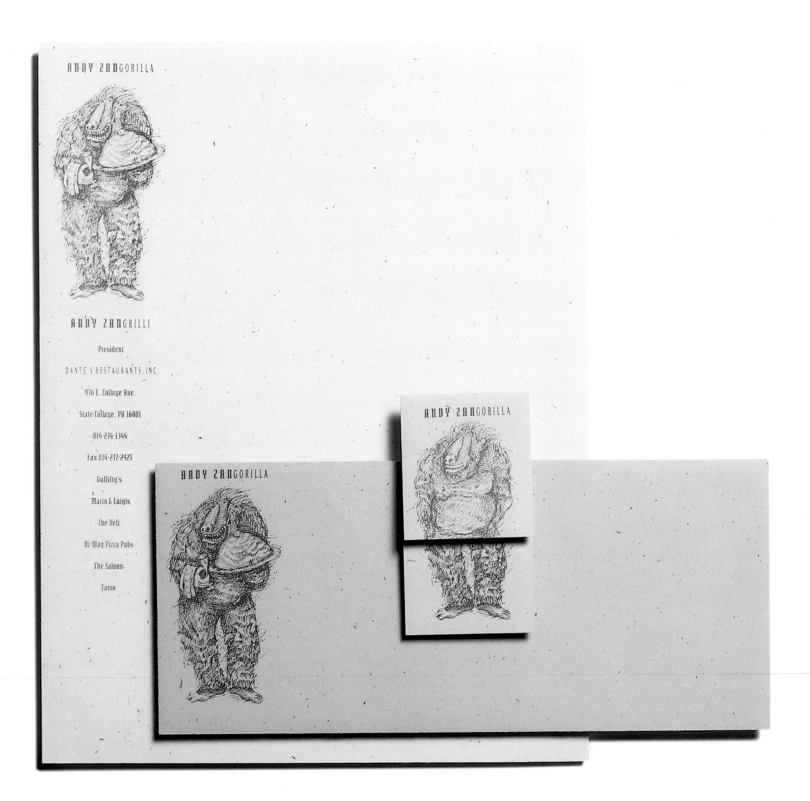

ANDY ZANGORILLA

ANDY ZANGRILLI

President

DANTE'S RESTAURANTS, INC.

936 E. College Ave.

State College, PA 16801

814-234-1344

Fax 814-237-2925

Gullifty's

Mario & Luigis

The Deli

Hi-Way Pizza Pubs

The Saloon

Taton

ANDY ZANGORILLA

ANDY ZANGORILLA

DESIGN FIRM Sommese Design
ART DIRECTOR Lanny Sommese, Kristin Sommese
DESIGNER Kristin Sommese
ILLUSTRATOR Lanny Sommese
CLIENT Dante's Restaurants Inc., Andy Zangrilli
PAPER/PRINTING Cross Pointe Genesis Script

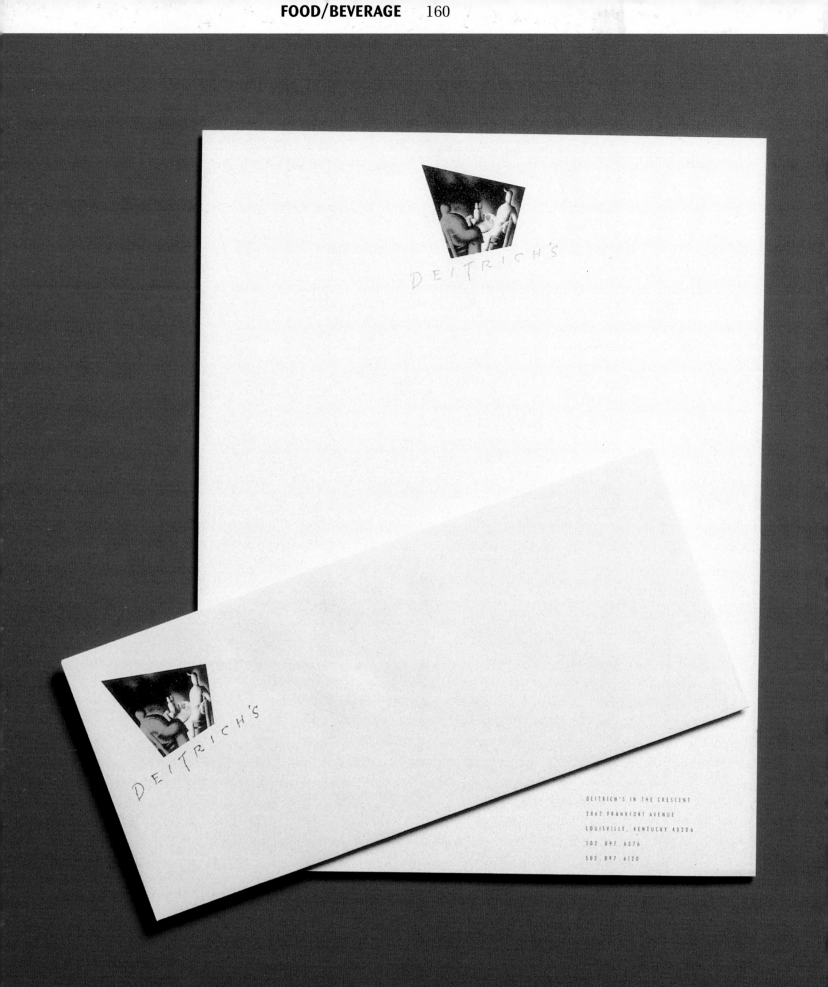

DESIGN FIRM	Choplogic
ART DIRECTOR	Walter McCord
DESIGNER	Walter McCord
ILLUSTRATOR	Bud Hixson
CLIENT	Deitrich's
PAPER/PRINTING	Curtis Flannel, 2 colors

DESIGN FIRM	Raven Madd Design
ART DIRECTOR	Mark Curtis
DESIGNER	Mark Curtis
ILLUSTRATOR	Mark Curtis
CLIENT	Villa Cuppachino Café

DESIGN FIRM	Mac By Night
ART DIRECTOR	Damion Hickman, Hector Garcia
DESIGNER	Damion Hickman
ILLUSTRATOR	Damion Hickman
CLIENT	Napa Valley Gourmet Salsa
PAPER/PRINTING	Deluxe Color

DESIGN FIRM	Creative Services by Pizza Hut
ART DIRECTOR	Lisa Voss, Lori Cox
DESIGNER	Lisa Voss
ILLUSTRATOR	Lisa Voss
CLIENT	Pizza Hut Kids Marketing
PAPER/PRINTING	Champion Carnival, 4 PMS

DESIGN FIRM	William Field Design
ART DIRECTOR	Fred Cisneros
DESIGNER	Fred Cisneros
ILLUSTRATOR	Fred Cisneros
CLIENT	Blue Corn Cafe
PAPER/PRINTING	Classic Crest

DESIGN FIRM	David Carter Design	**DESIGN FIRM**	Hornall Anderson	**DESIGN FIRM**	Segura Inc.
ART DIRECTOR	Gary Fobue		Design Works	**ART DIRECTOR**	Carlos Segura
DESIGNER	Gary Fobue	**ART DIRECTOR**	Jack Anderson	**DESIGNER**	Carlos Segura
ILLUSTRATOR	Linda Bleck	**DESIGNER**	Jack Anderson,	**ILLUSTRATOR**	Carlos Segura
CLIENT	Disney Land Hotel,		David Bates	**CLIENT**	FreeStyle (drink)
	Euro Disney, Paris	**ILLUSTRATOR**	David Bates,		
			George Tanagi		
		CLIENT	Capons Rotisserie		
			Chicken		

DESIGN FIRM	David Carter Design	**DESIGN FIRM**	Segura Inc.	**DESIGN FIRM**	David Carter Design
ART DIRECTOR	Sharon Lejune	**ART DIRECTOR**	Carlos Segura	**ART DIRECTOR**	David Brashier
DESIGNER	Sharon Lejune	**DESIGNER**	Carlos Segura	**DESIGNER**	David Brashier
ILLUSTRATOR	Sharon Lejune	**ILLUSTRATOR**	Carlos Segura	**ILLUSTRATOR**	David Brashier
CLIENT	Euro Disney,	**CLIENT**	Bud Dry	**CLIENT**	Sequoia Lodge,
	New York,				Euro Disney, Paris
	Euro Disney, Paris				

DESIGN FIRM David Carter Design
ART DIRECTOR Gary Fobue,
Lori Wilson
DESIGNER Gary Fobue,
Lori Wilson
ILLUSTRATOR Gary Fobue,
Lori Wilson
CLIENT Amapola Resturant,
Hotel Principe Felipe

DESIGN FIRM THARP DID IT
DESIGNER Rick Tharp
ILLUSTRATOR Jana Heer,
Rick Tharp
CLIENT The Occidental Grille
PAPER/PRINTING Simpson Paper,
Stormm
Graphicworks

DESIGN FIRM Palmquist & Palmquist
Design
ART DIRECTOR Kurt & Denise Palmquist
DESIGNER Kurt & Denise Palmquist
CLIENT The Bistro

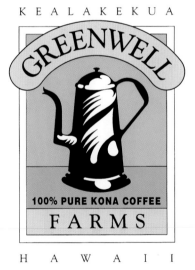

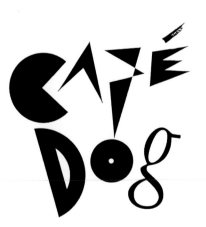

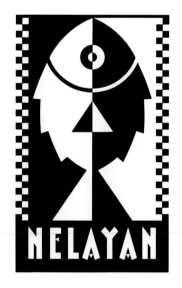

DESIGN FIRM The Weller Institute
for the Cure of
Design, Inc.
ART DIRECTOR Don Weller
DESIGNER Don Weller
ILLUSTRATOR Don Weller
CLIENT Greenwell Farms

DESIGN FIRM Choplogic
ART DIRECTOR Walter McCord,
Mary Cawein
DESIGNER Walter McCord,
Mary Cawein
ILUSTRATOR Walter McCord,
Mary Cawein
CLIENT Café Dog

DESIGN FIRM David Carter Design
ART DIRECTOR Kevin Prejean
DESIGNER Kevin Prejean
ILLUSTRATOR Kevin Prejean
CLIENT Grand Hyatt, Bali

DESIGN FIRM Eilts Anderson Tracy
ART DIRECTOR Patrice Eilts
DESIGNER Patrice Eilts,
Rich Kobs
ILLUSTRATOR Rich Kobs
CLIENT PBU Restaurants/
Grand St. Cafe

DESIGN FIRM W Designs
ART DIRECTOR Corinne West
DESIGNER Corinne West
CLIENT Carretto Cafes Inc.

DESIGN FIRM Sommese Design
ART DIRECTOR Lanny Sommese
DESIGNER Lanny Sommese
CLIENT Aquapenn Spring
Water Co.

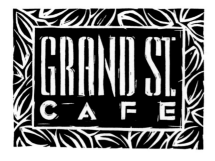

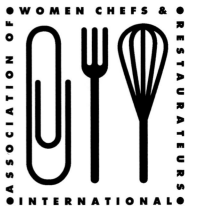

DESIGN FIRM David Carter Design
ART DIRECTOR Randall Hill
DESIGNER Randall Hill
ILLUSTRATOR Randall Hill
CLIENT Grand Hyatt, Taipei

DESIGN FIRM David Carter Design
ART DIRECTOR Randall Hill,
Brian Moss
DESIGNER Randall Hill,
Brian Moss
ILLUSTRATOR Randall Hill,
Brian Moss
CLIENT Sun International

DESIGN FIRM Schowalter² Design
ART DIRECTOR Toni Schowalter
DESIGNER Ilene Price,
Toni Schowalter
ILLUSTRATOR Ilene Price,
Toni Schowalter
CLIENT WCRIA

DESIGN FIRM David Carter Design
ART DIRECTOR David Brashier
DESIGNER David Brashier
CLIENT Disney Orlando,
Florida

DESIGN FIRM Luis Fitch Diseño
ART DIRECTOR Luis Fitch
DESIGNER Luis Fitch
CLIENT Picante Restaurant

DESIGN FIRM David Carter Design
ART DIRECTOR Sharon Lejeune
DESIGNER Sharon Lejeune
ILLUSTRATOR Pat Foss
CLIENT Hyatt Regency, Osaka

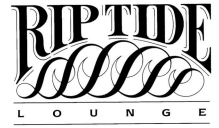

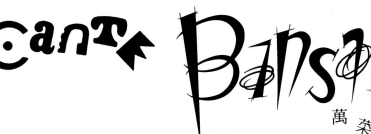

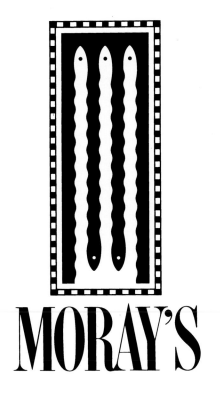

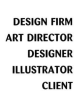

DESIGN FIRM David Carter Design
ART DIRECTOR Gary Lobue
DESIGNER Gary Lobue
ILLUSTRATOR Gary Lobue
CLIENT Moray's Restaurant

DESIGN FIRM David Carter Design
ART DIRECTOR Randall Hill
DESIGNER Randall Hill
ILLUSTRATOR Randall Hill
CLIENT Grand Hyatt, Bali

DESIGN FIRM Sommese Design
ART DIRECTOR Lanny Sommese
DESIGNER Lanny Sommese
ILLUSTRATOR Lanny Sommese
CLIENT Dante's Restaurants Inc.
This is the logo for the
children's menu.

Kids

Salads

Beverages

Lunch

Wine & Beer

Desserts

DESIGN FIRM Creative Services by Pizza Hut
ART DIRECTOR Lisa Voss, Lori Cox
DESIGNER Lisa Voss
ILLUSTRATOR Lisa Voss
CLIENT Pizza Hut Café

REAL ESTATE/ PROPERTIES

SERVICE
TOTAL LAWN CARE

CLIPP

Better Homes
& Restoration

ALASKA'S WILDERNESS LODGE

AMERICAN EQUITY PROPERTIES, INC.
555 REPUBLIC DRIVE, SUITE 219, PLANO, TEXAS 75074
TEL 214-233-5400 FAX 214-423-6517

AMERICAN EQUITY

OHIO
ASSOCIATION
OF REALTORS

LA·BOY

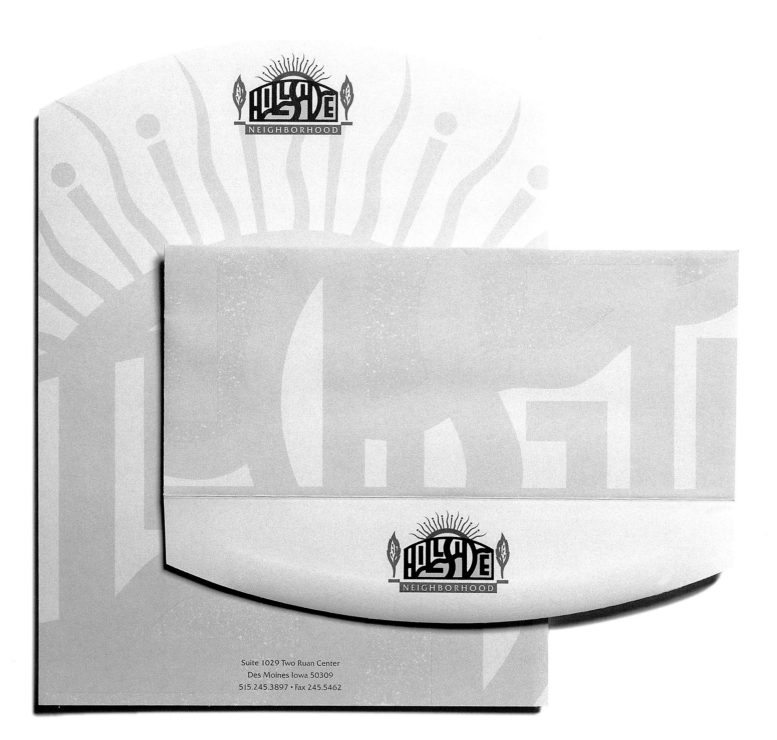

Suite 1029 Two Ruan Center
Des Moines Iowa 50309
515.245.3897 • Fax 245.5462

DESIGN FIRM	Sayles Graphic Design
ART DIRECTOR	John Sayles
DESIGNER	John Sayles
ILLUSTRATOR	John Sayles
CLIENT	Hillside Neighborhood
PAPER/PRINTING	James River, Vellum Gray, 2 colors

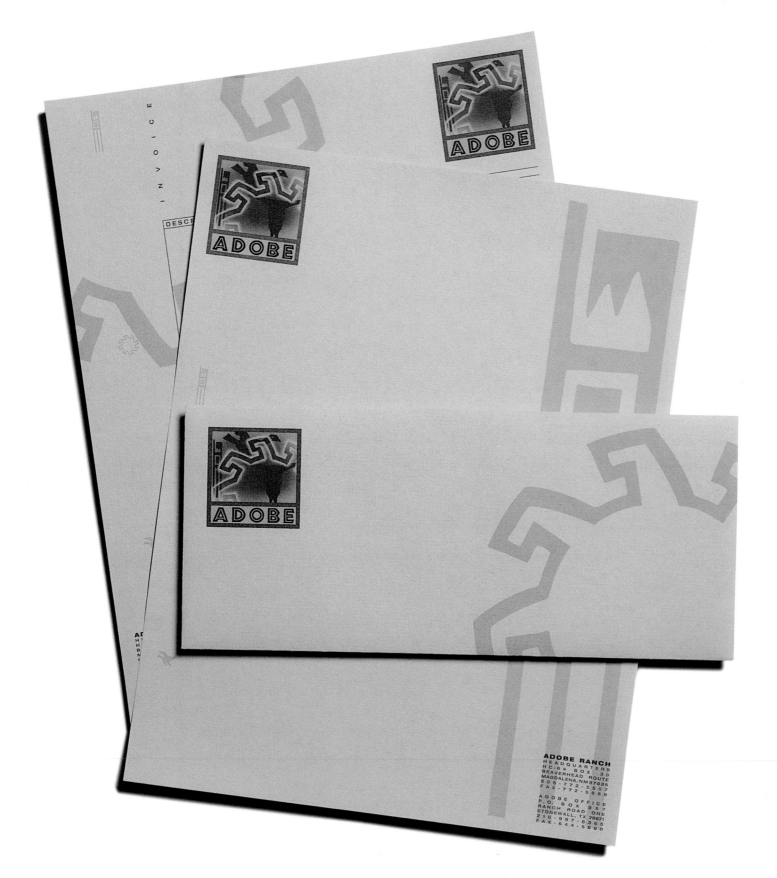

DESIGN FIRM	Romeo Empire Design
ART DIRECTOR	Vincent Romeo
DESIGNER	Vincent Romeo
ILLUSTRATOR	Vincent Romeo
CLIENT	Adobe Ranch, New Mexico
PAPER/PRINTING	Curtis Flannel

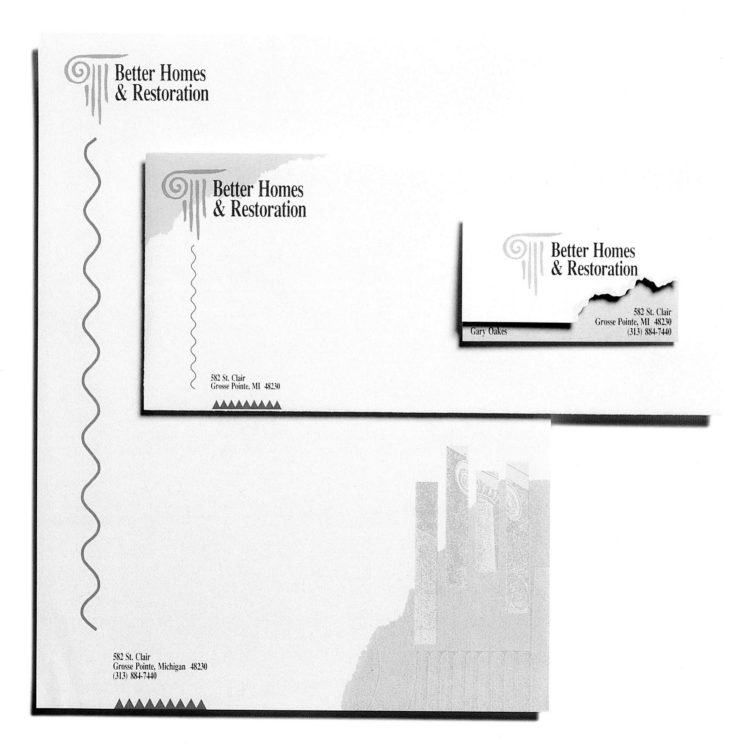

DESIGN FIRM Ridenour Advertising

ART DIRECTOR Kerry B. Ridenour

DESIGNER Kerry B. Ridenour

ILLUSTRATOR Kerry B. Ridenour

CLIENT Better Homes & Restoration

PAPER/PRINTING Passport, 4 colors

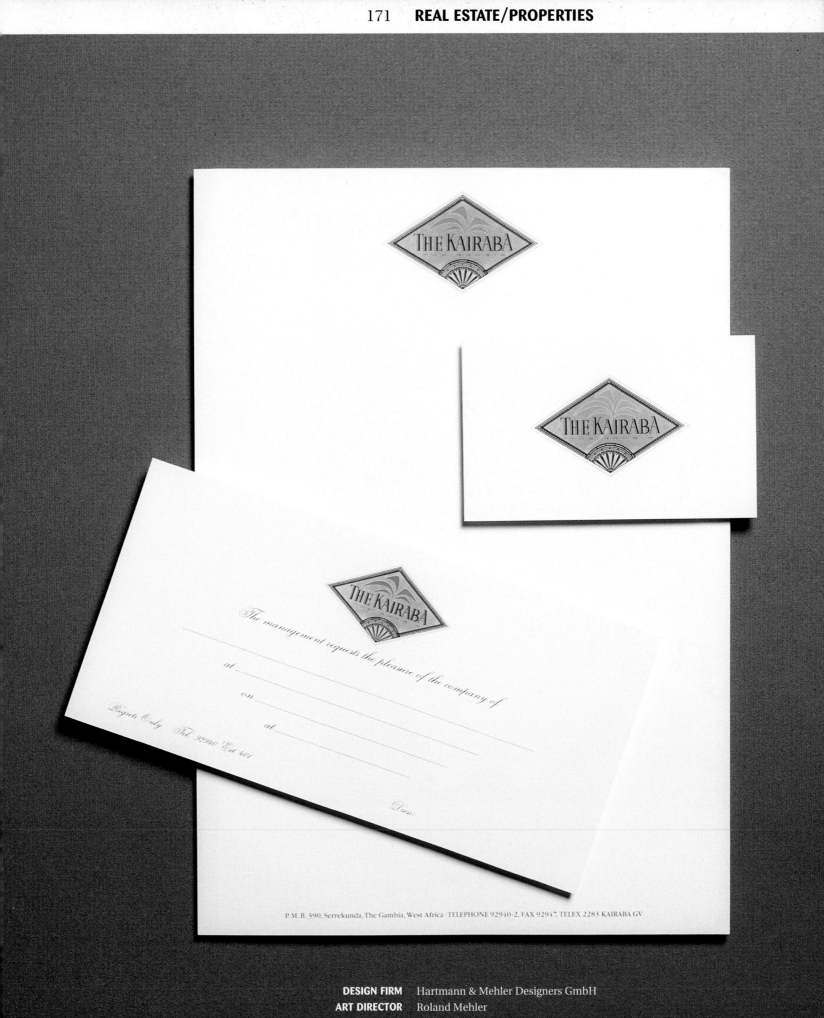

DESIGN FIRM	Hartmann & Mehler Designers GmbH
ART DIRECTOR	Roland Mehler
DESIGNER	Roland Mehler
ILLUSTRATOR	Roland Mehler
CLIENT	Steigenberger Consulting
PAPER/PRINTING	Enhance

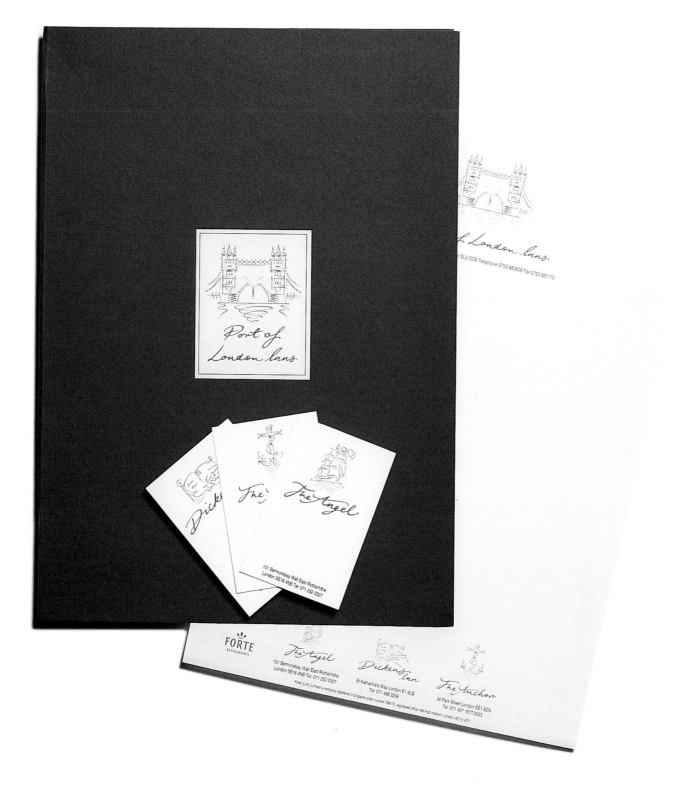

DESIGN FIRM	Hartmann & Mehler Designers GmbH
ART DIRECTOR	Roland Mehler
DESIGNER	Roland Mehler
ILLUSTRATOR	Roland Mehler
CLIENT	Steigenberger Consulting
PAPER/PRINTING	Enhance

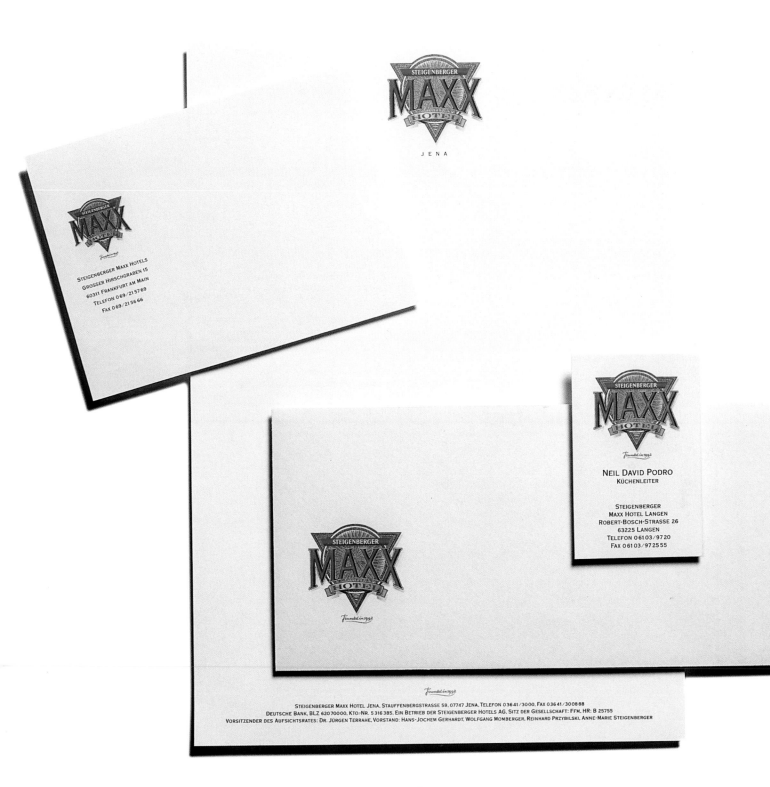

DESIGN FIRM Hartmann & Mehler Designers GmbH
ART DIRECTOR Roland Mehler
DESIGNER Roland Mehler
ILLUSTRATOR Roland Mehler
CLIENT Steigenberger Maxx Hotels
PAPER/PRINTING Croxley Heritage

DESIGN FIRM Signum
ART DIRECTOR Gregg Snyder
CLIENT Snyder Appraisals & Analysis
PAPER/PRINTING Gilbert Environment

DESIGN FIRM William Field Design
ART DIRECTOR William Field
DESIGNER William Field
CLIENT Melanie Peters Real Estate

DESIGN FIRM Debra Nichols Design
ART DIRECTOR Debra Nichols
DESIGNER Debra Nichols, Kelan Smith
CLIENT Stein Kingsley Stein

DESIGN FIRM Design/Joe Sonderman, Inc.
ART DIRECTOR Tim Gilland
DESIGNER Tim Gilland
CLIENT City of Rock Hill, South Carolina
PAPER/PRINTING Strathmore Writing, 7 colors

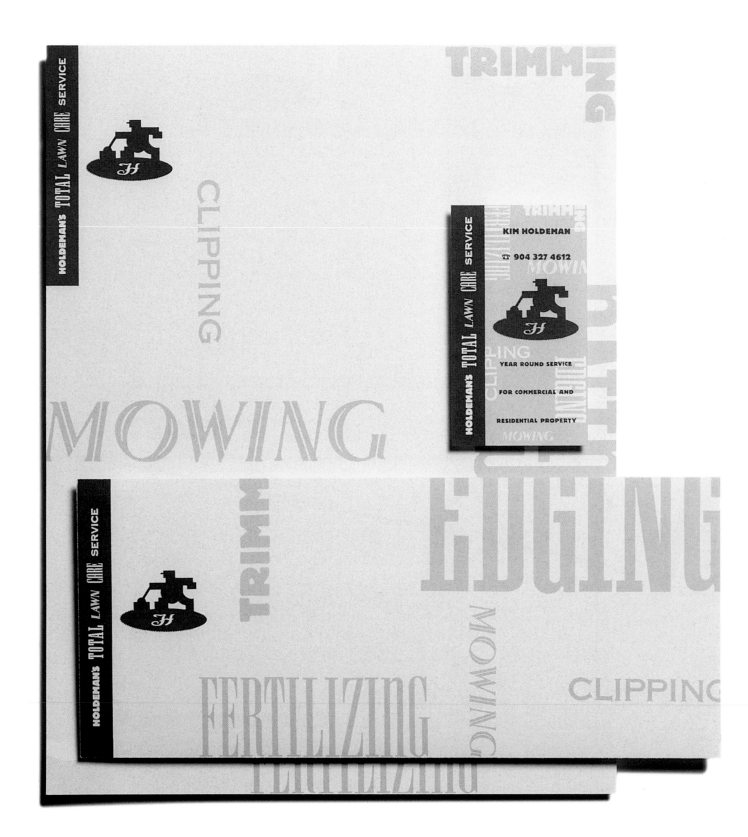

DESIGN FIRM Love Packaging Group
ART DIRECTOR Tracy Holdeman
DESIGNER Tracy Holdeman
ILLUSTRATOR Tracy Holdeman
CLIENT Holdeman's Total Lawn Care Service

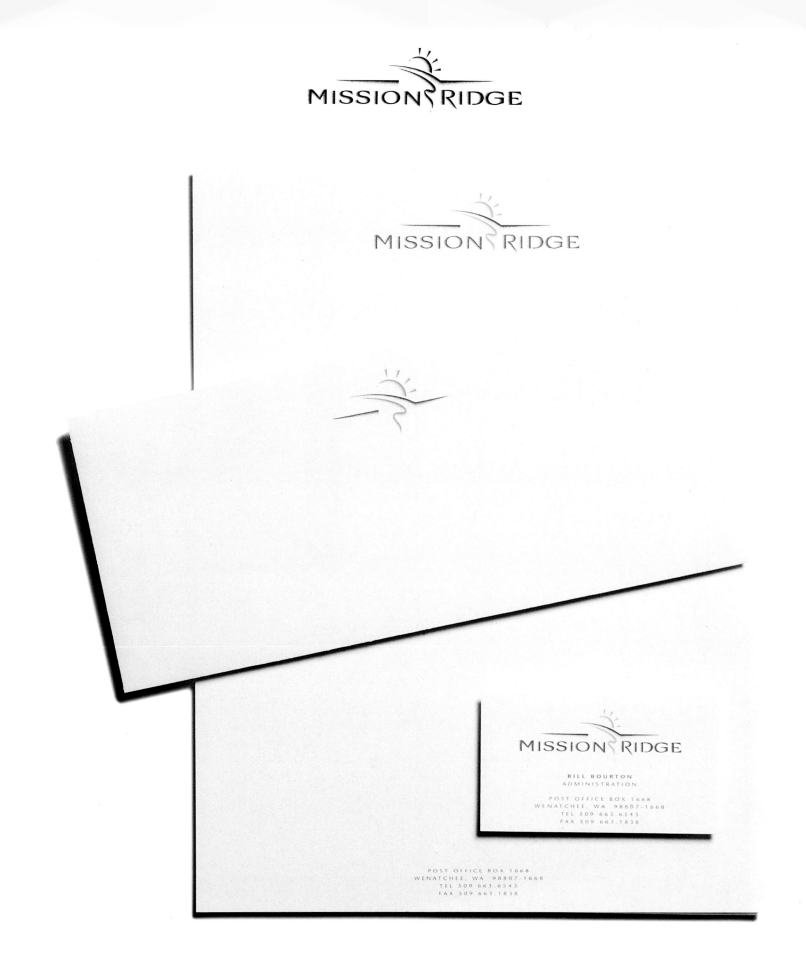

DESIGN FIRM Hornall Anderson Design Works

ART DIRECTOR Jack Anderson

DESIGNER Jack Anderson, Cliff Chung, David Bates, Leo Raymundo,
Denise Weir

CLIENT Mission Ridge

PAPER/PRINTING Simpson Environment

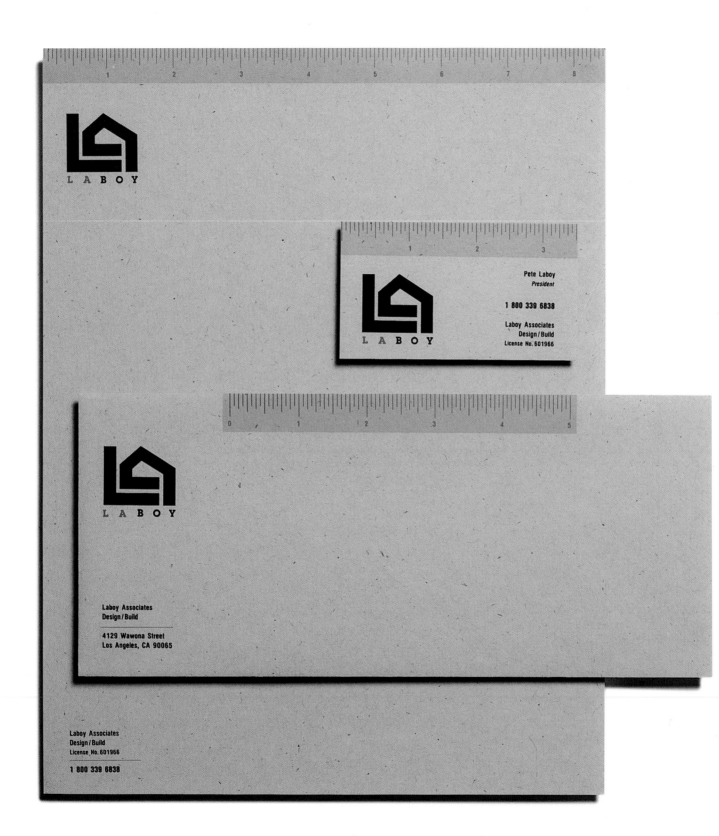

DESIGN FIRM Adele Bass & Co. Design
ART DIRECTOR Adele Bass
DESIGNER Adele Bass
ILLUSTRATOR Adele Bass
CLIENT Laboy & Associates
PAPER/PRINTING Kraft Speckletone, 3 colors

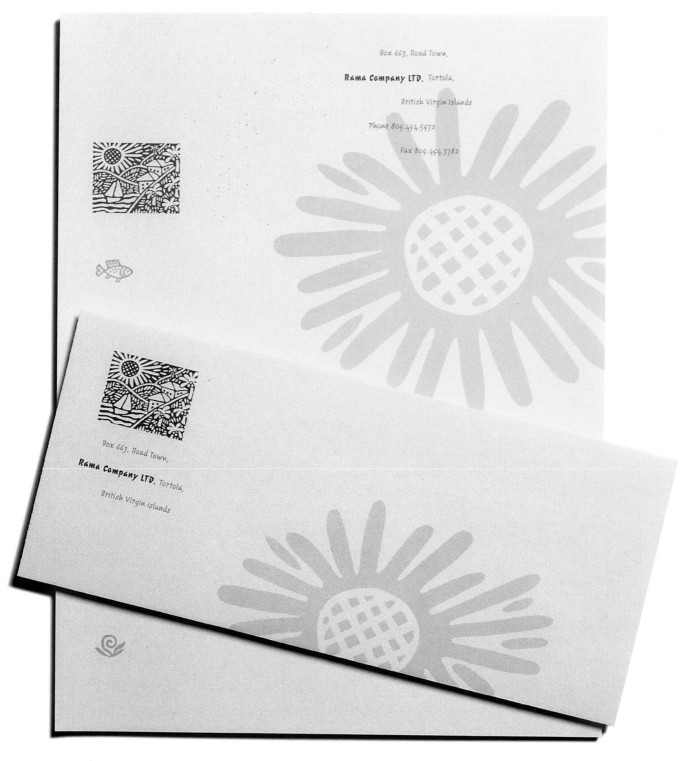

DESIGN FIRM Schowalter² Design
ART DIRECTOR Toni Schowalter
DESIGNER Toni Schowalter
ILLUSTRATOR Toni Schowalter
CLIENT Rama Villas, Ltd.

DESIGN FIRM	Jenssen Design Pty. Limited
ART DIRECTOR	David Jenssen
DESIGNER	David Jenssen, Karen Lloyd-Jones
ILLUSTRATOR	Karen Lloyd-Jones
CLIENT	Homebush Bay Corporation
PAPER/PRINTING	Mohawk Poseidon High Finish

DESIGN FIRM	Michael Stanard, Inc.
ART DIRECTOR	Michael Stanard, Lisa Fingerhut
DESIGNER	Lisa Fingerhut, Julie Gleason
CLIENT	Hal Stanard Realtor

Homebush Bay Corporation

Level 17, Westfield Tower
100 William Street
East Sydney NSW 2011
Telephone: (02) 354 1000
Facsimile: (02) 357 2902

A NSW State Government Project managed by Property Services Group

Hal Stanard Realtor
6640 34th Avenue North
St. Petersburg, Florida 33710
Phone 813.345.8640

HOTEL AUF DER WARTBURG

HOTEL AUF DER WARTBURG · 99817 EISENACH, WARTBURG · TELEFON 0 36 91/51 11 · TELEFAX 0 36 91/51 11
WIRTSCHAFTSBETRIEBE WARTBURG GMBH · BANKVERBINDUNG: DEUTSCHE BANK AG, BLZ 820 700 00, KONTO 2 460 019

CUSTOM PROPERTIES OF SANTA FE
a general contracting firm

1494 St. Francis Drive
Santa Fe, New Mexico 87501
505-982-8824 • 505-470-0586
FAX: 505-989-3669
License #031241

DESIGN FIRM	Hartmann & Mehler Designers GmbH
ART DIRECTOR	Roland Mehler
DESIGNER	Roland Mehler, Hans Bell
ILLUSTRATOR	Hans Bell
CLIENT	Hotel auf der Wartburg
PAPER/PRINTING	Croxley Heritage

DESIGN FIRM	William Field Design
ART DIRECTOR	Fred Cisneros
DESIGNER	Fred Cisneros
ILLUSTRATOR	Fred Cisneros
CLIENT	Custom Properties of Sante Fe
PAPER/PRINTING	Genesis

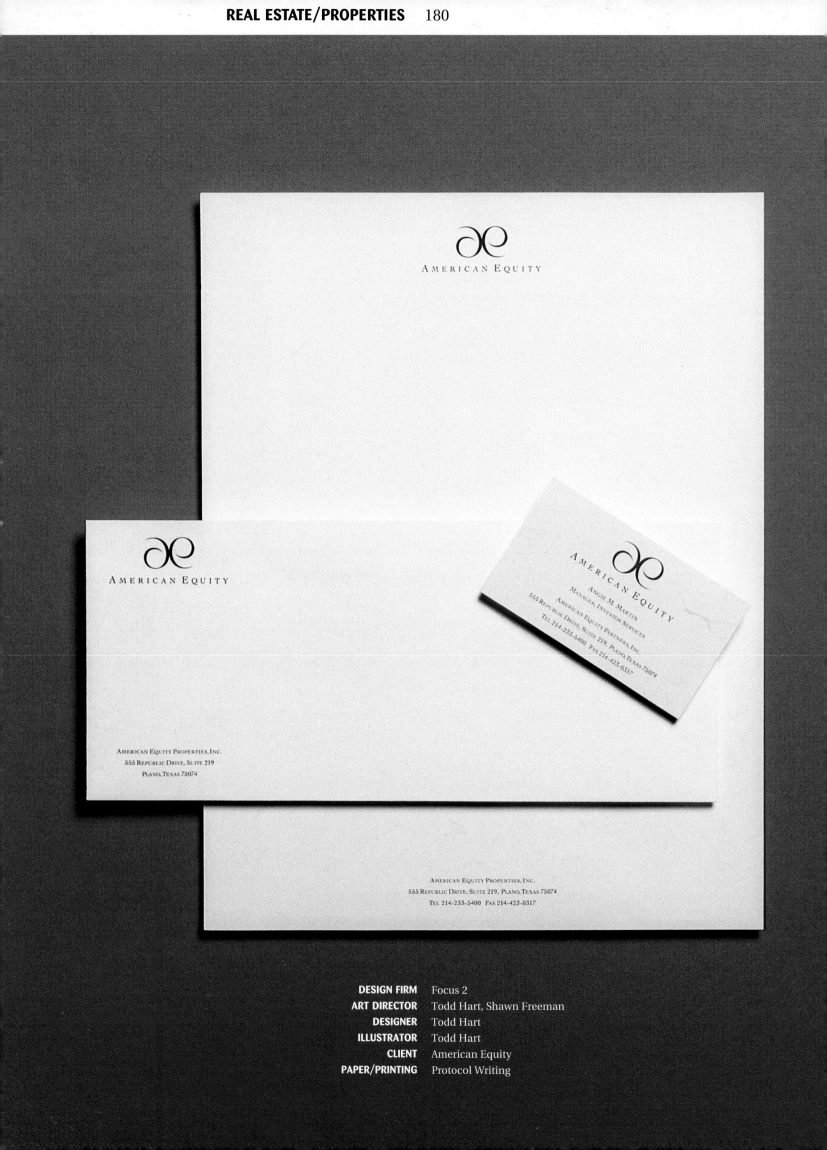

DESIGN FIRM Focus 2
ART DIRECTOR Todd Hart, Shawn Freeman
DESIGNER Todd Hart
ILLUSTRATOR Todd Hart
CLIENT American Equity
PAPER/PRINTING Protocol Writing

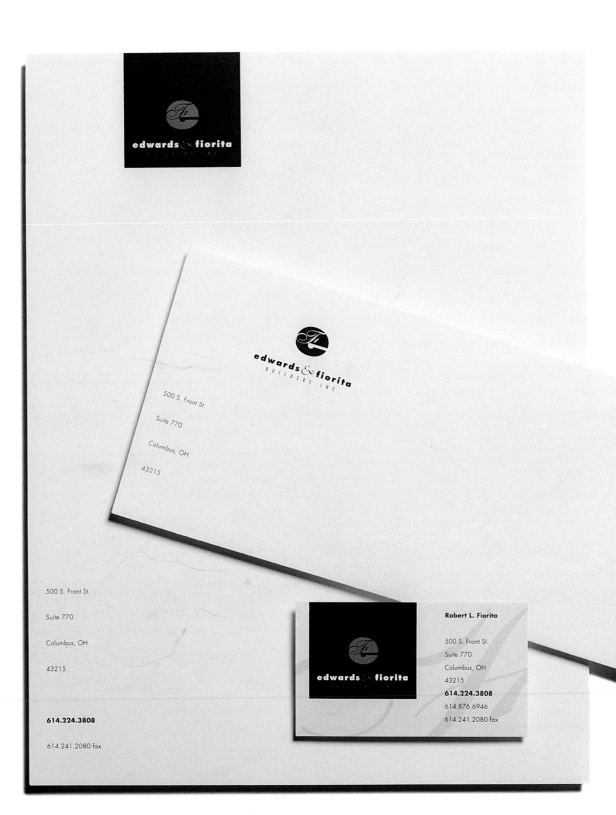

DESIGN FIRM Integrate Inc.
ART DIRECTOR Stephen E. Quinn
DESIGNER Darryl Levering
CLIENT Edwards & Fiorita Builders

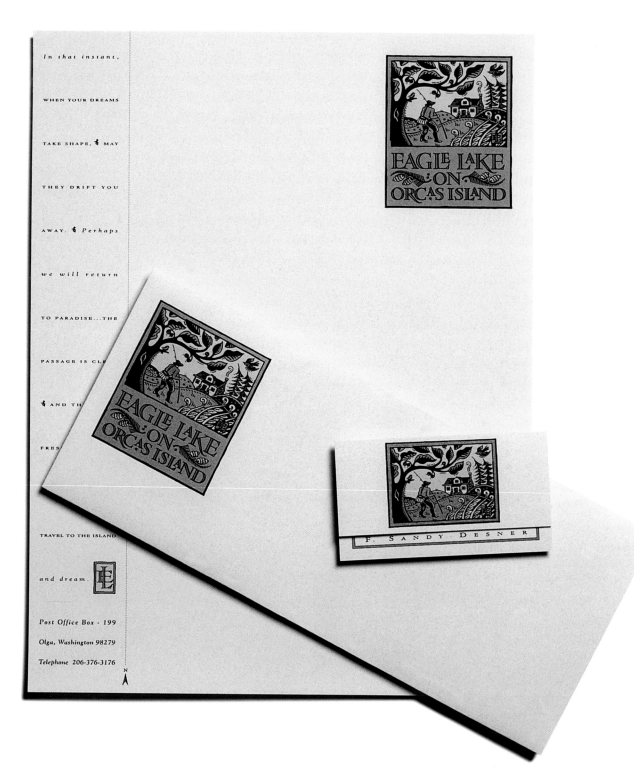

DESIGN FIRM	Hornall Anderson Design Works
ART DIRECTOR	Julia LaPine
DESIGNER	Julia LaPine, Denise Weir
ILLUSTRATOR	Julia LaPine
CLIENT	Eagle Lake on Orcas Island
PAPER/PRINTING	Simpson Environment Recycled

OHIO
ASSOCIATION
OF REALTORS®

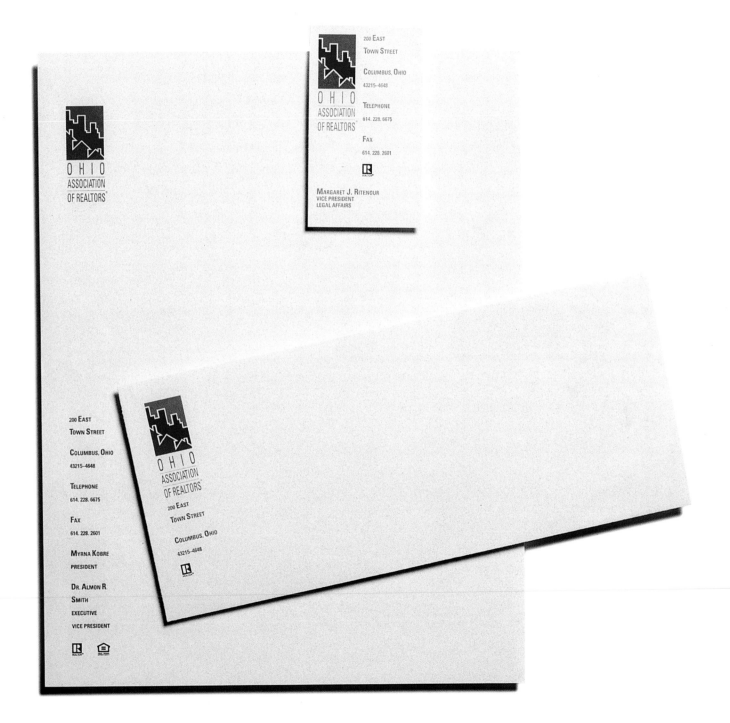

DESIGN FIRM Rickabaugh Graphics
ART DIRECTOR Eric Rickabaugh
DESIGNER Mark Krumel
CLIENT Ohio Association of Realtors

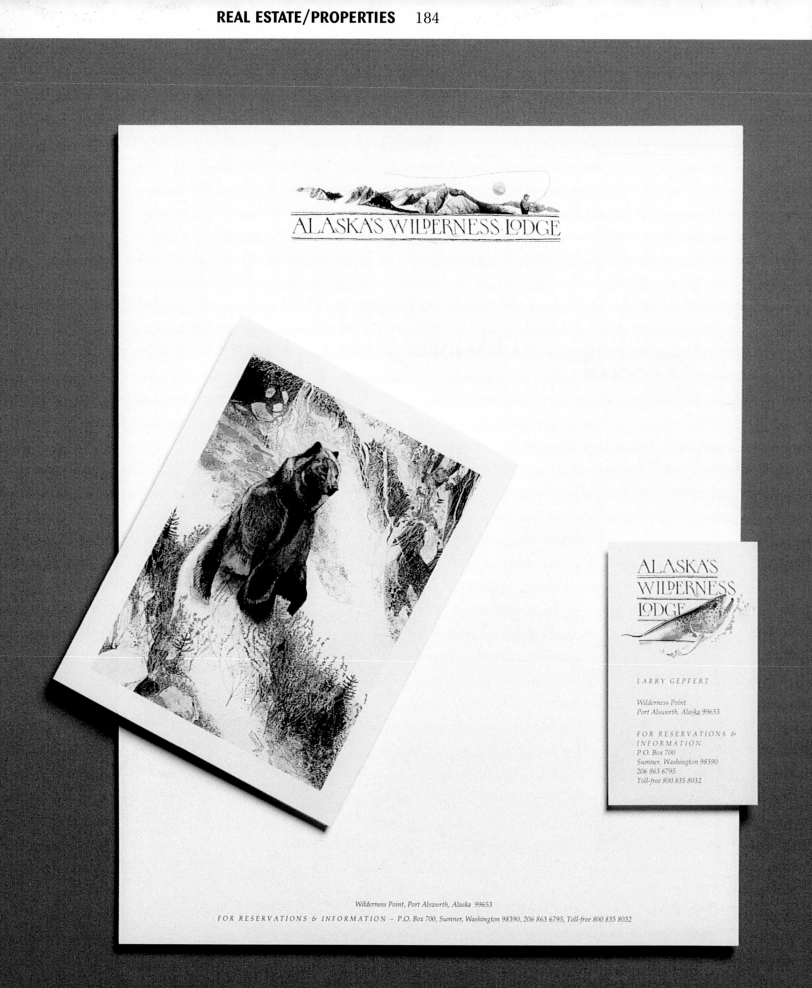

DESIGN FIRM	SHR Perceptual Management
ART DIRECTOR	Barry Shepard
DESIGNER	Douglas Reeder
ILLUSTRATOR	Jack Unruh
CLIENT	Alaska Wilderness Lodge
PAPER/PRINTING	Evergreen Birch

DESIGN FIRM David Carter Design
ART DIRECTOR Randall Hill,
Lori Wilson
DESIGNER Randall Hill,
ILLUSTRATOR Lori Wilson
Randall Hill,
Lori Wilson
CLIENT Hotel Principe Felipe

DESIGN FIRM The Weller Institute
for the Cure of
Design, Inc.
ART DIRECTOR Don Weller
DESIGNER Don Weller
ILLUSTRATOR Don Weller
CLIENT Lewis & Wolcott

DESIGN FIRM David Carter Design
ART DIRECTOR Sharon Lejune
DESIGNER Sharon Lejune
CLIENT Hotel New York, Euro
Disney, Paris

DESIGN FIRM David Carter Design
ART DIRECTOR Kevin Prejean,
Sharon Lejune
DESIGNER Kevin Prejean,
Sharon Lejune
ILLUSTRATOR Kevin Prejean,
Sharon Lejune
CLIENT Hotel New York,
Euro Disney, Paris

DESIGN FIRM David Carter Design
ART DIRECTOR Lori Wilson,
Randall Hill
DESIGNER Lori Wilson,
Randall Hill
ILLUSTRATOR Lori Wilson,
Randall Hill
CLIENT Disney's Newport Bay
Club Hotel

DESIGN FIRM Rickabaugh Graphics
ART DIRECTOR Eric Rickabaugh
DESIGNER Tina Zientarski
ILLUSTRATOR Tina Zientarski
CLIENT City of Columbus/
Recreation & Parks Dept.

DESIGN FIRM	David Carter Design
ART DIRECTOR	David Brashier
DESIGNER	David Brashier
ILLUSTRATOR	David Brashier
CLIENT	Sequoia Lodge, Euro Disney, Paris

DESIGN FIRM	David Carter Design
ART DIRECTOR	Lori Wilson
DESIGNER	Lori Wilson
ILLUSTRATOR	Lori Wilson
CLIENT	Inn of the Anasazi

DESIGN FIRM	Gary Greene Artworks
ART DIRECTOR	Gary Greene
DESIGNER	Gary Greene
ILLUSTRATOR	Gary Greene
CLIENT	Robin Eggeman/ Real Estate Broker

DESIGN FIRM	Lambert Design Studio
ART DIRECTOR	Christie Lambert
DESIGNER	Christie Lambert, Joy Cathey
CLIENT	The Jorgen Group

DESIGN FIRM	The Weller Institue for the Cure of Design, Inc.
ART DIRECTOR	Don Weller
DESIGNER	Don Weller
CLIENT	Pointe of View

DESIGN FIRM	David Carter Design
ART DIRECTOR	Lori Wilson
DESIGNER	Lori Wilson
ILLUSTRATOR	Lori Wilson
CLIENT	Grand Hyatt, Bali

INDUSTRY/
MANUFACTURING

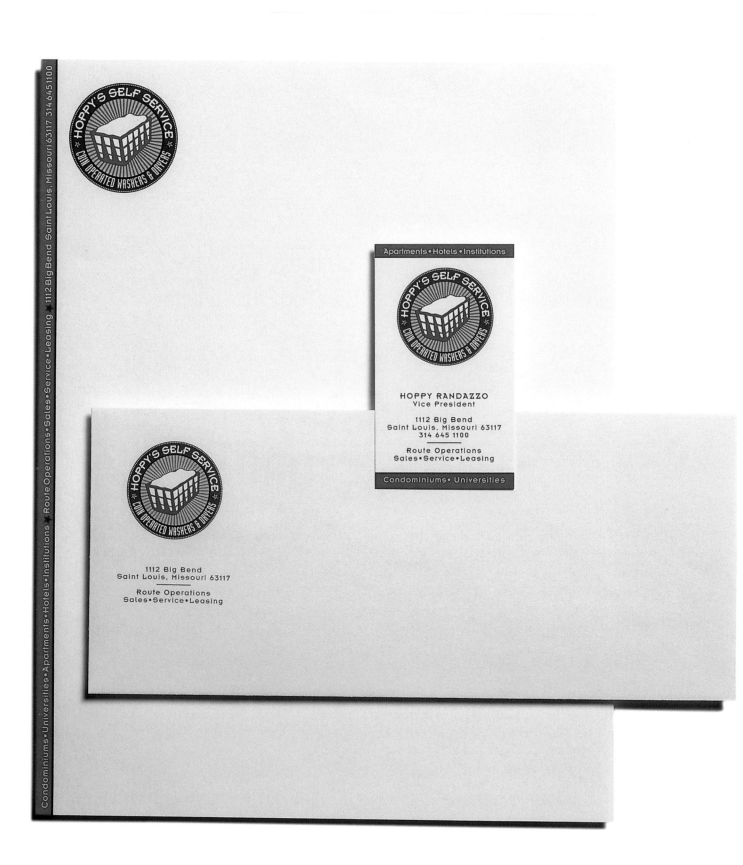

DESIGN FIRM 38 North

ART DIRECTOR Nida Zada

CLIENT Hoppy's Self Service

PAPER/PRINTING 3 colors

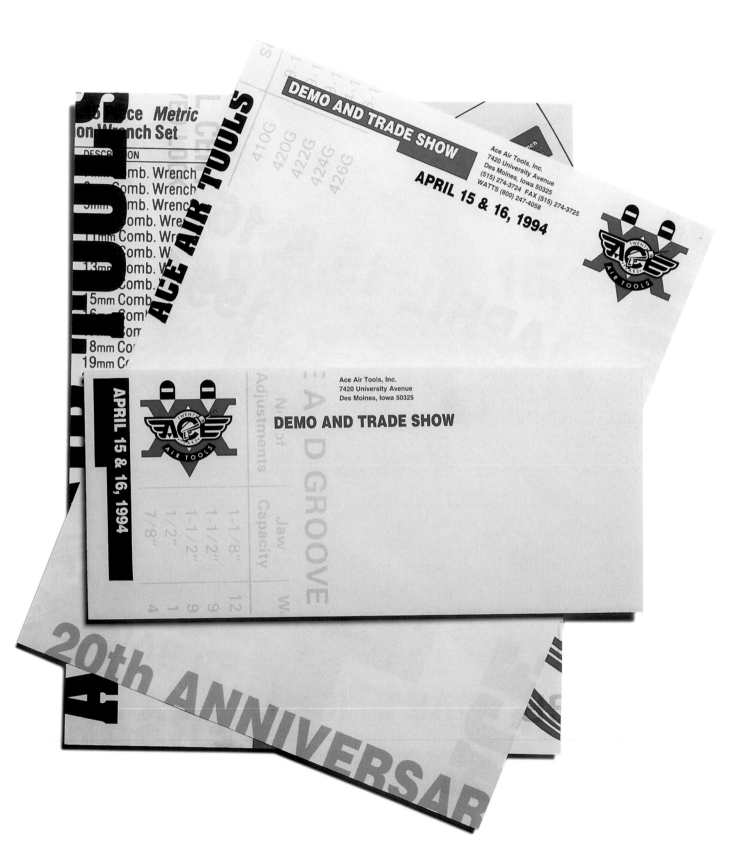

DESIGN FIRM Sayles Graphic Design
ART DIRECTOR John Sayles
DESIGNER John Sayles
ILLUSTRATOR John Sayles
CLIENT Ace Air Tools
PAPER/PRINTING James River, Graphika Vellum White, 2 colors

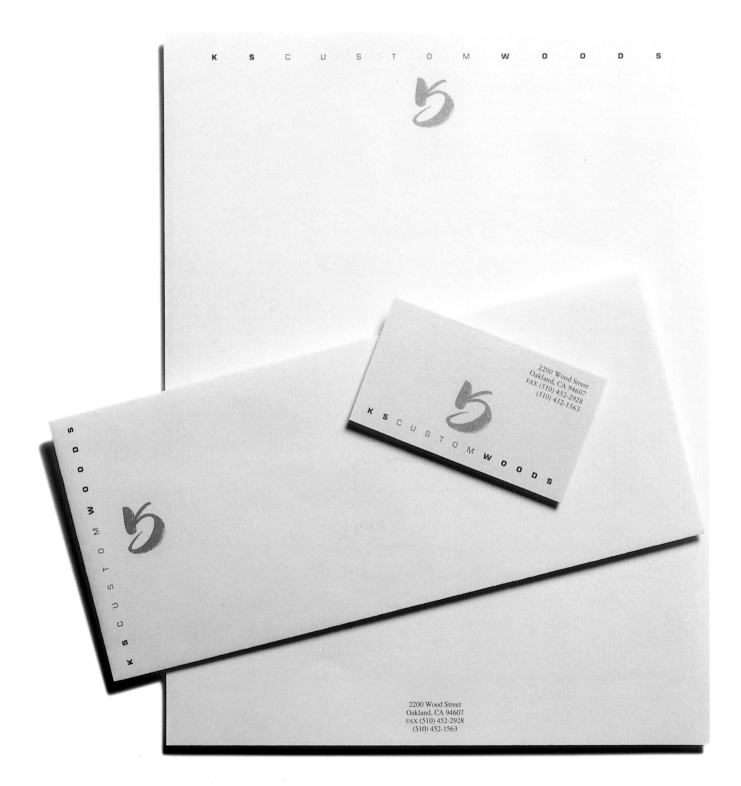

DESIGN FIRM Dan Frazier Design
ART DIRECTOR Dan Frazier
DESIGNER Dan Frazier
ILLUSTRATOR Sandra Bruce
CLIENT KS Custom Woods
PAPER/PRINTING Strathmore Writing

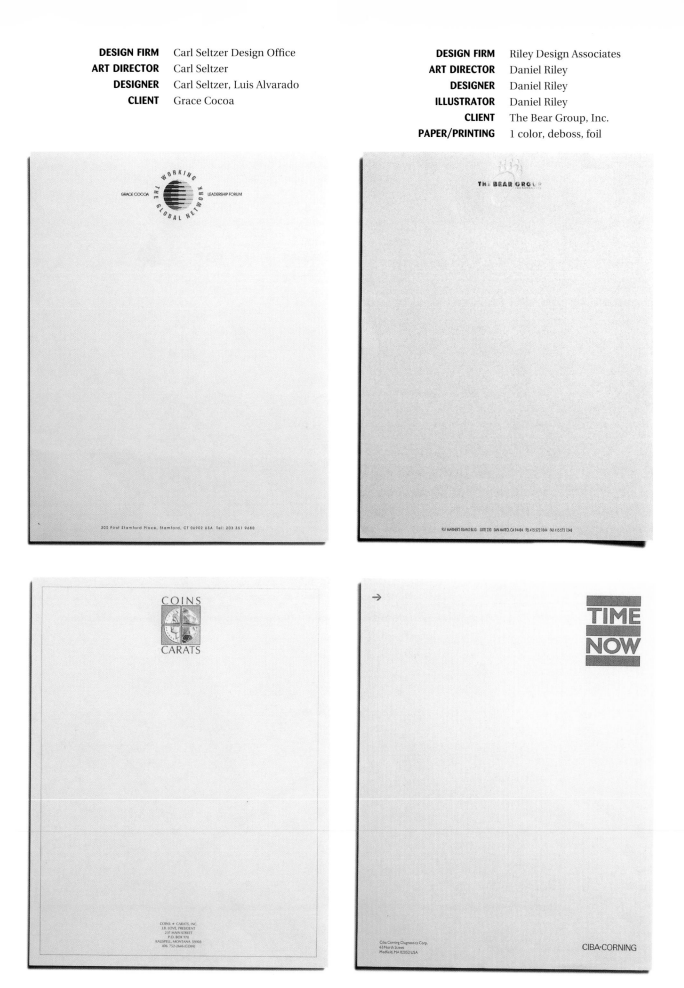

DESIGN FIRM	Carl Seltzer Design Office
ART DIRECTOR	Carl Seltzer
DESIGNER	Carl Seltzer, Luis Alvarado
CLIENT	Grace Cocoa

DESIGN FIRM	Riley Design Associates
ART DIRECTOR	Daniel Riley
DESIGNER	Daniel Riley
ILLUSTRATOR	Daniel Riley
CLIENT	The Bear Group, Inc.
PAPER/PRINTING	1 color, deboss, foil

DESIGN FIRM	Ellen Kendrick Creative, Inc.
ART DIRECTOR /DESIGNER	Ellen K. Spalding
ILLUSTRATOR	Ellen K. Spalding
CLIENT	Coins & Carats, Inc.
PAPER/PRINTING	Neenah Classic Crest, black and metallic blue, silver and holographic foils, sculptured brass die

DESIGN FIRM	Elizabeth Resnick Design
ART DIRECTOR	Elizabeth Resnick
DESIGNER	Elizabeth Resnick
CLIENT	CIBA Corning Diagnostics Corporation
PAPER/PRINTING	Curtis Brightwater, 2 colors

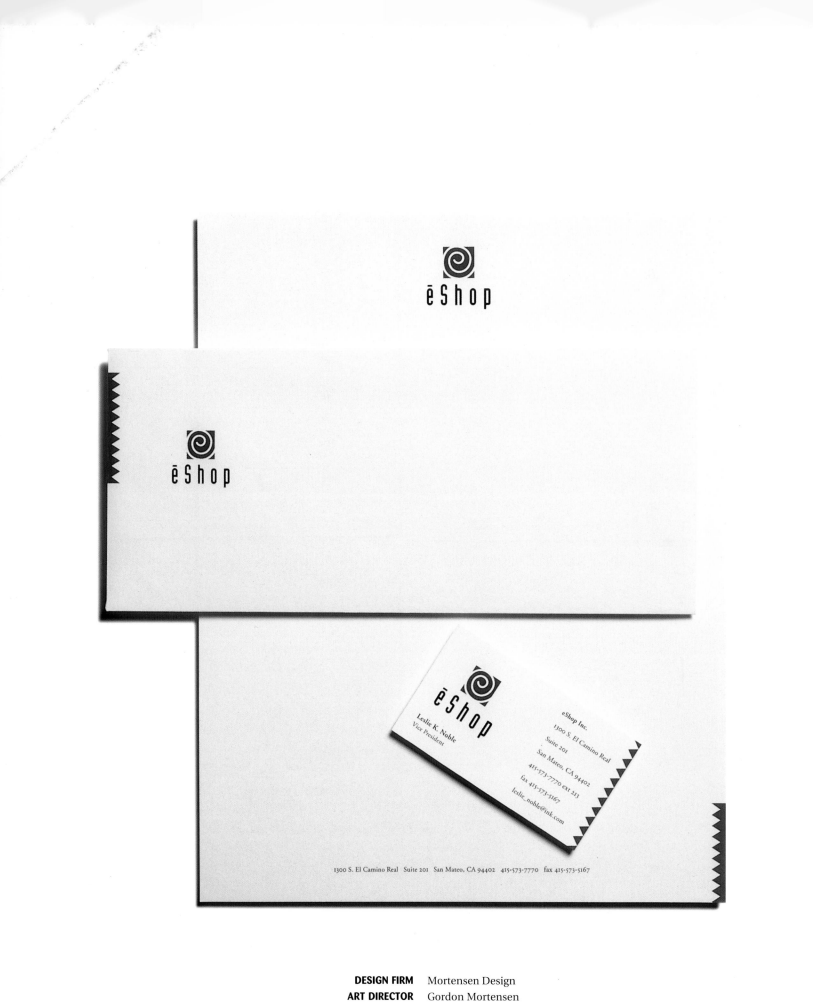

DESIGN FIRM Mortensen Design
ART DIRECTOR Gordon Mortensen
DESIGNER Gordon Mortensen
CLIENT eShop Inc.
PAPER/PRINTING Classic Crest/Foreman

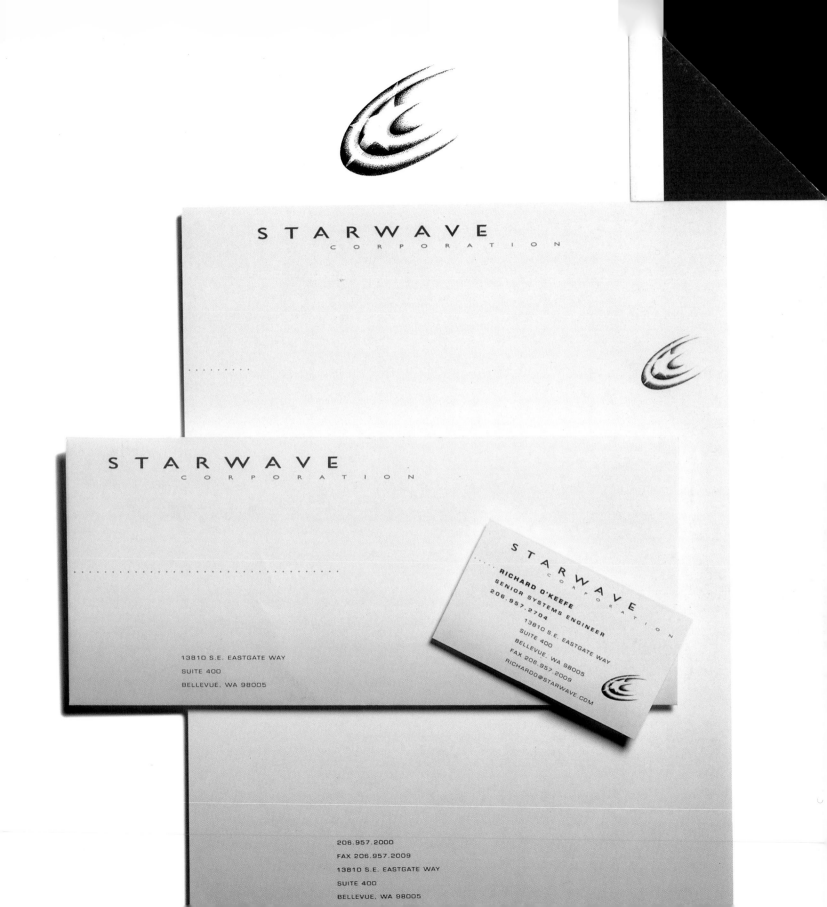

STARWAVE
CORPORATION

STARWAVE
CORPORATION

STARWAVE
CORPORATION

RICHARD O'KEEFE
SENIOR SYSTEMS ENGINEER
206.957.2704
13810 S.E. EASTGATE WAY
SUITE 400
BELLEVUE, WA 98005
FAX 206.957.2009
RICHARDO@STARWAVE.COM

13810 S.E. EASTGATE WAY

SUITE 400

BELLEVUE, WA 98005

206.957.2000

FAX 206.957.2009

13810 S.E. EASTGATE WAY

SUITE 400

BELLEVUE, WA 98005

Hunter®
The Irrigation Innovators
1940 Diamond St. □ San Marcos, CA 92069 □ Tel 619-744-5240 □ Fax 619-744-7461

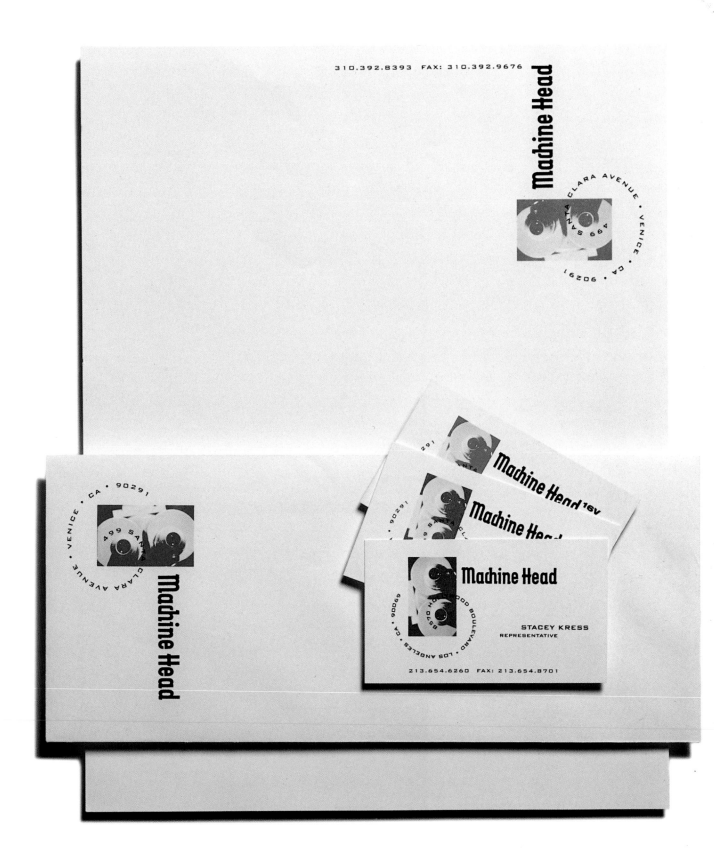

DESIGN FIRM Lorna Stovall Design
ART DIRECTOR Lorna Stovall
DESIGNER Lorna Stovall
CLIENT Machine Head
PAPER/PRINTING Starwhite Vicksberg

DESIGN FIRM	Vaughn Wedeen Creative
ART DIRECTOR	Steve Wedeen, Daniel Michael Flynn
DESIGNER	Daniel Michael Flynn
ILLUSTRATOR	Bill Gerhold
CLIENT	Jones Intercable
PAPER/PRINTING	French Speckletone Old Green text.

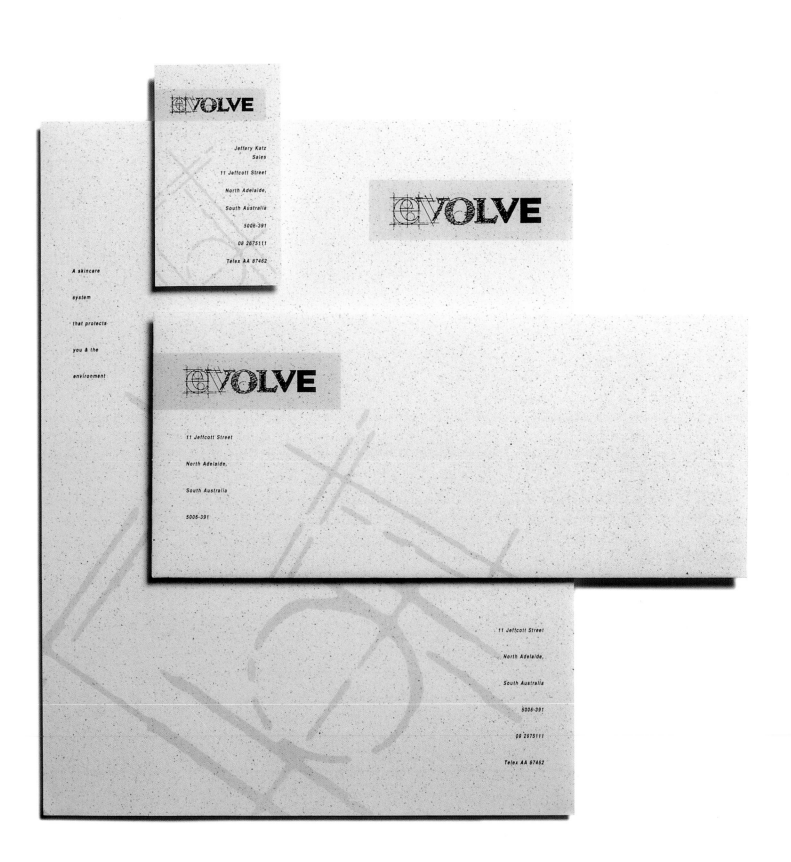

DESIGN FIRM E.M. Design
DESIGNER Elise Moyer
ILLUSTRATOR Elise Moyer
CLIENT Evolve

DESIGN FIRM Hornall Anderson Design Works
ART DIRECTOR Jack Anderson
DESIGNER Jack Anderson, Mary Hermes, Leo Raymundo
ILLUSTRATOR Yutaka Sasaki
CLIENT Watson Furniture

DESIGN FIRM	Segura Inc.
ART DIRECTOR	Carlos Segura
DESIGNER	Carlos Segura
PHOTOGRAPHY	Geof Kern
CLIENT	Merchandise Mart
PAPER/PRINTING	Argus

DESIGN FIRM	Hornall Anderson Design Works
ART DIRECTOR	Jack Anderson
DESIGNER	Jack Anderson, Julia LaPine, David Bates, Mary Hermes, Lian Ng
CLIENT	Active Voice
PAPER/PRINTING	Starwhite Vicksburg Tiara Smoothtext

DESIGN FIRM	Muller & Company
ART DIRECTOR	David Shultz
DESIGNER	David Shultz
CLIENT	Desco Coatings, Inc.
PAPER/PRINTING	Cross Pointe, Passport/LaGue

DESIGN FIRM James Clark Design Images
ART DIRECTOR James Clark
DESIGNER James Clark, Linda Sewell
ILLUSTRATOR Linda Sewell
CLIENT United Paint Sundry Distributor of America

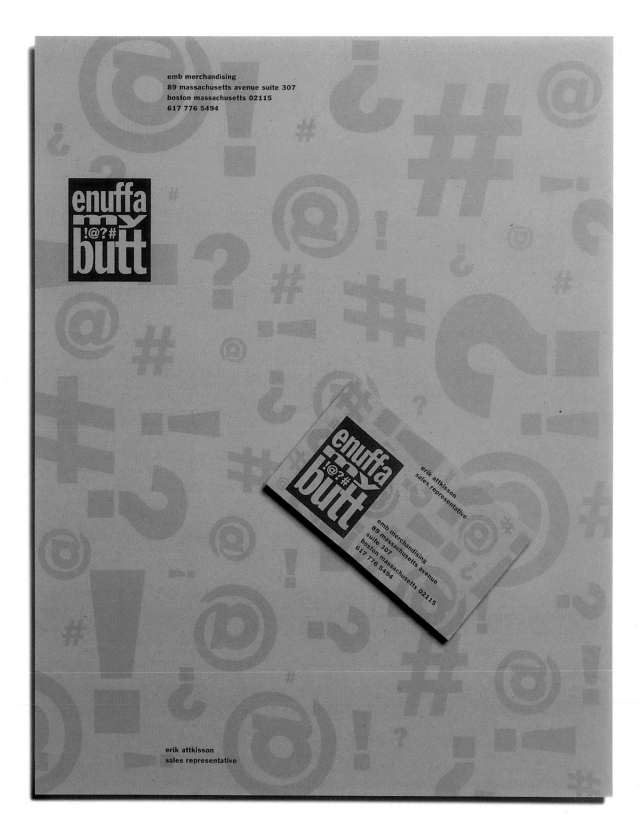

DESIGN FIRM Visual Dialogue
ART DIRECTOR Fritz Klaetke
DESIGNER Fritz Klaetke, Karen Striebeck
CLIENT EMB Merchandising
PAPER/PRINTING French Durotone, construction gold

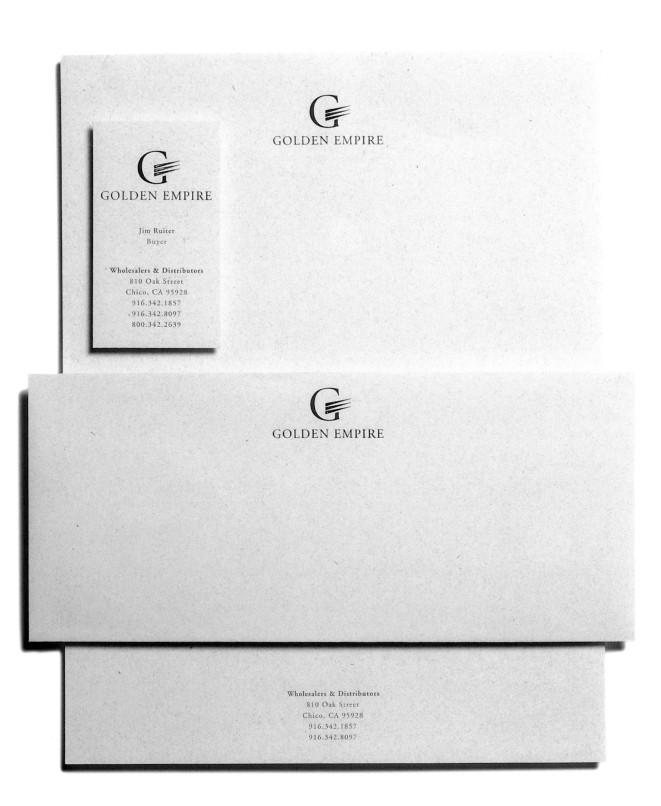

DESIGN FIRM	Image Group
ART DIRECTOR	David Zavala, Eric Sanchez
DESIGNER	David Zavala, Eric Sanchez
CLIENT	Golden Empire Distributing
PAPER/PRINTING	Classic Crest Recycled

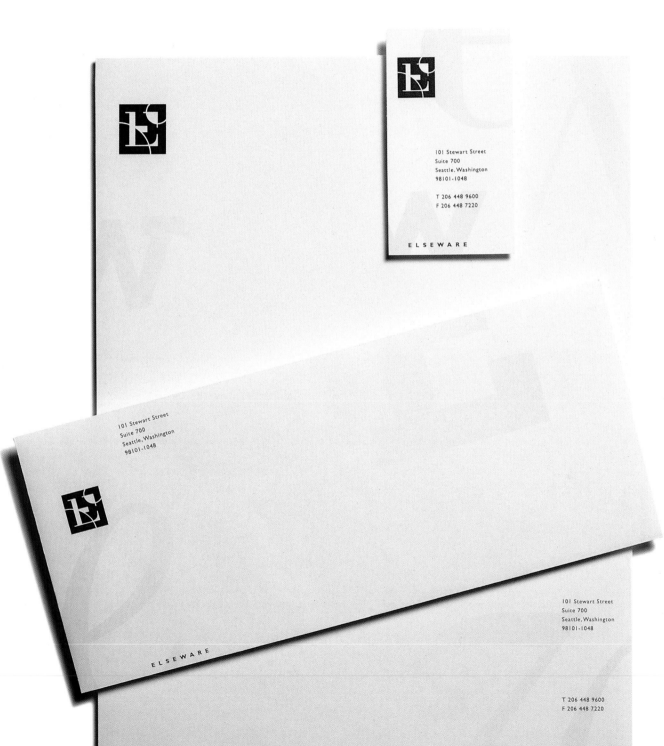

101 Stewart Street
Suite 700
Seattle, Washington
98101-1048

T 206 448 9600
F 206 448 7220

ELSEWARE

101 Stewart Street
Suite 700
Seattle, Washington
98101-1048

ELSEWARE

101 Stewart Street
Suite 700
Seattle, Washington
98101-1048

T 206 448 9600
F 206 448 7220

ELSEWARE

GRANITE SOFTWARE

GRANITE SOFTWARE

300 East Main Street, Milford, Ma 01757

300 East Main Street, Milford, Ma 01757 Tel 508 634.3200 Fax 508 634.8381

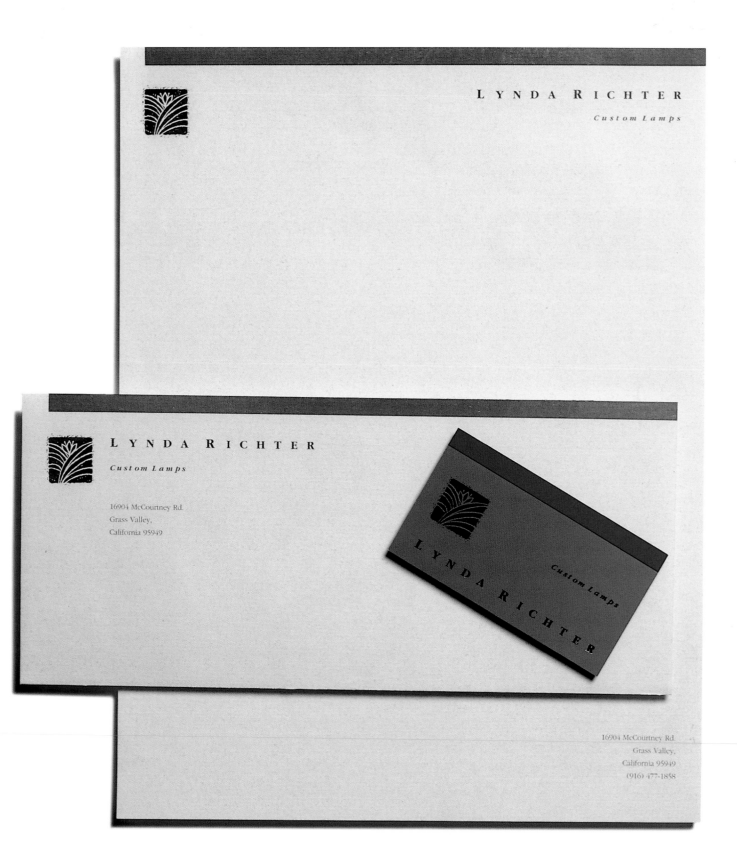

DESIGN FIRM	LeeAnn Brook Design
ART DIRECTOR	LeeAnn Brook
DESIGNER	LeeAnn Brook
ILLUSTRATOR	LeeAnn Brook
CLIENT	Lynda Richter
PAPER/PRINTING	Classic Laid Millstone, foil emboss

DESIGN FIRM	Aslan Grafix
ART DIRECTOR	Tracy Grubbs
DESIGNER	Tracy Grubbs
CLIENT	Aus-tech Mold & Design

DESIGN FIRM	Armin Vogt Partner/Corporate & Packaging Design
ART DIRECTOR	Armin Vogt
DESIGNER	Armin Vogt
CLIENT	Electro Bauer AG

DESIGN FIRM	Hornall Anderson Design Works
ART DIRECTOR	Jack Anderson
DESIGNER	Jack Anderson, Cliff Chung, David Bates
CLIENT	Nordstrom

DESIGN FIRM	Strategic Communications
ART DIRECTOR	Charles Drummond, Rick Tharp
DESIGNER	Designer Jana Heer, Rick Tharp
CLIENT	Signature Software, Inc.

DESIGN FIRM	Porter, Matjasich & Associates
ART DIRECTOR	Carol Matjasich
DESIGNER	Robert Rausch
ILLUSTRATOR	Maria Stroster
CLIENT	Abbott Laboratories Diagnostics Division

DESIGN FIRM	Earl Gee Design
ART DIRECTOR	Earl Gee
DESIGNER	Earl Gee
ILLUSTRATOR	Earl Gee
CLIENT	Sun Microsystems – FIT @ SUN (employee fitness center)

DESIGN FIRM	Earl Gee Design	**DESIGN FIRM**	Turner Design	**DESIGN FIRM**	Armin Vogt
ART DIRECTOR	Earl Gee	**ART DIRECTOR**	Bert Turner		Partner/Corporate &
DESIGNER	Earl Gee, Fani Chung	**DESIGNER**	Bert Turner		Packaging Design
ILLUSTRATOR	Earl Gee	**ILLUSTRATOR**	Bert Turner	**ART DIRECTOR**	Armin Vogt
CLIENT	Sun Microsystems	**CLIENT**	I-Ware	**DESIGNER**	Armin Vogt
	"SMART" Program			**CLIENT**	Grafothek Basel

DESIGN FIRM	Ron Kellum Inc.	**DESIGN FIRM**	Hornall Anderson	**DESIGN FIRM**	Modern Dog
ART DIRECTOR	Ron Kellum		Design Works	**ART DIRECTOR**	Brent Turner,
DESIGNER	Ron Kellum	**ART DIRECTOR**	Jack Anderson		Luke Edgar
CLIENT	Topix	**DESIGNER**	Jack Anderson,	**DESIGNER**	Michael Strassburger
			David Bates,	**ILLUSTRATOR**	Michael Strassburger
			Cliff Chung	**CLIENT**	K2 Snowboards
		CLIENT	Microsoft Corporation		

[W O R L D W I D E
O P E R A T I O N S]

[M I S S I O N
S T A T E M E N T]

[S T R A T E G I C
I N I T I A T I V E S]

[V A L U E S]

[A R C H I T E C T U R A L
D I R E C T I O N]

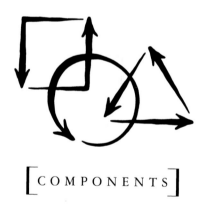

[C O M P O N E N T S]

DESIGN FIRM Earl Gee Design
ART DIRECTOR Earl Gee
DESIGNER Earl Gee, Fani Chung
ILLUSTRATOR Earl Gee
CLIENT Sun Microsystems
Worldwide Operations

URBAN HORSE

A CONTEMPORARY STATEMENT OF TRADITIONAL SIMPLICITY.

ARTÉ SALON

FOREMAST CLUB

MISCELLANEOUS

WINDSTAR CRUISES

100 Elliot Ave. W
Seattle Wa 98819
206.281.3535

N.Y. 10012 212-941-5932

BUMBLE

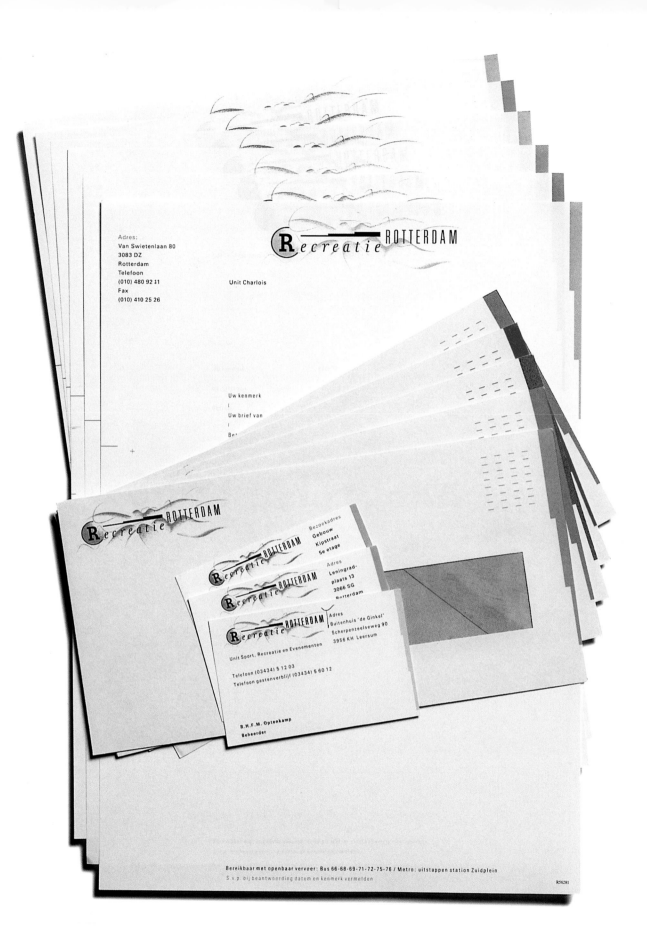

DESIGN FIRM Proforma Rotterdam
ART DIRECTOR Aadvan Pommelen
DESIGNER Gert Jan Rooijakkers
CLIENT Recreative Rotterdam
PAPER/PRINTING Bankpost

DESIGN FIRM	Sayles Graphic Design
ART DIRECTOR	John Sayles
DESIGNER	John Sayles
ILLUSTRATOR	John Sayles
CLIENT	Adam Katzman
PAPER/PRINTING	James River, Gray Parchment

DESIGN FIRM	Mike Salisbury Communications
ART DIRECTOR	Mike Salisbury
DESIGNER	Mike Salisbury
ILUSTRATOR	Mike Salisbury
CLIENT	Mike Salisbury
PAPER/PRINTING	Recycled

DESIGN FIRM	The Green House
ART DIRECTOR	Brian Green
DESIGNER	Brian Green
ILLUSTRATOR	Brian Green
CLIENT	Crucial Films
PAPER/PRINTING	Connoseur, 1 color, foil thermography

DESIGN FIRM	Handler Design Ltd.
ART DIRECTOR	Bruce Handler
DESIGNER	Bruce Handler
ILLUSTRATOR	Bruce Handler
CLIENT	Kidstuff
PAPER/PRINTING	Curtis Flannel

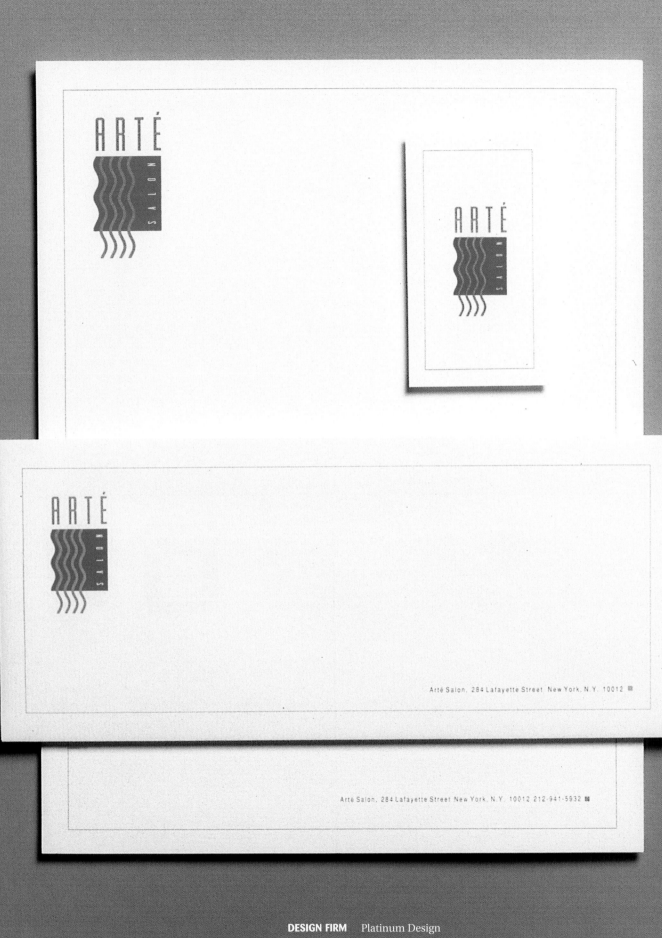

DESIGN FIRM	Platinum Design
ART DIRECTOR	Sandy Quinn
DESIGNER	Kathleen Phelps, Sandy Quinn
ILLUSTRATOR	Kathleen Phelps
CLIENT	Arté Salon
PAPER/PRINTING	Strathmore Writing Laid

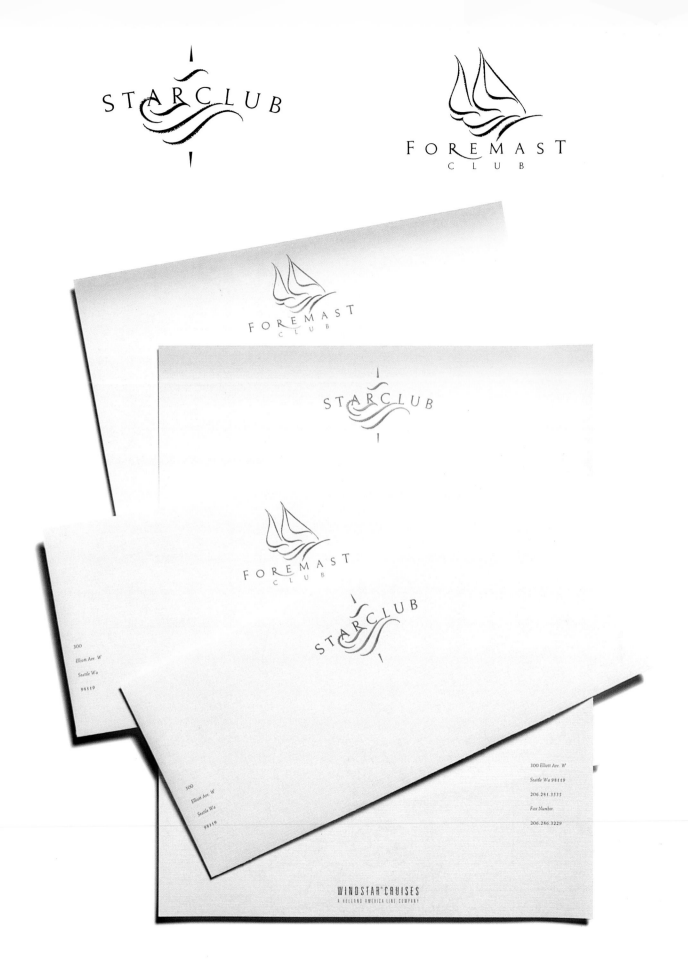

DESIGN FIRM	Hornall Anderson Design Works
ART DIRECTOR	Jack Anderson
DESIGNER	Jack Anderson, Denise Weir, Lian Ng, David Bates
ILLUSTRATOR	Glenn Yoshiyama
CLIENT	Windstar Cruises
PAPER/PRINTING	Neenah Classic Laid

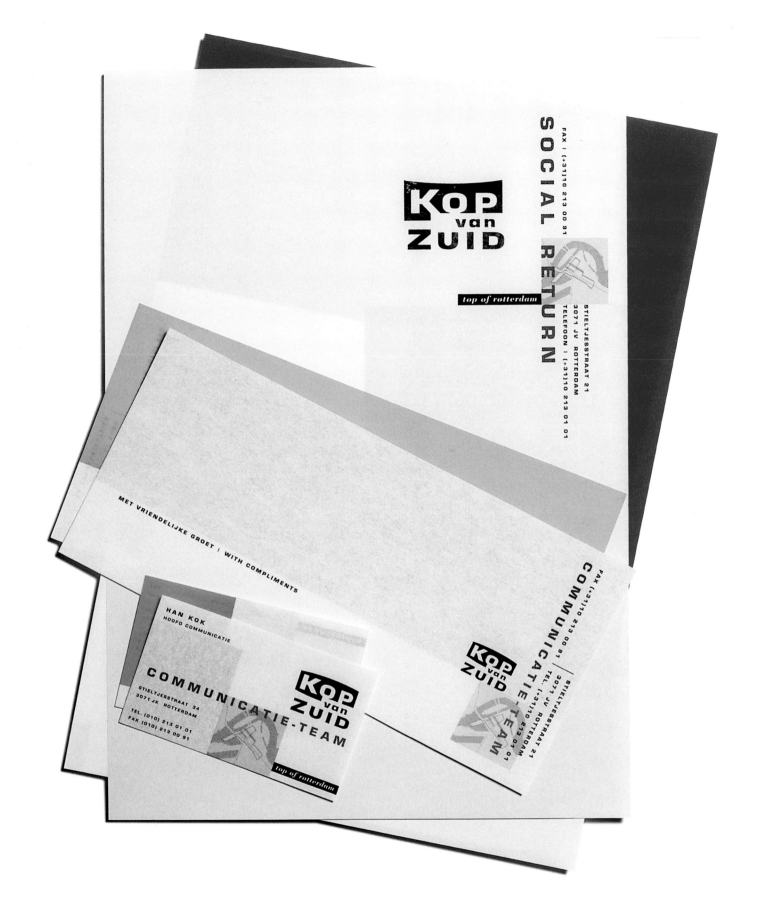

DESIGN FIRM Proforma Rotterdam
ART DIRECTOR Mirjam v.d. Haspel
DESIGNER Michael Snitker
CLIENT Kop van Zuid
PAPER/PRINTING Bankpost

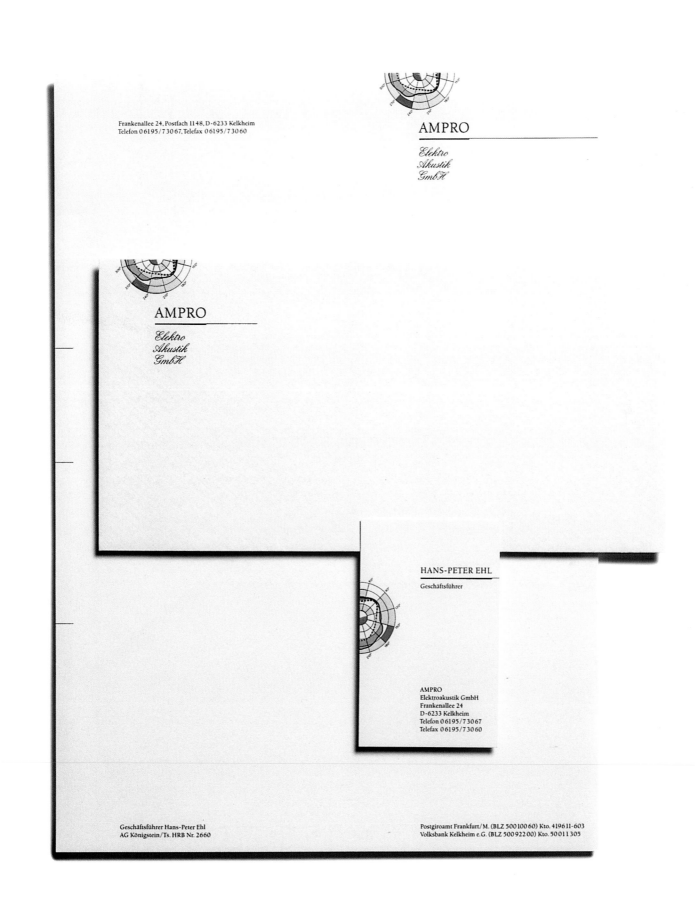

DESIGN FIRM Hartmann & Mehler Designers GmbH
ART DIRECTOR Roland Mehler
DESIGNER Roland Mehler
ILLUSTRATOR Roland Mehler
CLIENT Ampro
PAPER/PRINTING Croxley Heritage

JAKARTA PELANGI
PRODUCTIONS
Jakarta Design Center, 6th Floor
Jalan Gatot Subroto No 53, Slipi
Jakarta 10260, Indonesia
phone. 530 4615, 530 4616
549 5130 ext 141, fax. 530 4616

JAKARTA PELANGI
PRODUCTIONS
Jakarta Design Center, 6th Floor
Jalan Gatot Subroto No 53, Slipi
Jakarta 10260, Indonesia
phone. 530 4615, 530 4616
549 5130 ext 141, fax. 530 4616
cel.phone. 082. 101 0902

DESIGN FIRM	Wigwam Designs Pte. Ltd.
ART DIRECTOR	Rustam Moh'd
DESIGNER	Rustam Moh'd
CLIENT	Jakarta Pelangi Productions

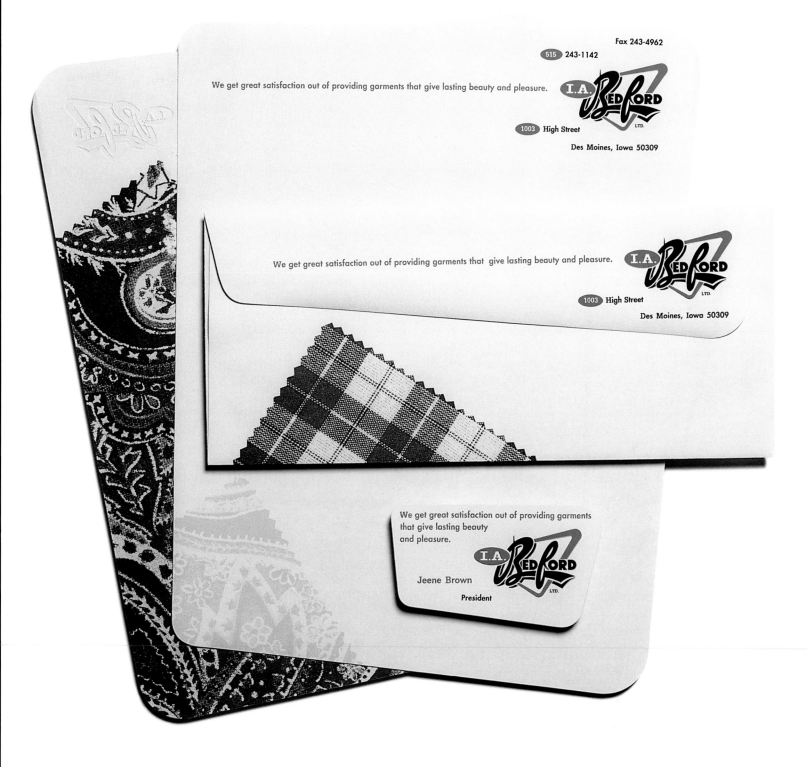

DESIGN FIRM	Sayles Graphic Design
ART DIRECTOR	John Sayles
DESIGNER	John Sayles
ILLUSTRATOR	John Sayles
CLIENT	I.A. Bedford
PAPER/PRINTING	James River, Graphika Vellum Natural, 3 colors

DESIGN FIRM	Sayles Graphic Design
ART DIRECTOR	John Sayles
DESIGNER	John Sayles
ILLUSTRATOR	John Sayles
CLIENT	Teri & Andy TeBockhorst
PAPER/PRINTING	Hammermill, White

DESIGN FIRM	Sayles Graphic Design
ART DIRECTOR	John Sayles
DESIGNER	John Sayles
ILLUSTRATOR	John Sayles
CLIENT	Schaffer's Bridal Shop
PAPER/PRINTING	James River, Parchment White

DESIGN FIRM	Pig Studios
ART DIRECTOR	Brandon Griffin
DESIGNER	Sandra Smarp, Brandon Griffin
ILLUSTRATOR	Sandra Smarp
CLIENT	Two Pie Are Music, Inc.
PAPER/PRINTING	Strathmore Writing, Bright White, 2 PMS

DESIGN FIRM	Image Group
ART DIRECTOR	Dan Frazier
DESIGNER	David Zavala
ILLUSTRATOR	David Zavala
CLIENT	EMU Acres
PAPER/PRINTING	Evergreen

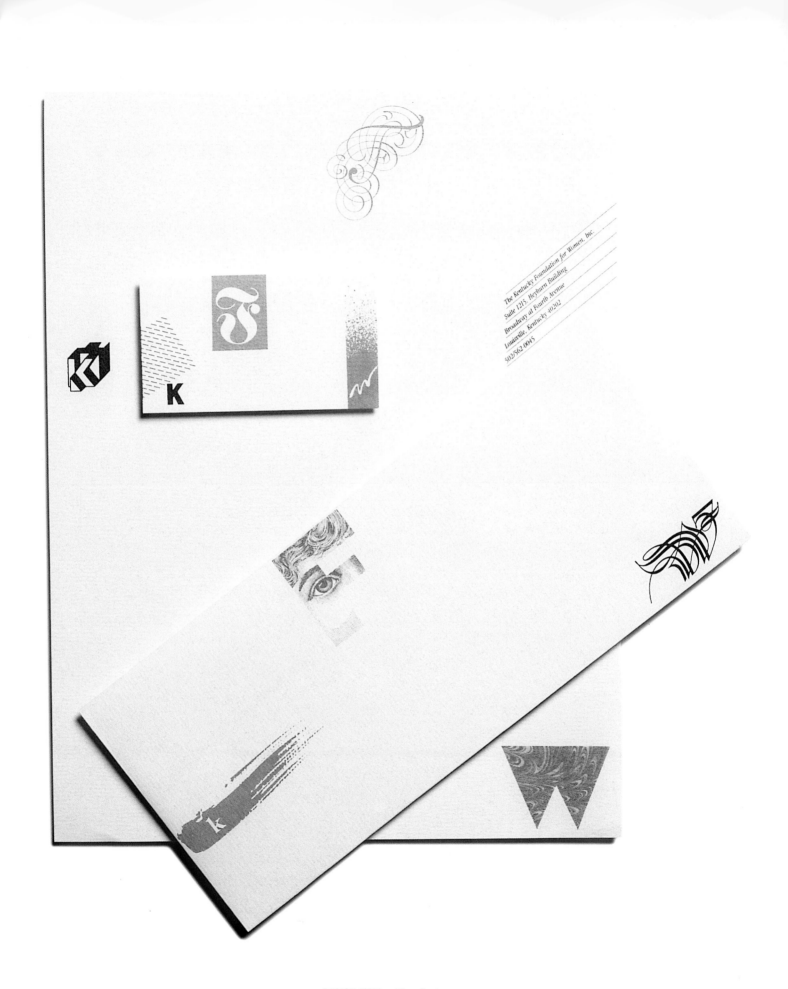

The Kentucky Foundation for Women, Inc.
Suite 1215, Heyburn Building
Broadway at Fourth Avenue
Louisville, Kentucky 40202
502/562.0045

DESIGN FIRM	Choplogic
DESIGNER	Walter McCord, Julius Friedman
ILLUSTRATOR	Walter McCord, Julius Friedman
CLIENT	Kentucky Foundation for Women
PAPER/PRINTING	Simpson Gainsborough, 3 colors

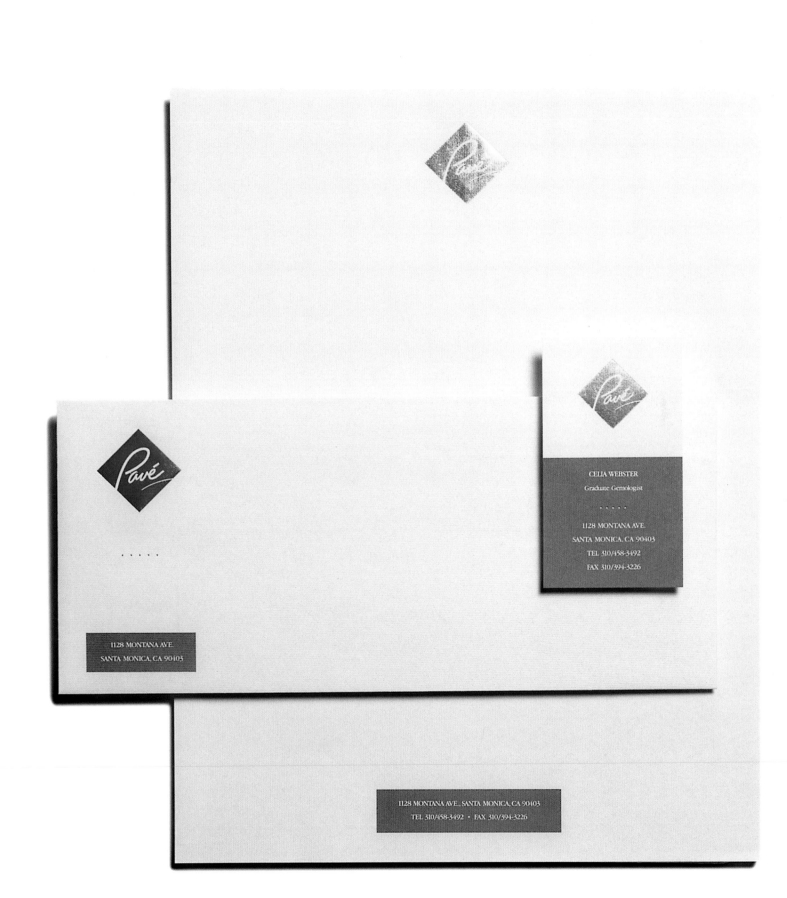

DESIGN FIRM Shimokochi/Reeves
ART DIRECTOR Mamoru Shimokochi, Anne Reeves
DESIGNER Mamoru Shimokochi, Anne Reeves
CLIENT Pavé
PAPER/PRINTING Graphika

ADDYS
1993

ADVERTISING
PROFESSIONALS
OF DES MOINES

POST OFFICE
BOX 133
DES MOINES
IOWA 50301

ADDYS
1993

ADVERTISING
PROFESSIONALS
OF DES MOINES

REACH
FOR THE
STARS

REACH
FOR THE
STARS

DESIGN FIRM Sayles Graphic Design
ART DIRECTOR John Sayles
DESIGNER John Sayles
ILLUSTRATOR John Sayles
CLIENT Advertising Professionals of Des Moines
PAPER/PRINTING James River, Graphika Natural, 2 colors

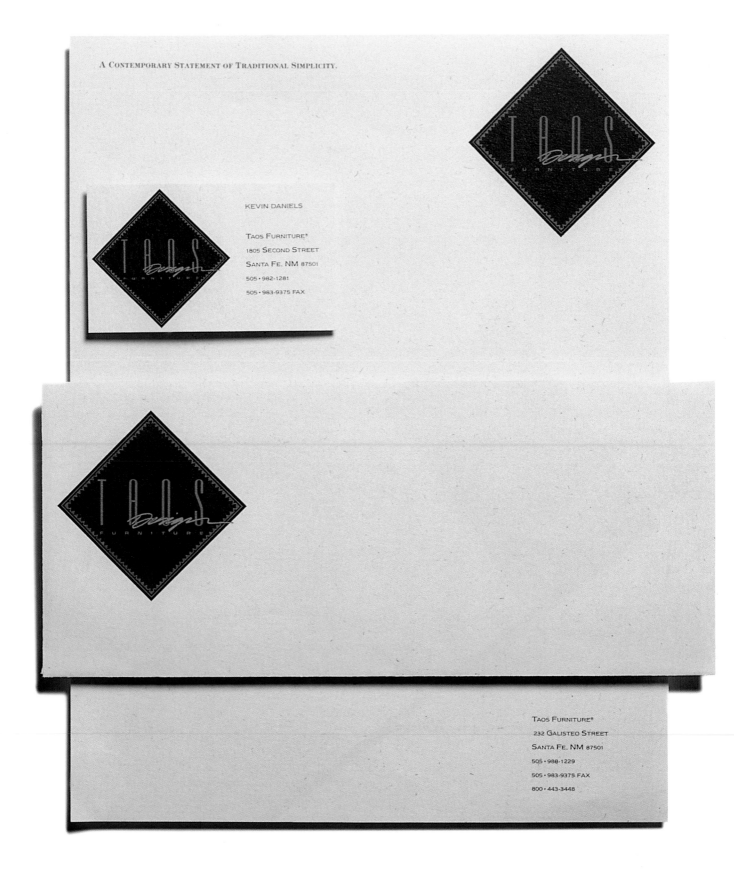

A CONTEMPORARY STATEMENT OF TRADITIONAL SIMPLICITY.

KEVIN DANIELS

TAOS FURNITURE®
1805 SECOND STREET
SANTA FE, NM 87501
505 • 982-1281
505 • 983-9375 FAX

TAOS FURNITURE®
232 GALISTEO STREET
SANTA FE, NM 87501
505 • 988-1229
505 • 983-9375 FAX
800 • 443-3448

DESIGN FIRM	Vaughn Wedeen Creative
ART DIRECTOR	Rick Vaughn
DESIGNER	Rick Vaughn
CLIENT	Taos Furniture
PAPER/PRINTING	French Speckletone Creme Text

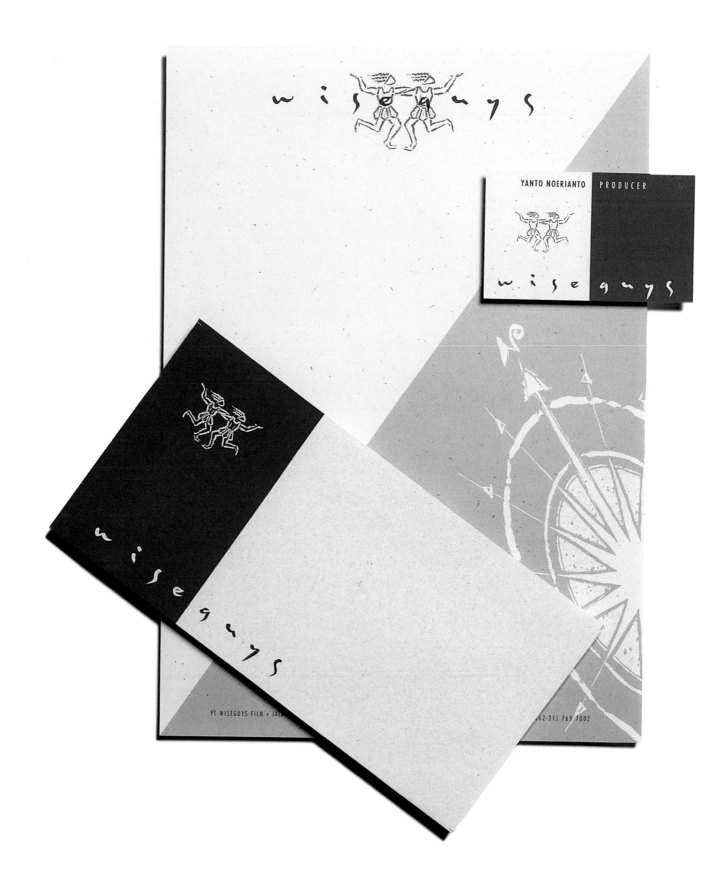

DESIGN FIRM	Wigwam Designs Pte. Ltd.
ART DIRECTOR	Rustam Moh'd
DESIGNER	Rustam Moh'd
ILLUSTRATOR	Rustam Moh'd
CLIENT	Wiseguys Pte. Ltd.
PAPER/PRINTING	Recycled

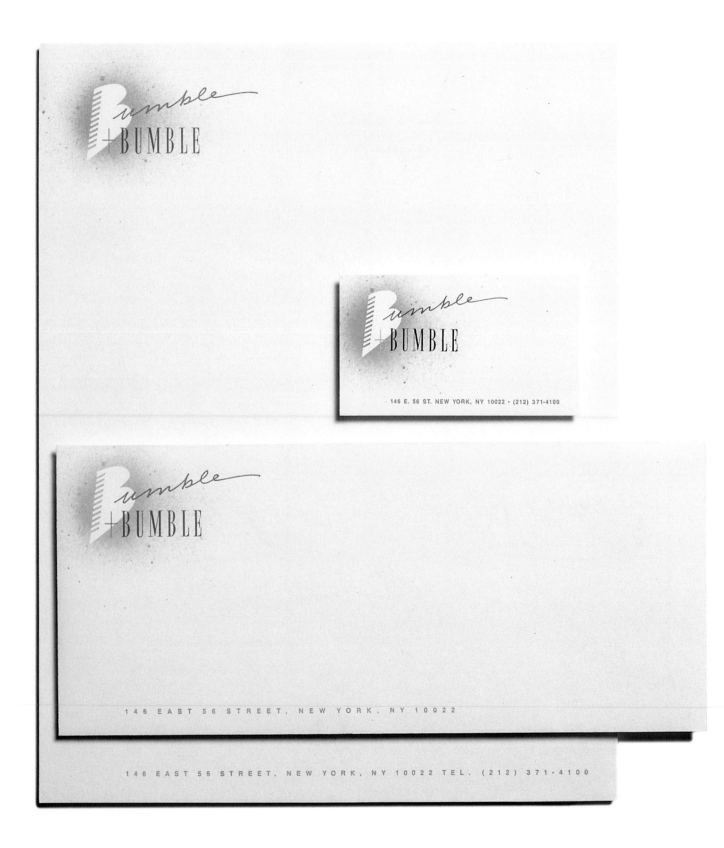

DESIGN FIRM Mike Quon Design Office
ART DIRECTOR M. Gordon, Mike Quon
DESIGNER Mike Quon
ILLUSTRATOR Mike Quon
CLIENT Bumble & Bumble/Hair Salon

custom paint, detailing, fiberglass repairs
complete restoration, reproduction parts
all makes
specializing in classic/antique autos
Harley-Davidson motorcyles
free estimates, free pick up & delivery

Frederick Powers, Jr.
Manager

39 Old Salt Road
Old Orchard Beach, ME 04064
207-934-1314
home 207-967-3997

39 Old Salt Road
Old Orchard Beach, ME 04064

39 Old Salt Road ■ Old Orchard Beach, Maine 04064 ■ Telephone 207-934-1314 ■ home 207-967-3997

DESIGN FIRM	Bayon Marketing Design
ART DIRECTOR	Cecile Bayon
DESIGNER	Cecile Bayon
ILLUSTRATOR	Cecile Bayon
CLIENT	Powers Auto Body
PAPER/PRINTING	Classic Crest

DESIGN FIRM	Hartmann & Mehler Designers GmbH
ART DIRECTOR	Roland Mehler
DESIGNER	Roland Mehler
ILLUSTRATOR	Roland Mehler
CLIENT	Stadelmann & Thorer

DESIGN FIRM Mike Quon Design Office
ART DIRECTOR Dale Pon, Mike Quon
DESIGNER Mike Quon
ILLUSTRATOR Mike Quon
CLIENT CD 101.9

DESIGN FIRM	Modern Dog
ART DIRECTOR	Rick Rankin
DESIGNER	Michael Strassburger, Robynne Raye
CLIENT	Alice B. Theatre
PAPER/PRINTING	Simpson Evergreen

DESIGN FIRM Kom Design Munich
ART DIRECTOR Caren Schindelwick
ILLUSTRATOR Caren Schindelwick
CLIENT Maxi (a perfume shop)
PAPER/PRINTING 4 colors

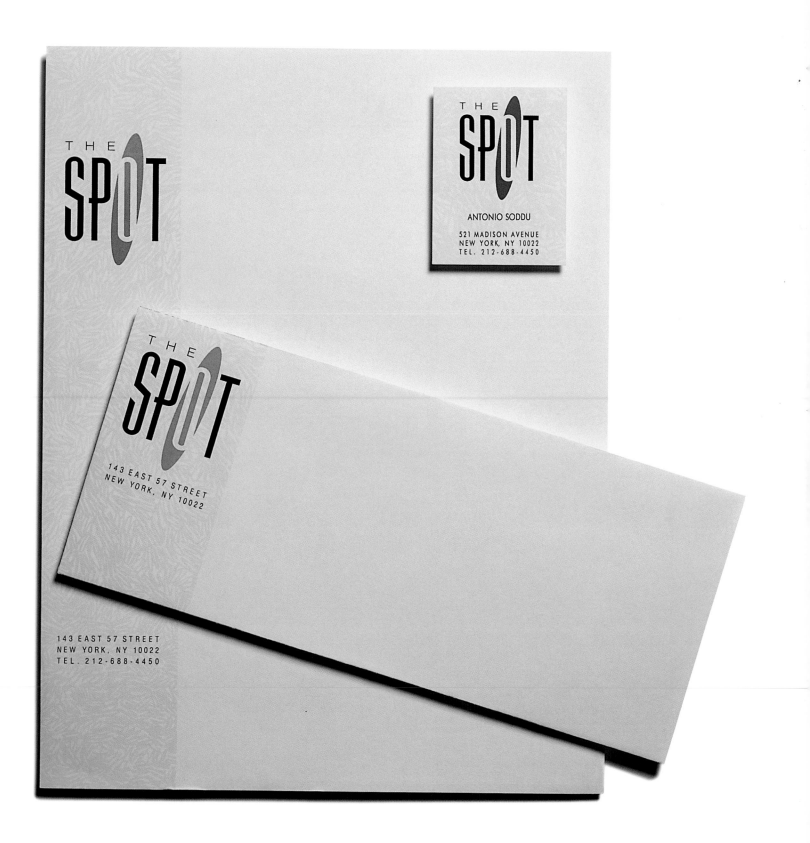

DESIGN FIRM	Mike Quon Design Office
ART DIRECTOR	Mike Quon
DESIGNER	Mike Quon
ILLUSTRATOR	Mike Quon
CLIENT	The Spot/Hair Salon

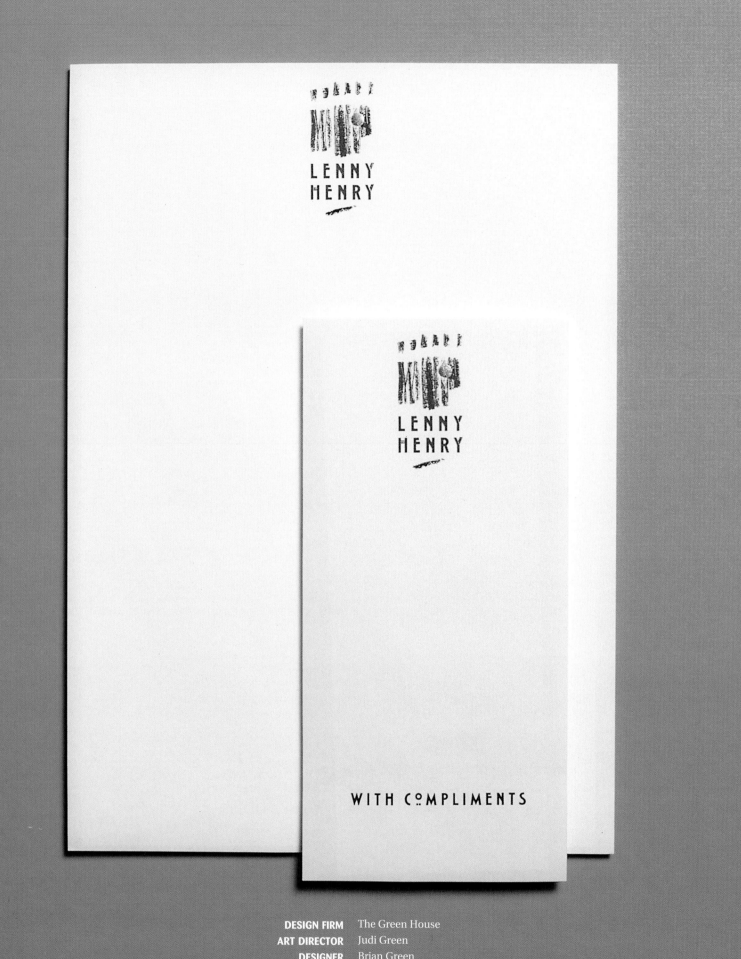

DESIGN FIRM The Green House
ART DIRECTOR Judi Green
DESIGNER Brian Green
ILLUSTRATOR Brian Green
CLIENT Lenny Henry
PAPER/PRINTING Evergreen, 1 color with 2 foils.

DESIGN FIRM L. F. Banks, Associates
ART DIRECTOR Lori Banks
DESIGNER Dorie Phillips
ILLUSTRATOR Dorie Phillips
CLIENT American Karate Studio

DESIGN FIRM Modern Dog
ART DIRECTOR Robynne Raye, Sheila Hughes
DESIGNER Robynne Raye, Michael Strassburger
CLIENT One Reel
PAPER/PRINTING Simpson Vicksburg

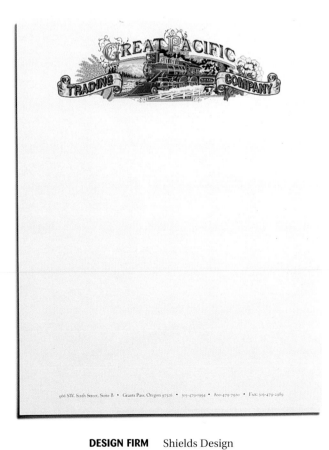

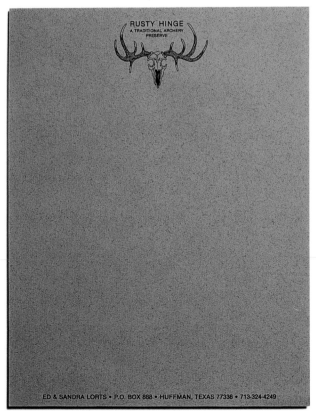

DESIGN FIRM Shields Design
ART DIRECTOR Charles Shields
DESIGNER Charles Shields
ILLUSTRATOR Doug Hansen
CLIENT Great Pacific Trading Company
PAPER/PRINTING Classic Crest

DESIGN FIRM Total Designers
ART DIRECTOR Ed Lorts
DESIGNER Ed Lorts
ILLUSTRATOR Ed Lorts
CLIENT The Rusty Hinge Lodge
PAPER/PRINTING 100% Recycled Rag

CRITTERS AND

CHRYSANTHEMUMS

GOES COUNTRY

The Dallas Arboretum

and Botanical Garden

8617 Garland Road

Dallas, Texas 75218

CRITTERS AND
CHRYSANTHEMUMS
GOES COUNTRY

The Dallas Arboretum

and Botanical Garden

8617 Garland Road

Dallas, Texas 75218

Society for Prevention

of Cruelty to Animals

362 South Industrial

Dallas, Texas 75207

DESIGN FIRM	Focus 2
ART DIRECTOR	Todd Hart, Shawn Freeman
DESIGNER	Todd Hart
ILLUSTRATOR	Todd Hart
CLIENT	SPCA of Texas
PAPER/PRINTING	Evergreen

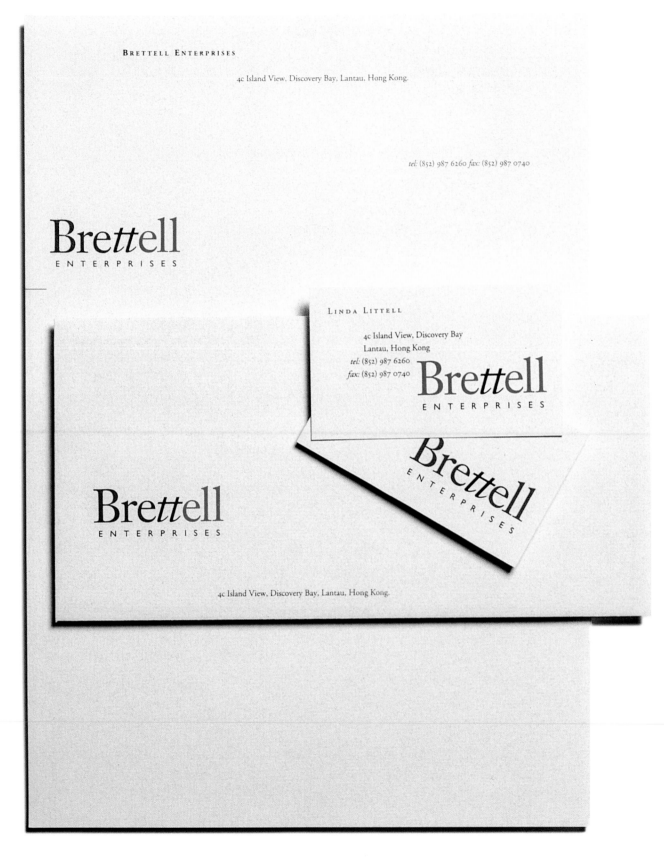

BRETTELL ENTERPRISES

4c Island View, Discovery Bay, Lantau, Hong Kong.

tel: (852) 987 6260 *fax:* (852) 987 0740

Bre*tt*ell
ENTERPRISES

LINDA LITTELL

4c Island View, Discovery Bay
Lantau, Hong Kong
tel: (852) 987 6260
fax: (852) 987 0740

Bre*tt*ell
ENTERPRISES

Bre*tt*ell
ENTERPRISES

Bre*tt*ell
ENTERPRISES

4c Island View, Discovery Bay, Lantau, Hong Kong.

DESIGN FIRM The Design Associates
ART DIRECTOR Victor Cheong
DESIGNER Victor Cheong, Philip Sven
CLIENT Brettell Enterprises
PAPER/PRINTING Gilbert

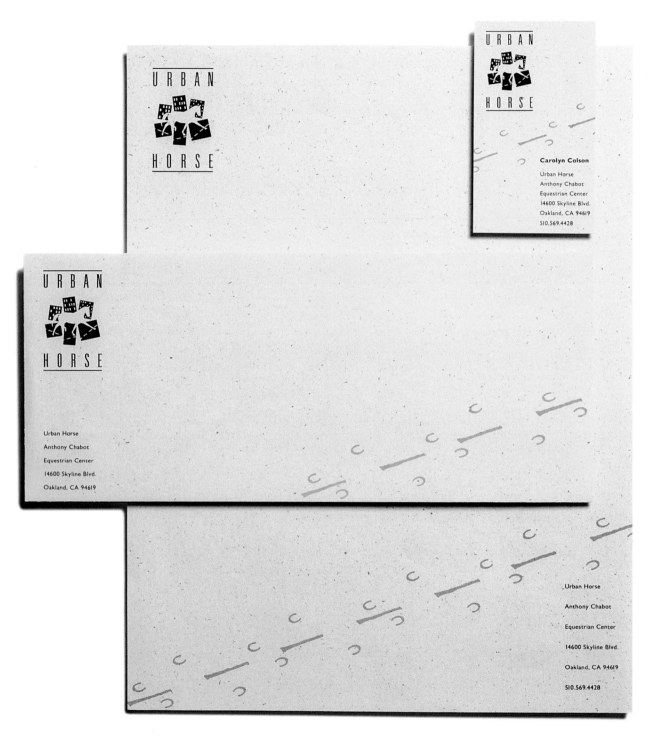

DESIGN FIRM Bruce Yelaska Design
ART DIRECTOR Bruce Yelaska
DESIGNER Bruce Yelaska
ILLUSTRATOR Bruce Yelaska
CLIENT Urban Horse
PAPER/PRINTING Champion Benefit

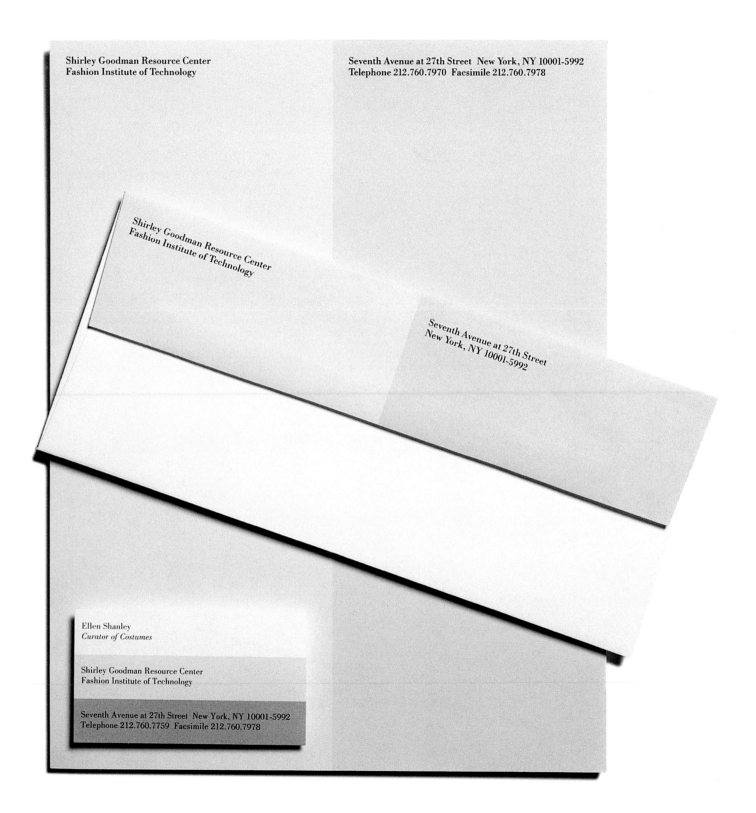

Shirley Goodman Resource Center
Fashion Institute of Technology

Seventh Avenue at 27th Street New York, NY 10001-5992
Telephone 212.760.7970 Facsimile 212.760.7978

Shirley Goodman Resource Center
Fashion Institute of Technology

Seventh Avenue at 27th Street
New York, NY 10001-5992

Ellen Shanley
Curator of Costumes

Shirley Goodman Resource Center
Fashion Institute of Technology

Seventh Avenue at 27th Street New York, NY 10001-5992
Telephone 212.760.7759 Facsimile 212.760.7978

DESIGN FIRM M Plus M Incorporated
ART DIRECTOR Takaaki Matsumoto, Michael McGinn
DESIGNER Takaaki Matsumoto
CLIENT Fashion Institute of Technology

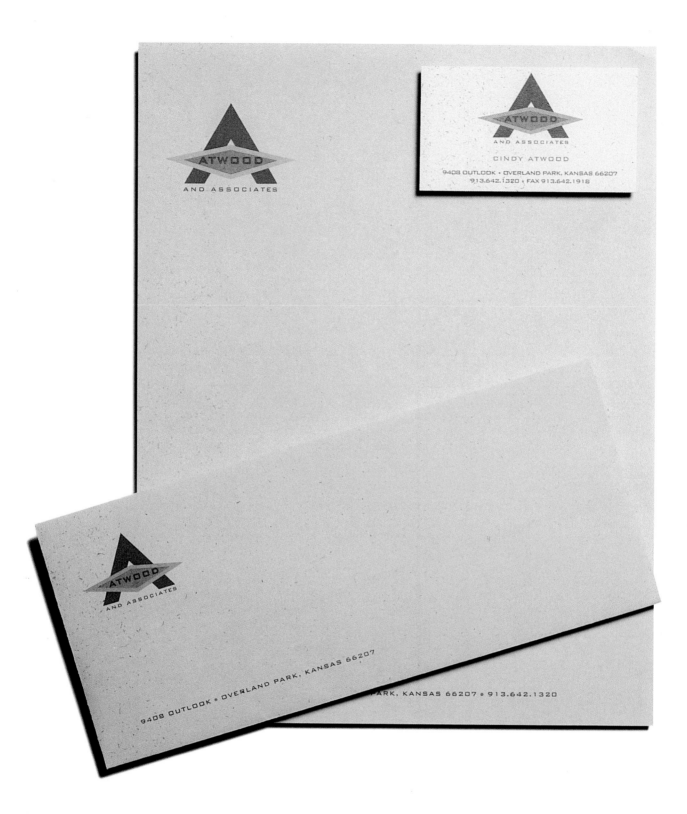

DESIGN FIRM WRK
ART DIRECTOR Deb Robinson
DESIGNER Deb Robinson
CLIENT Atwood and Associates
PAPER/PRINTING Speckletone/Colormark

DESIGN FIRM	Design Art, Inc.	**DESIGN FIRM**	Design Art, Inc.	**DESIGN FIRM**	Design Art, Inc.
ART DIRECTOR	Norman Moore	**ART DIRECTOR**	Norman Moore	**ART DIRECTOR**	Norman Moore
DESIGNER	Norman Moore	**DESIGNER**	Norman Moore	**DESIGNER**	Norman Moore
CLIENT	Roger Davies Records	**CLIENT**	Patty Smyth	**CLIENT**	Riverhorse Music

DESIGN FIRM	Riley Design Associates	**DESIGN FIRM**	Muller + Company	**DESIGN FIRM**	Riley Design Associates
ART DIRECTOR	Daniel Riley	**ART DIRECTOR**	John Muller	**ART DIRECTOR**	Daniel Riley
DESIGNER	Daniel Riley	**DESIGNER**	David Shultz	**DESIGNER**	Daniel Riley
ILLUSTRATOR	Daniel Riley	**CLIENT**	Weideman	**ILLUSTRATOR**	Daniel Riley
CLIENT	Hewlett Packard			**CLIENT**	Ernst & Young

DESIGN FIRM Schowalter² Design
ART DIRECTOR Toni Schowalter
DESIGNER Ilene Price,
 Toni Schowalter
CLIENT Towers Perrin

DESIGN FIRM Segura Inc.
ART DIRECTOR Carlos Segura
DESIGNER Carlos Segura
ILLUSTRATOR Carlos Segura
CLIENT Elements

DESIGN FIRM M Plus M Incorporated
ART DIRECTOR Takaaki Matsumoto,
 Michael McGinn
DESIGNER Takaaki Matsumoto
ILLUSTRATOR Takaaki Matsumoto
CLIENT Congregation Rodeph
 Sholom

Life on Earth
Rethinking the Future

DESIGN FIRM Bruce Yelaska Design
ART DIRECTOR Bruce Yelaska
DESIGNER Bruce Yelaska
ILLUSTRATOR Bruce Yelaska
CLIENT Bank of America
 This logo is for a traveling
 exhibit on the rain forest
 and the environment.

DESIGN FIRM Sommese Design
ART DIRECTOR Lanny Sommese
DESIGNER Kristin Sommese
ILLUSTRATOR Lanny Sommese
CLIENT Penn State Jazz Club

DESIGN FIRM Hornall Anderson
 Design Works
ART DIRECTOR Jack Anderson
DESIGNER Jack Anderson,
 David Bates
ILLUSTRATOR David Bates
CLIENT Seattle Camerata

DESIGN FIRM	Lambert Design Studio
ART DIRECTOR	Christie Lambert
DESIGNER	Joy Cathey
CLIENT	The Family Place

DESIGN FIRM	Segura Inc.
ART DIRECTOR	Carlos Segura
DESIGNER	Carlos Segura
ILLUSTRATOR	Carlos Segura
CLIENT	Glade

DESIGN FIRM	David Carter Design
ART DIRECTOR	Sharon Lejune
DESIGNER	Sharon Lejune
ILLUSTRATOR	Sharon Lejune
CLIENT	Anzu

DESIGN FIRM	Tracy Sabin, Illustration & Design
ART DIRECTOR	Alison Hill
DESIGNER	Tracy Sabin
ILLUSTRATOR	Tracy Sabin
CLIENT	Turner Entertainment Co.

DESIGN FIRM	Sommese Design
ART DIRECTOR	Lanny Sommese
DESIGNER	Lanny Sommese
ILLUSTRATOR	Lanny Sommese
CLIENT	Fonds Alexandre Alexandre.

DESIGN FIRM	Delmarva Power Visual Communications Design Firm
	Christy MacIntyre
ART DIRECTOR	John Alfred
DESIGNER	John Alfred
ILLUSTRATOR	John Alfred
CLIENT	Edge Moor Fish Hatchery

DESIGN FIRM Smith Group
Communications
ART DIRECTOR Gregg Frederickson
DESIGNER Gregg Frederickson
CLIENT Waterhouse Place

DESIGN FIRM Segura Inc.
ART DIRECTOR Carlos Segura
DESIGNER Carlos Segura
ILLUSTRATOR Carlos Srgura
CLIENT Arete Furniture

DESIGN FIRM Design Art, Inc.
ART DIRECTOR Norman Moore
DESIGNER Norman Moore
CLIENT Digital Design Centre

DESIGN FIRM Eilts Anderson Tracy
ART DIRECTOR Patrice Eilts
DESIGNER Patrice Eilts
ILLUSTRATOR Patrice Eilts
CLIENT Nelson Adluns
Museum of Art for
"Intelligence of Forms,
an African Exhibit."

DESIGN FIRM Luis Fitch Diseño
ART DIRECTOR Luis Fitch
DESIGNER Luis Fitch
CLIENT Fletop (hair salon)

DESIGN FIRM Smith Group
Communications
ART DIRECTOR Gregg Frederickson
DESIGNER Gregg Frederickson
CLIENT United States
Botanic Garden

DESIGN FIRM Segura Inc.
ART DIRECTOR Carlos Segura
DESIGNER Carlos Segura
ILLUSTRATOR Carlos Segura
CLIENT Deni Furniture

DESIGN FIRM Lambert Design Studio
ART DIRECTOR Christie Lambert
DESIGNER Joy Cathey
CLIENT The Family Place
(children's art and
music festival)

DESIGN FIRM Regal Airport/Art Dept.
DESIGNER Timmy Kan
CLIENT Regal Airport Hotel

DESIGN FIRM Tieken Design &
Creative Services
ART DIRECTOR Fred E. Tieken
DESIGNER Fred E. Tieken
ILLUSTRATOR Fred E. Tieken
CLIENT Arizona International
Film Festival

DESIGN FIRM Lambert Design Studio
ART DIRECTOR Christie Lambert
DESIGNER Christie Lambert,
Joy Cathey
ILLUSTRATOR Joy Cathey
CLIENT Anita Misra. The client
used this logo for her
bridal shower — a bar
and lingerie shower.

DESIGN FIRM MacVicar Design &
Communications
ART DIRECTOR John Vance
DESIGNER William A. Gordon
CLIENT Marketing International
Corporation

DESIGN FIRM Luis Fitch Diseño
ART DIRECTOR Luis Fitch
DESIGNER Luis Fitch
CLIENT Freak's
This client is a "young" clothing company for skateboarders.

DESIGN FIRM Luis Fitch Diseño
ART DIRECTOR Luis Fitch
DESIGNER Luis Fitch
CLIENT Scott Foresman Publishers

DESIGN FIRM Segura Inc.
ART DIRECTOR Carlos Segura
DESIGNER Carlos Segura
ILLUSTRATOR Carlos Segura
CLIENT Source Lotion/ Helene Curtis

DESIGN FIRM Studio Seireeni
ART DIRECTOR Richard Seireeni
DESIGNER Jim Pezzullo
ILLUSTRATOR Bob Maile
CLIENT Skuld

DESIGN FIRM Eilts Anderson Tracy
ART DIRECTOR Patrice Eilts
DESIGNER Patrice Eilts
ILLUSTRATOR Patrice Eilts
CLIENT Total Entertainment

DESIGN FIRM David Carter Design
ART DIRECTOR Lori Wilson
DESIGNER Lori Wilson
ILLUSTRATOR Faith Delong
CLIENT Disney Orlando, Florida

DESIGN FIRM	Design Art, Inc.	**DESIGN FIRM**	Studio Seireeni	**DESIGN FIRM**	Riley Design Associates
ART DIRECTOR	Norman Moore	**ART DIRECTOR**	Romane Cameron	**ART DIRECTOR**	Daniel Riley
DESIGNER	Norman Moore	**DESIGNER**	Romane Cameron	**DESIGNER**	Daniel Riley
CLIENT	Digital Art 3D	**ILLUSTRATOR**	Romane Cameron	**ILLUSTRATOR**	Daniel Riley
	Graphics	**CLIENT**	Wilshire Designs	**CLIENT**	Randy Licht Inc.

DESIGN FIRM	Segura Inc.	**DESIGN FIRM**	Hornall Anderson	**DESIGN FIRM**	Muller + Compnay
ART DIRECTOR	Carlos Segura		Design Works	**ART DIRECTOR**	John Muller
DESIGNER	Carlos Segura	**ART DIRECTOR**	Jack Anderson	**DESIGNER**	Mike Muller
ILLUSTRATOR	Carlos Segura	**DESIGNER**	Jack Anderson,	**CLIENT**	Kansas City Jazz
CLIENT	Vicous Rumor/band		Brian O'Neill		Commission
		CLIENT	Gang of Seven		

INDEX/DIRECTORY

Ace Architects 67
Adam, Filippo & Associates 117, 137, 139
Adele Bass & Co. Design 59, 76, 177
Albert Juarez Design & Illustration 88
Animus Communicacao 152
Armin Vogt Partner/Corporate & Packaging Design 208, 209
Aslan Grafix 118, 208
Barbara Raab Design 44
Bartels & Company, Inc. 8, 52, 53, 65, 91, 107, 122, 136
Bayon Marketing Design 230
Beauchamp Design 27, 61, 63, 194
Bi-design 46
Blue Sky Design 20
Bruce Yelaska Design 116, 240, 244
Cactus Design 20
Carl Seltzer Design Office 191
Cheryl Waligory Design 81
Choplogic 65, 160, 163, 224
Cisneros Design 8
Clifford Selbert Design 12, 68, 82, 131
Coker Golley Ltd. 153
Communication Design, Inc. 66
Creative EDGE 26, 57, 123
Creative Services by Pizza Hut 37, 145, 161, 166
Dan Frazier Design/Image Group 96, 190
David Carter Design 162, 163, 164, 165, 185, 186, 245, 248
Debra Nichols Design 105, 155, 174
Delmarva Power Corp Comm. 140, 245
Design Art, Inc. 59, 116, 140, 243, 246, 249
The Design Associates 80, 104, 111, 239
Design/Joe Sonderman, Inc. 174
Designs N Logos 157
Dewitt Kendall-Chicago 16, 40
Divoky, Stephen 157
E. M. Design 197
Earl Gee Design 59, 106, 135, 208, 209, 210
Eilts Anderson Tracy 59, 70, 89, 99, 114, 140, 164, 246, 248
Elizabeth Resnick Design 25, 191
Ellen Kendrick Creative, Inc. 108, 191
Ema Design 24, 35, 45
Envision 21
Eskind Waddell 64
Focus 2 80, 180, 238
Fountainhead Graphics 116
Frank D'Astolfo Design 141
Gary Greene Artworks 186
GrandPre and Whaley, Ltd. 17, 45, 48, 109
The Great American Logo Company 141
The Green House 53, 213, 236
Handler Design Ltd. 134, 213
Hartmann & Mehler Designers GmbH 171, 172, 173, 179, 217, 231

Hawley & Armian Marketing/Design 30, 79
Heart Graphic Design 25, 71, 104
Peter Hermesmann 84
Hill, Alan 45
Hoffmann & Angelic Design 36
Hornall Anderson Design Works 37, 39, 62, 72, 74, 89, 108, 110, 162, 176, 182, 193, 198, 200, 205, 208, 209, 215, 244, 249
i4 Design 98
Ilan Geva & Friends 125
Image Group 93, 133, 134, 157, 204, 223
Images 43
Inkwell Publishing Co., Inc. 97
Integrate Inc. 134, 181
James Clark Design Images 23, 202
Jenssen Design Pty. Limited 95, 100, 138, 179
Jim Ales Design 99
Jon Wells Associates 56, 134
Kom Design Munich 234
L. F. Banks, Associates 237
Lambert Design Studio 118, 186, 245, 247
Laura Herrmann Design 28
LeAnn Brook Design 207
Let Her Press 150
Linnea Gruber Design 41
Lipson Alport Glass & Associates 116
Lorna Stovall Design 49, 195
Love Packaging Group 55, 175
Luis Fitch Diseno 140, 165, 246, 248
M. Renner Design 20
M Plus M Incorporated 241, 244
Mac By Night 161
MacVicar Design & Communications 117, 139, 247
Mark Oldach Design 54
The Marketing & Design Group 127
McCafferty, Randall 25
Metalli Linberg Adv. Jacket
Michael Stanard, Inc. 179
Mike Salisbury Communications 213
Mike Quon Design Office 80, 229, 232, 235
Modern Dog 209, 233, 237
Mortensen Design 192
Muller & Company 19, 37, 201, 243, 249
Musikar Design 8, 65
Nesnadny & Schwartz 146
New Idea Design Inc. 141
O&J Design, Inc. 104, 112
Ortega Design 11, 113, 158
Palmquist & Palmquist Design 117, 163
Pandamonium Designs 31
Patri-Keker Design 53
Pig Studios 222
Platinum Design 87, 214
Porter, Matjasich & Associates 208
Proforma Rotterdam 6, 69, 212, 216
Puccinelli Design 25, 75, 103

Punctuation 18
Ramona Hutko Design 141
Raven Madd Design 33, 161
Regal Airport/Art Dept. 247
Reliv, Inc. 156
Richard Danne & Associates Inc. 141
Rickabaugh Graphics 116, 183, 185
Ridenour Advertising 51, 170
Riley Design Associates 116, 118, 139, 191, 243, 249
Robbins, Nora 53
Romeo Empire Design 121, 169
Ron Kellum Inc. 7, 209
Sayles Graphic Design 42, 124, 126, 129, 143, 168, 189, 213, 219, 220, 221, 226
Schindelwick, Caren 34
Schmeltz & Warren 58, 83
Schowalter[2] Design 117, 139, 141, 157, 164, 178, 244
Segura Inc. 13, 37, 47, 50, 59, 78, 89, 101, 162, 199, 244, 245, 246, 247, 248, 249
Sharpe Grafikworks 45
Shelly, Jeff 20
Shields Design 9, 85, 86, 104, 237
Shimokochi/Reeves 225
SHR Perceptual Management 92, 115, 184
Signum 174
Smith Group Communications 108, 130, 246
Sommese Design 37, 140, 144, 159, 164, 165, 244, 245
Source/Inc. 108
Steven Gulla Graphic Design 206
Strategic Communications 208
Studio Michael 22
Studio Seireeni 248, 249
Teknøs Design Group 32
THARP DID IT 14, 73, 147, 163
38 North 8, 188
Thomas Hillman Design 29, 99
Tieken Design & Creative Services 37, 247
TMCA, Inc. 94
Total Designers 237
Tracy Sabin Illustration & Design 245
Trickett & Webb Limited Jacket
Turner Design 128, 139, 209
TW Design 118
Ultimo Inc. 102
Vaughn Wedeen Creative 15, 118, 132, 196, 227
Visual Dialogue 203
Vrontikis Design Office 120, 148, 149, 151
W Designs 164
Walsh and Associates, Inc. 80, 99, 154
The Weller Institute for the Cure of Design, Inc. 117, 139, 163, 185, 186
Wigwam Design Pte. Ltd. 10, 218, 228
William Field Design 65, 161, 174, 179
WRK 242

Ace Architects
330 2nd Street
Oakland, CA 94607

Adam, Filippo & Associates
1206 Fifth Avenue
Pittsburgh, PA 15219

Adele Bass & Co. Design
758 E. Colorado Boulevard #209
Pasadena, CA 91101

Albert Juarez Design &
Illustration
2900 McKinley
El Paso, TX 79930

Animus Communicacao
LaDeira Do Ascurra 115-A
22241-320/RIO/RJ/Brazil

Armin Vogt Partner
Corporate & Packaging Design
Munsterplatz 8
CH-4001 Basel

Aslan Grafix
6507 Rain Creek Parkway
Austin, TX 78759

Barbara Raab Design
3105 Valley Drive
Alexandria, VA 22302

Bartels & Company, Inc.
3284 Ivanhoe Avenue
St. Louis, MO 63139

Bayon Marketing Design
P.O. Box 214
Kennebunk, ME 04043

Beauchamp Design
9848 Mercy Road No. 8
San Diego, CA 92129

Bi-design
502 Alabama Drive
Herndon, VA 22070

Blue Sky Design
6401 SW 132 Ct. Circle
Miami, FL 33183

Bruce Yelaska Design
1546 Grant Avenue
San Francisco, CA 94133

Cactus Design
312 Montgomery Street
Alexandria, VA 22314

Carl Seltzer Design Office
120 Newport Center Drive
Suite 206
Newport Beach, CA 92660

Cheryl Waligory Design
145 W. 12th St. #25
New York, NY 10011

Choplogic
2014 Cherokee Parkway
Louisville, KY 40204

Cisneros Design
3168 Plaza Blanca
Santa Fe, NM 87505

Clifford Selbert Design
2067 Massachusetts Avenue
Cambridge, MA 02140

Coker Golley Ltd.
101 Marietta Street
Suite 3310
Atlanta, GA 30303

Communication Design, Inc.
One North Fifth Street
Suite 500
Richmond, VA 23219

Creative EDGE
2 Church Street
Burlington, VT 05401

Creative Services by Pizza Hut
9111 E. Douglas
Wichita, KS 67207

Dan Frazier/Image Group
25 Main Street
Suite 203
Chico, CA 95928

David Carter Design
4112 Swiss Avenue
Dallas, TX 75204

Debra Nichols Design
468 Jackson Street
San Francisco, CA 94111

Delmarva Power Corp. Comm.
P.O. Box 231
Wilmington, DE 19899

Design Art, Inc.
6311 Romaine Street #7311
Los Angeles, CA 90038

The Design Associates
89 Wellington St. 5A1
Central, Hong Kong

Design/Joe Sonderman, Inc.
P.O. Box 35146
Charlotte, NC 28235

Designs N Logos
24 Wilson Avenue NE
P.O. Box 6159
St. Cloud, MN 56302

Dewitt Kendall-Chicago
5000 Marine Drive 4D
Chicago, IL 60640

Stephen Divoky
1048 N.E. 95th Street
Seattle, WA 98115

E.M. Design
9526 S. 207th Place
Kent, WA 98031

Earl Gee Design
501 Second Street, Suite 700
San Francisco, CA 94107

Eilts Anderson Tracy
4111 Baltimore
Kansas City, MO 64111

Elizabeth Resnick Design
126 Payson Road
Chestnut Hill, MA 02167

Ellen Kendrick Creative, Inc.
1707 Nicholasville Road
Lexington, KY 40503

Ema Design
1228 Fifteenth Street
Suite 301
Denver, CO 80202

Envision Communications, Inc.
120 South Brook Street
Louisville, KY 40202

Eskind Waddell
260 Richmond Street West
Suite 201
Toronto M5V 1W5 Ontario
Canada

Focus 2
3333 Elm Suite 203
Dallas, TX 75226

Fountainhead Graphics
6740 Clough Pike
Suite 202-206
Cincinnati, OH 45244

Frank D'Astonfo Design
80 Warren Street #32
New York, NY 10007

Gary Greene Artworks
21820 NE 156th Street
Woodinville, WA 98072

GrandPre and Whaley, Ltd.
475 Cleveland Avenue North
Suite 222
St. Paul, MN 55104

The Great American Logo
Company
14800 N.W. Cornell Road #4C
Portland, OR 97229

The Green House
64 High St.
Harrow-on-the-Hill
London HA1 3LL UK

Handler Design Ltd.
17 Ralph Avenue
White Plains, NY 10606

Hartmann & Mehler Designers
GmbH
CorneliusstraBe 8
60325 Frankfurt am Main
Germany

Hawley & Armian
Marketing/Design
305 Newbury #22
Boston, MA 02115

Heart Graphic Design
501 George Street
Midland, MI 48640

Peter Hermesmann
306 Bainbridge Street
Philadelphia, PA 19147

Allan Hill
2535 Tulip Lane
Langhorne, PA 19053

Hoffmann & Angelic Design
317-1675 Martin Drive
White Rock, B.C.
Canada V4A 6E2

Hornall Anderson Design Works
1008 Western, Suite 600
Seattle, WA 98104

i4 Design
55C Gate 5 Road
SaulSalito, CA 94965

Ilan Geva & Friends
1340 N. Astor #1608
Chicago, IL 60610

Image Group
25 Main Street
Suite 203
Chico, CA 95928

Images
1835 Hampden Court
Louisville, KY 40205

Inkwell Publishing Co., Inc.
10 San Pablo Street
Bo. KapitolYo Pasig
Metro Manila, Philippines 1603

Integrate Inc.
503 S. High Street
Columbus, OH 43215

James Clark Design Images
200 West Mercer #102
Seattle, WA 98119

Jenssen Design Pty. Limited
2A Glen Street
Milsons Point NSW 2061
Australia

Jim Ales Design
123 Townsend Street #480
San Francisco, CA 94107

Jon Wells Associates
407 Jackson Street
Suite 206
San Francisco, CA 94111

Kom Design Munich
Georg-Brauchle-Ring 68
80992 Munich

L. F. Banks Associates
8th & Chestnut Street
Philadelphia, PA

Lambert Design Studio
7007 Twin Hills Avenue
Suite 213
Dallas, TX 75231

Laura Herrmann Design
69 Atlantic Road
Gloucester, MA 01930

Leann Brook Design
P.O. Box 1788
Nevada City, CA 95959

Let Her Press
1544 Westerly Terrace
Los Angeles, CA 90026

Linnea Gruber Design
1775 Hancock Street #190
San Diego, CA 92110

Lipson Alport Glass
666 Dundee Road #103
Northbrook, IL 60062

Lorna Stovall Design
1088 Queen Anne Place
Los Angeles, CA 90019

Love Packaging Group
700 E. 37th Street North
Wichita, KS 67201

Luis Fitch Diseno
1116 Harrison Avenue
Columbus, OH 43201

M. Renner Design
Weiherway 3
CH-4123 Australia

M Plus M Incorporated
17 Cornelia Street
New York, NY 10014

Mac By Night
22975 Caminito Olivia
Laguna Hills, CA 92653

MacVicar Design &
Communications
2615-A Fhirlington Road
Arlington, VA 22206

Mark Oldach Design
3525 N. Oakly
Chicago, IL 60614

The Marketing & Design Group
297 Garfield Avenue
Oakhurst, NJ 07755

Randall McCafferty
305 Edgewood Road
Pittsburgh, PA 15221

Metalli Lindberg Adv.
Via Garibaldi, 5/D
31015 Conegliano (Treviso) Italy

Michael Stanard, Inc.
One Thousand Main Street
Evanston, IL 60202

Mike Salisbury Communications
2200 Amapola Ct.
Torrance, CA 90504

Mike Quon Design Office
568 Broadway #703
New York, NY 10012

Modern Dog
601 Valley Street No. 309
Seattle, WA 98109

Mortensen Design
416 Bush Street
Mountain View, CA 94041

Muller & Company
4739 Belleview
Kentuck City, MO 64112

Musikar Design
7524 Indian Hills Drive
Rockville, MD 20855

Nesnadny & Schwartz
10803 Magnolia Drive
Cleveland, OH 44106

New Idea Design Inc.
3702 S. 16th Street
Omaha, NE 68107

O & J Design, Inc.
9 West 29th Street
New York, NY 10001

Ortega Design Studio
1735 Spring Street
St. Helena, CA 94574

Palmquist & Palmquist Design
P.O. Box 325
Bozeman, MT 59771

Pandamonium
14 Mt. Hood Road
Suite 3
Boston, MA 02135

Patri-Keker Design
1859 Mason St. #1
San Francisco, CA 94133

Pig Studios
41 Wooster Street
New York, NY 10013

Platinum Design
14 W. 23rd Street
New York, NY 10010

Porter/Matjasich & Associates
154 West Hubbard
Chicago, IL 60610

Proforma Rotterdam
Slepersvest 5-7
3011 MK Rotterdam

Puccinelli Design
114 E. De La Guerra #5
Santa Barbara, CA 93101

Punctuation
3-14, 3rd Floor, Berjaya
Plaza, 55100 KL, West Malaysia

Ramona Hutko Design
9607 Bulls Run Parkway
Bethesda, MD 20817

Raven Madd Design
P.O. Box 11331
Wellington, New Zealand

Regal Airport Hotel
SA PO Road
Kowloon City
Kowloon Hong Kong

Reliv, Inc.
1809 Clarkson Road
Chesterfield, MO 63017

Richard Danne & Associates Inc.
126 Fifth Avenue
New York, NY 10011

Rickabaugh Graphics
384 W. Johnstown Road
Gahanna, OH 43230

Ridenour Advertising
33975 Dequindre
Suite 106
Troy, MI 48083

Riley Design Associates
214 Main Street Suite A
San Mateo, CA 94401

Nora Robbins
19 Holden Road
Belmont, MA 02178

Romeo Empire Design
154 Spring Street
New York, NY 10012

Ron Kellum Inc.
151 First Avenue PH-1
New York, NY 10003

Sayles Graphic Design
308 Eighth Street
Des Moines, Iowa 50309

Caren Schindelwick
Longwiedo Str. 26a
85221 Dachen, Germany

Schmeltz & Warren
74 Sheffield Road
Columbus, OH 43214

Schowalter² Design
21 The Crescen
Short Hills, NJ 07078

Segura, Inc.
361 W. Chestnut
Chicago, IL 60610

Sharpe Grafikworks
815 Main Street
Cincinnati, OH 45202

Jeff Shelly
300 Mercer Street
Apt. 28I
New York, NY 10003

Shields Design
415 E. Olive Avenue
Fresno, CA 93728

Shimokochi/Reeves
4465 Wilshire Blvd. #100
Los Angeles, CA 90010

SHR Perceptual Management
8700 E. Via De Ventura
Suite 100
Scottsdale, AZ 85258

Signum
1904 Nancy Court Number 7
Champaign, IL 61821

Smith Group Communications
614 SW 11th
Portland, OR 97205

Sommese Design
481 Glenn Road
State College, PA 16803

Source/Inc.
116 S. Michigan Avenue
Chicago, IL 60451

Steven Gulla Graphic Design
65 Sullivan Street
Suite 8A
New York, NY 10012

Strategic Communications
308 Southwest 1st Avenue
Suite 181
Portland, OR 97204

Studio Michael
1775 Hancock #190
San Diego, CA 92110

Studio Seireeni
708 S. Orange Grove
Los Angeles, CA 90036

Teknøs Design Group
111 Cooper Street
Santa Cruz, CA 95060

THARP DID IT
21 University Avenue
Suite 21
Los Gatos, CA 95030

38 North
2001 S. Hanley
Suite 200
St. Louis, MO 63144

Thomas Hillman Design
193 Middle Street
Portland, ME 04101

Tieken Design & Creative Services
2800 N. Central Avenue
Suite 150
Phoenix, AZ 85004

TMCA, Inc.
2231 Devine Street
Suite 304
Columbia, SC 29205

Total Designers
P.O. Box 888
Huffman, TX 77336

Tracy Sabin, Illustration & Design
13476 Ridley Road
San Diego, CA 92129

Trickett & Webb Limited
The Factory, 84 Marchmont Street
London WC1N 1AG

Turner Design
1210 Barkley Rd.
Charlotte, NC 20209

TW Design
3490 Piedmont Road
Suite 1200
Atlanta, GA 30305

Ultimo Inc.
41 Union Sq. West
Suite 209
New York, NY 10003

Vaughn Wedeen Creative
407 Rio Grande NW
Albuquerque, NM 87104

Visual Dialogue
429 Columbus Avenue #1
Boston, MA 02116

Vrontikis Design Office
2021 Pontius Avenue
Los Angeles, CA 90025

W Designs
14 Hollywood Place
Hohokus, NJ 07423

Walsh and Associates, Inc.
4464 Fremont North #310
Seattle, WA 98103

The Weller Institute for the Cure
of Design, Inc.
P.O. Box 726
Park City, UT 84060

Wigwam Designs Pte. Ltd.
32A Sago Street
Singapore 0105

William Field Design
355 E. Palace Avenue
Santa Fe, NM 87501

WRK
602 Westport Road
Kentuck City, MO 64111